Studio Lighting Anywhere

The Digital Photographer's

Guide to Lighting On Location

and in Small Spaces

Joe Farace

AMHERST MEDIA, INC. ■ BUFFALO, NY

DEDICATION

This book is dedicated to Dave Hall, a talented photographer, webmaster of Glamour Models (www.glamourmodels. com), and one of the kindest, most generous people that I've ever had the pleasure to know.

Copyright © 2011 by Joe Farace.
All photographs by the author unless otherwise noted.
All rights reserved.

Cover photograph © 2011 by Mary Farace.

Published by:
Amherst Media, Inc.
P.O. Box 586
Buffalo, N.Y. 14226
Fax: 716-874-4508
www.AmherstMedia.com

Publisher: Craig Alesse
Senior Editor/Production Manager: Michelle Perkins
Assistant Editor: Barbara A. Lynch-Johnt
Editorial assistance provided by Chris Gallant, Sally Jarzab, and John S. Loder

ISBN-13: 978-1-60895-298-4
Library of Congress Control Number: 2010940512
Printed in Korea.
10 9 8 7 6 5 4 3 2 1

Check out Amherst Media's blogs at: http://portrait-photographer.blogspot.com/
http://weddingphotographer-amherstmedia.blogspot.com/

CONTENTS

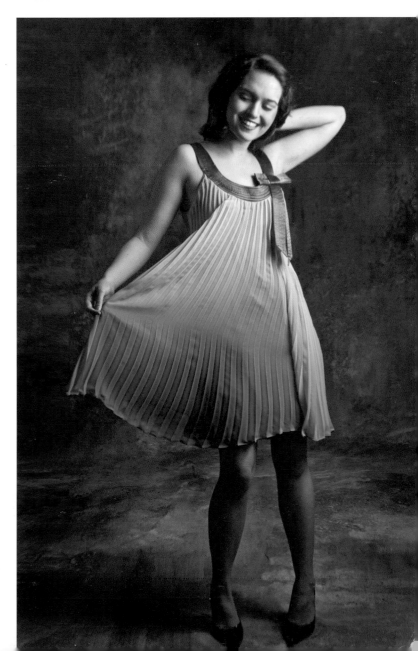

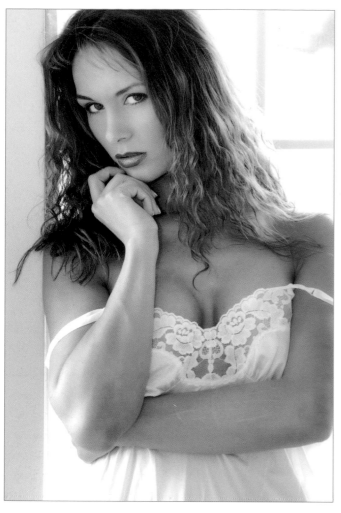

ACKNOWLEDGMENTS

Books like this one are not written in a vacuum, and many people helped make this one possible. A big thank you goes out to Amherst Media's Craig Alesse for dreaming up the "studio lighting anywhere" concept and giving me a chance to write this book.

Along the way, many photographers helped me to understand what goes into the art and science of studio lighting, and I'm grateful to them for their help and encouragement. This includes the legendary Don Feltner, who encouraged and inspired me in so many ways during my early photographic career as well as Lightware's Paul Peregrine (www.lightwareinc.com) and Plume Ltd.'s Gary Regester (www.plumeltd.com), both of whom know more about studio lighting than any other two people on this planet. Thanks also to Paul for contributing a photograph from a model shoot we did together.

Thanks also goes out to the many companies who offered technical assistance and product shots for this book, including Adorama's (www.adorama .com) Jerry Deutsch; Booth Photo's (www.boothphoto.com) Jeff Cowdrey and Sheila Tait; Dennis Cole of Backgrounds by Cole (www.coleandcompany.com); Dynalite's (www.dynalite.com) Jim Morton; JTL Corporation's (www.jtlcorp.com) Jonathan Zou; the creative staff at Grin&Stir (www.light waredirect.com); Mark Astmann of Manfrotto Distribution (www.manfrot todistribution.us); Silverlake Photo's Travis Gadsby (www.silverlakephoto .com), a terrific photographer who also supplied some images; and Westcott's (www.fjwestcott.com) Amber McCoy and Jennifer Holtsberry.

I would also like to thank my own personal support team who both encourage and bail me out of technical and creative problems. This includes Pulitzer Prize-winning photographer Barry Staver (www.barrystaver.com), who made the portrait of me that appears on page 6. I would also like to thank him for his continuing friendship and motivation. Thanks also goes out to technical guru Kevin Elliott of DigitalMD (www.digitalmd.net), who helps me with computer-related technical issues, and photographer Jack Dean (www.jackdeanphotography.com), who supplied some shots of me in action and permitted me to do several shoots in the purpose-built structure behind his Fort Lupton, Colorado home.

To demonstrate that there's more than one approach to lighting, I wanted this book to feature images made by other photographers. I would like to thank the following people for contributing images and making this book more comprehensive: Vinnie Ariniello for his behind-the-scenes shots; Jerry Bolyard (www.jzbphotography.com), whose photography exhibits a rare

combination of technical and aesthetic skill that's hard to beat; Dave Hall, whom I dedicated this book to; WKH Photography's (www.wkhphotography.phy) Kent Hepburn, whose photographic style exudes a wholesome sensuality; Matthew Staver, who is not just one of the nicest young photographers out there but also one of the most talented; and Craig Minielly of Aura Photographics (www.auraphotographics.com), who is the genius behind Craig's Actions (www.craigsactions.com). A big thank you goes out to all of the different people who posed for the photographs that appear in this book. Photographing people is a shared endeavor, and I owe a huge debt of gratitude to all of the people whose photographs appear in this book.

Lastly, I would like to thank my wonderful wife Mary (www.maryfarace.com), who is an outstanding people photographer in her own right and who over the years has taught me a lot about portrait lighting. She not only made some of the photos for this book, including the cover shot, but served as a model for others. Mary has been and is my greatest fan. She is as much responsible for what's in this book as anyone, and I'll always be grateful for her love and support.

ABOUT THE AUTHOR

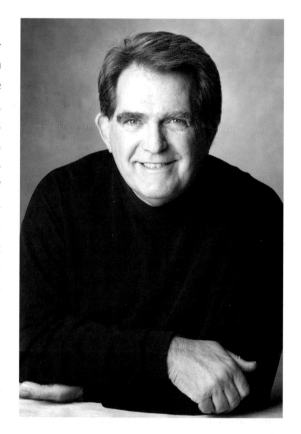

Joe Farace's interest in digital imaging combines an engineering education from Johns Hopkins University with training in photography he acquired at the Maryland Institute, College of Art. Joe is the author of many books about photography, digital imaging, and the business of photography, and this one represents the thirty-second book he's published. He is Contributing Writer and Photographer to *Shutterbug* magazine, which also publishes his monthly "Digital Innovations" and "Web Profiles" columns. His writing also occasionally appears in *Professional Photographer* and other domestic and foreign magazines. Joe's honors include the Photographic Craftsman's award presented by the Professional Photographers of America, Honorary Membership from the Independent Photographers of Colorado for "dedication and services to the photographic community," and he's a Media Professional member of the American Auto Writers and Broadcasters Association.

For daily tips on photography, follow Joe on Twitter (www.twitter.com/JoeFarace).

Barry Staver made this photograph of the author in his living room with a large octagonal lightbank attached to a Dynalite (www.dynalite.com) power pack and head system. To capture the photograph, he used a Canon EOS 5D and 24–70mm f/2.8L lens. The exposure was $1/160$ at f/6.3 and ISO 100. © 2011 Barry Staver.

INTRODUCTION

"There are two kinds of photographers: those who compose pictures and those who take them. The former work in studios. For the latter, the studio is the world. For them, the ordinary doesn't exist: everything in life is a source of nourishment."—*Ernst Haas*

Unfortunately the camera's EXIF data doesn't include outside temperature, but I think it was in the 40s when I captured this image using a Canon EOS 1D Mark II with an EF 85mm f/1.8 lens. I used an EX 550 flash to add fill. The exposure was $^1/_{250}$ at f/13 and ISO 400. Creating a shot like this takes a hardy model who's willing to get her feet wet.

One thing you should know from the start is that this book is about photographing people, not products or things. If you're interested in that latter type of photography, I recommend Robert Morrissey's *Master Lighting Guide for Commercial Photographers*, which is also available from Amherst Media. The techniques for photographing people versus a box of corn flakes may seem marginally similar and while they involve lights, lighting modifiers, and cameras, the addition of the human element makes a big difference and is in some ways easier than photographing products and in other ways more difficult. Some of these positive and negative aspects come from the photographer and the milieu they're comfortable working, some come from the subject matter. So, if you're interested in photographing real people, you've come to the right place. Unlike my last Amherst Media book, *Joe Farace's Glamour Photography*, this one features all kinds of people photography, including fashion, glamour, and portraiture.

Much of my portrait and fashion photography is done on location, but when you're living in a place like Colorado, you'll sometimes find that you or your subject aren't in the mood to go stomping around in the snow. That's when a studio comes in handy. Some people naturally prefer working in the studio. They enjoy the comfort and convenience that's only possible when they have complete control over the lighting used to photograph people. However, not everyone has the room and the budget to set up a formal shooting space. I don't. Over the years, I've carved out spare corners of my basement to create tiny but effective "studios." Some of the photographs you'll see on these pages were made in an 8x9-foot space sandwiched between a model train layout at camera right and an old sofa at camera left.

The real secret of the "studio lighting anywhere" concept, if there is one, is having the right attitude and choosing the right equipment. That gear doesn't have to be expensive, which is why in the pages that follow I'll show you how to make your images look like they were made in a real studio, even if that "studio" is a garage.

Richard Avedon once said, "I think all art is about control—the encounter between control and the uncontrollable." That's what a dedicated studio, no matter its size or location, provides to a photographer. It is a safe haven from the real world where, like the *Outer Limits* voice says, you can control the lighting, the background, and subject. When working in this kind of environment, I control everything from the subject's pose to their clothing and makeup, and the resulting photographs tend to be as much a portrait of me as they are of my subject.

What often emerges from all that control is a style. Photographic style is not something I'm conscious of when shooting, but the truth is, we all develop a signature way of shooting over time. The danger is, of course, that we keep shooting that same way or creating different versions of the same shot for the rest of our lives. Any style you develop must grow and change as you learn. Otherwise, what's the point? The starting point of anybody's style—and that includes me—is often the result of copying a photographer's work that we like. Since it's almost always impossible to exactly duplicate the look of someone else's image, we make accommodations as far as equipment, environment, and experience is concerned. As we continue to shoot and learn from experience and reading magazine articles and books, we start to tweak and improve those results until what emerges is truly a personal style.

WHAT'S IN THIS BOOK?

This book was written for the photographer who wants to do studio-type lighting but may not have the budget or space to set up a permanent studio. I've tried to keep the methods used to make all of the photographs in this book as transparent as possible. You won't have to attend a workshop or buy a DVD to learn any of my "secrets." Whatever studio lighting tips, tricks, and techniques I've practiced over the past thirty years are all right here on these pages for you to read and absorb. Nothing was held back. I've tried to keep the language as clear and buzzword free as possible, but the lighting world is filled with jargon, and it is sometimes hard to get around that fact. If I've used a term that's unfamiliar and it's not explained immediately after it is presented, you can find it in the glossary at the back of this book.

The cameras, lenses, and lighting equipment I used to create the images in this book were purchased with my own money. Occasionally some images were made while testing equipment for product reviews for *Shutterbug* or *Professional Photographer* magazine, but that is the only exception. You may be surprised to learn that after I finish writing a review or feature story, I must return the equipment to the manufacturer. Since I actually pay for my own gear, you'll probably also notice that some of the cameras used to make these photographs are relatively old, at least in Internet years. (It's like dog years.) All this proves is that if these photographs still look good, you don't need the latest SLR to capture studio-style photographs. In fact, many of the cameras

This photograph of Tia Stoneman was made in an 8x9-foot space that was cleared in my basement, low ceilings and all. It was made with a Canon EOS 5D and EF 85mm f/1.8 lens and two inexpensive monolights, each mounted with equally low-priced photographic umbrellas to soften the light. The exposure was $1/60$ at f/13 and ISO 200.

I shoot with were purchased as used or "refurbs" that were available at less-than-new prices. When it comes to studio photography, I think it's a good idea to be a thrifty shopper. In addition to shopping at retail establishments, you should consider purchasing used cameras and lighting gear on eBay or from friends upgrading to newer, more expensive models.

You should know that I am not employed, under contract, or sponsored by any camera or photographic lighting company. My mention of specific equipment used to make any of the photographs in this book does not constitute an endorsement by me of any brand of camera, lens, or studio lighting gear. The information on the equipment used to make the photographs is provided in the captions because readers inevitably want to know this kind of stuff, but you should use this information only as a guide. Everyone has their favorite equipment and methods. Keep in mind that the tools and techniques I use are not the only option; they are simply what I or a contributing photographer used for the shot. I strongly believe the attitude you bring to a shoot is more important than the equipment.

I've included lots of product shots in the following pages to let you know what the gear looks like. When I've mentioned a specific product in the text or captions, I've also provided a link to the company's web site so you can check price and availability. In the other photographs that appear on these pages, I've made an attempt to provide full technical details with each caption including the camera, lens, exposure, and all lighting data—often including a lighting diagram for some of the images. I've also tried to tell you where the image was made, and some of those locations may surprise you. For photographs that were contributed by guest photographers, I will provide as complete caption detail as possible.

The models who appear in this book represent many different looks and ethnic backgrounds. Some are professional models, others are aspiring models, and some are just "regular people" who posed for the fun of it. I've tried to use their photographs to enhance the ideas and concepts explained in the text, not just to show you a cool photo, although I hope that's part of the deal too. Unless otherwise noted in the captions, all of the photographs are © 2011 Joe Farace, All Rights Reserved. I've invited a few guest shooters to share their images and styles, and their names and copyright attribution are noted in the captions and with gratitude in the Acknowledgments.

All of the text and postproduction effects were made using an Apple MacPro computer with 5GB RAM, 3TB of internal storage, two built-in DVD-R drives, and an external recordable Blu-Ray drive. My Windows machine is an Apple iMac with 500GB of hard drive running Microsoft Vista Home (under Apple's Boot Camp) and an external 4TB network drive. The computers are networked and a router lets me wirelessly connect the Mac-Book Pro laptop I take on location. In the digital imaging universe, these are what I would call middle-of-the-road machines, and I know photographers

Photographing people is more challenging than photographing mannequins because our faces are not symmetrical. The way light affects the planes of the face will dictate your lighting placement. You'll need to make adjustments on occasion, as real people don't stand perfectly still. It's okay to practice with mannequins, like Anna here, until you'll learn a little more about lighting. See chapter 7 for a shot using this same lighting setup and costume, this time worn by a real person.

who work with less complex computers and others using more extensive and expensive systems. Digital imagers working with systems with more power, larger memory, and higher-capacity drives will be able to produce all of the workflow and effects shown in chapter 8 more quickly, while those with smaller, slower systems will have to be more patient.

During all of our explorations, I want you to have fun. Having fun is the single most important component of photography, and studio lighting should be fun too. Think of this adventure as your sandbox, but instead of sand, you get to toss light around to create magical moments. I know that it's fun for me, and I hope it's fun for you too. Thanks for joining me in what I like to think of as adventures in studio photography. I wish all of you success.

—Joe Farace (Brighton, Colorado 2011)

This is a classic Joe Farace-style studio shot that was made in my basement, just steps away from a furnace that's out of camera range to the left. The model is typically placed in a three-quarter pose; she is looking directly at the camera and seldom has a "say cheese" smile. Lighting was from three different studio lights placed in a manner I'll explain in coming chapters. The image was captured directly in monochrome mode using a Nikon D90 with AF-S Nikkor 18–105mm zoom lens and an exposure of $1/60$ at f/14 and ISO 200.

1. GETTING STARTED WITH STUDIO LIGHTING

"The pictures have a reality for me that the people don't.
It is through the photographs that I know them."—*Richard Avedon*

A wise photographer once told me, "Light is light." The most important characteristics of any studio lighting system are the quality, quantity, and color of the output. The kind of hardware you use will have an impact on all of these aspects, but the quality of the light can be further affected by using light modifiers, a topic that is covered in the next chapter. In this one, you'll find that studio lighting equipment can be divided into two basic categories: continuous lighting or electronic flash.

CONTINUOUS LIGHTING

Studio flash units are a necessary evil for making photographs when you don't have enough available light, which is one reason I also like to shoot using continuous light sources—especially for portraits. Continuous lighting is so named because it is "on" continuously, much like a lightbulb or the sun, enabling you to use your in-camera light meter to measure the light falling on your subject. Continuous lighting equipment lets you see how the light—shadows and highlights—is falling on your subject. Also, because it can be relatively inexpensive, it is a good starting point for anyone on a budget. Continuous lighting sources typically use quartz or photoflood bulbs that can be hot, even dangerously so—which is why they are often called "hot lights." An increasing number of continuous lighting tools are being made with fluorescent lights—hence, they are cool "hot lights."

Instead of the subject being distracted (and maybe blink) because of the repeated pop of electronic flash, continuous light sources allow them to relax and let you relax too. Because the light is continuous, you can use all of your SLR's automatic exposure modes without having to worry about the camera selecting a shutter speed that won't sync with the flash. What happens when shooting flash with a shutter speed that's out of sync? You'll see in chapter 6.

Hot Lights vs. Cool Lights. For years, photographers have used continuous light sources to make images of people. These light sources fall under

> Continuous lighting equipment lets you see how the light is falling on your subject.

the general heading of "hot lights" and have many advantages over flash: they can be inexpensive, let you see the light as captured (which means you can use your camera's built-in meter), and are generally smaller and lighter than electronic flash units. On the downside, their color temperature can be a problem (see "Kelvin Temperatures" on page 31) and they are, waddaya know, hot.

For digital photographers, dealing with mismatched color temperatures is a thing of the past. Most digital SLRs include settings for tungsten light, and some will even let you dial in a specific color temperature in degrees Kelvin. For that first shot, don't forget to try the camera's Auto White Balance (AWB) setting. Many times this setting will produce spot-on color without any color temperature gymnastics. If all else fails, you can use the camera's built-in controls to create a custom white balance for a specific lighting setup. The key for doing this is having a dependable "white" color source that can be used to calibrate your camera, then follow the instructions in your camera's user's guide.

Hot lights come is several flavors including photofloods, HMI (Hydrargyrum Medium arc Iodide), and quartz, and each system has its own unique characteristics as well as pros and cons. Photofloods are comprised of a housing, stand bracket, and reflector and use an incandescent bulb that's not all that different from a household lightbulb. As with all of the bulbs used in hot light systems, they are relatively fragile and should be handled with care. You should always have a few backup bulbs in case one breaks before or during a photo session.

Originally designed for the film and video industry, HMI lights have several advantages over standard incandescent or quartz lights. When compared to incandescent lights, they deliver five times the light output per watt and generate less heat. Unlike quartz, the color temperature of HMI lights is the same as sunlight and doesn't require a tungsten color balance setting in the camera. They are a flicker-free light source and are pricey, but you can rent them.

In between photofloods and HMI is the Goldilocks of continuous lighting, the quartz light, which is available in a variety of sizes and shapes—and in a range of price points to suit almost anyone's lighting budget. Quartz lighting fixtures use high-pressure incandescent lamps containing halogen gases whose filaments burn at higher temperatures with higher efficiency, producing more lumens per watt than an incandescent lamp. Quartz does not darken with age but gets extremely hot, so be sure to let them cool off before touching them to avoid getting burnt fingers.

The only problem with traditional "hot lights" is that they are, well, *hot* and not all that comfortable to work under for subject and photographer alike. Welcome to a new world of continuous light sources powered by fluorescent bulbs. I know what you're thinking: aren't fluorescent lights those thingies that produced horrible green light when shooting slide film?

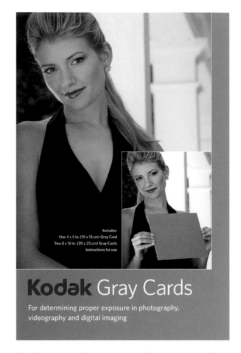

Kodak Gray Cards

For determining proper exposure in photography, videography and digital imaging

My favorite white source for custom white balance is the flip side of the redoubtable Kodak Gray Card. One side of the card has the infamous 18 percent gray and the other has 90 percent reflection (white). Photo courtesy of Eastman Kodak.

The only problem with traditional "hot lights" is that they are, well, *hot*.

Yes, but as it turns out, daylight-balanced fluorescents are the perfect light source for digital photography. Tungsten lights produce 93 percent heat and only 7 percent red light. By comparison, fluorescent light is cooler, brighter, and comes out the winner for color balance. Fluorescent lights used for photography are daylight-balanced, and their RGB output spikes closely match the receptive RGB spikes of a CCD or CMOS imaging chip. A CCD is least sensitive in its blue channel, and tungsten light has the least output in the blue channel. When combined with infrared output (that's the heat), it can overcome the chip's spectral response.

ELECTRONIC FLASH

Most photographers are more familiar with flash than continuous lights, because every point-and-shoot camera has one. The light from electronic flash is almost instantaneous, so you can't directly see the effect of the light on your subject. However, most studio lights have a "modeling" light (a con-

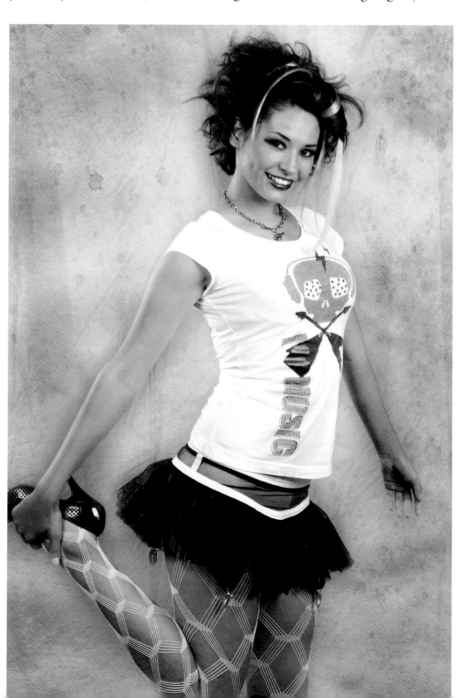

This photograph was made in my basement using three Flashpoint II (www.adorama.com) monolights and a Canon EOS 40D with a 50mm f/1.8 lens that I bought on eBay for $50. Exposure was $1/60$ at f/10 and ISO 100. The background was an inexpensive Adorama Belle Drape muslin. The image was tweaked using techniques that I'll show you in chapter 8.

tinuous light source) to show an approximation of the lighting effect that will be achieved in the final image.

Flash output is often measured in watt-seconds (the term Joule is sometimes used instead), a unit of electrical energy that's equal to the work done when a current of one ampere passes through a resistance of one ohm for one second. It's basically a way to measure the power and discharge capacity of an electronic flash's power supply. Think raw automobile horsepower but understand that because the watt-seconds rating doesn't take the reflector design into consideration, it's not a perfect indication of the total amount of light that can be produced by an electronic flash. An "effective watt-seconds" rating will give you a better idea of the kind of output you can expect from the flash unit.

The amount of light emitted when a flash is fired can also be specified in lumenseconds. A lumen is a unit of measurement of light intensity falling on a surface. A lumensecond refers to a light of one lumen for one second or the equivalent, such as two lumens for half a second. The number of lumenseconds produced by a particular flash system depends on how effectively the flash turns electrical energy into light energy or watt-seconds into lumenseconds. Most electronic flash units produce between 15 to 50 lumenseconds per watt-second. What all this means is that sometimes an efficient 300 watt-second system may produce as much actual light energy as an inefficient system rated at 1000 watt-seconds.

Some manufacturers use guide numbers (GN) as a measurement of flash output because it more or less considers the entire lighting package. Guide numbers are quoted in feet or meters (depending on where you live in the world) and are valid for a given ISO setting. The higher the guide number, the more the light output. Guide numbers can also serve as a way to calculate aperture when shooting without a flash meter. (More on them later.) To determine the correct aperture, you divide the guide number by the distance from the flash to the subject, not the camera to the subject.

All light behaves in accordance with the Inverse Square Rule. This rule states that light's intensity decreases by the square of the distance from the subject or, more simply, that light falls off slowly when the light source is far from the subject and rapidly when it is close to the subject. You don't have to be Stephen Hawking to figure out that this can have an impact on the quality of light. I'll kick off chapter 2 with a rule of thumb that places this in context.

That's just part of the confusion about studio lighting equipment. Some photographers think it's too complicated and too expensive, but in reality it doesn't have to be either. Part of this misunderstanding is created by a seemingly bewildering array of product types and their accompanying buzzwords. The purpose of this chapter is to take the mystery (and misery) out of studio lighting hardware and help you understand the technology so you can use these versatile tools to make better pictures.

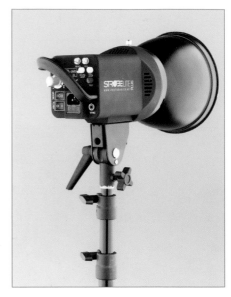

The Westcott (www.fjwestcott.com) Strobelite monolight produces 150 watt-seconds output and is wrapped in a compact and lightweight design. The polycarbonate housing weighs less than 3.5 pounds and measures 9x5x8 inches. At full power, the Strobelite's recycle time averages two seconds. Power output is continuously variable from $\frac{1}{4}$ to full power. Need more power? The Strobelite Plus shown here provides 400 watt-seconds and the same two-second recycle time at full power. Photo courtesy of F.J. Westcott Co.

LIGHTING HARDWARE OPTIONS

A monolight (referred to as a monobloc by our European friends) is a self-contained studio flash that is typically, but not always, powered by an AC power source. This type of light allows for the fitting of light modification attachments, such as reflectors, lightbanks, or umbrellas. (More on these devices in chapter 2.) The unit consists of a power source and a light head, all contained within a single, compact housing. Monolights usually have variable output settings. These allow to you change their light's output from full, to half, to quarter, and sometimes down to $\frac{1}{32}$ power to provide control over the final aperture desired. One of the monolight's most valuable features is a separate modeling light that allows you to preview what the flash should look like falling on your subject. The modeling light sometimes allows for variable power settings, which will allow you to preview the effect of different settings.

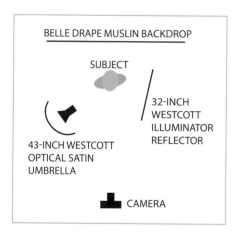

This image was made using a single Westcott Strobelite Plus placed at camera left with a 43-inch Westcott Optical White Satin Umbrella mounted in a traditional bounce mode. A 32-inch Westcott Illuminator reflector was placed on camera right. The photo was captured with an EOS 1D Mark II N and EF 85mm f/1.8 lens. The manual mode exposure was $\frac{1}{60}$ at f/8 and ISO 100. See the diagram above.

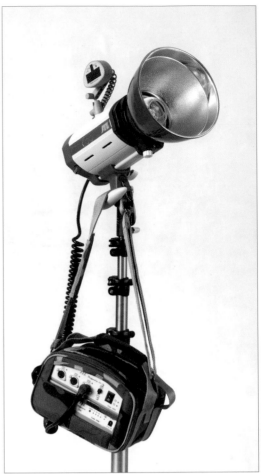

ABOVE—JTL's (www.jtlcorp.com) Mobilight DC-600 is a battery-operated strobe that works with the company's lithium battery pack, which supports the JTL Mobilight DC-600/1000 or one of two Mobilight 301s depending on the position of the selector switch on the output box. The Mobilight 301 can also be powered by AC current. Output of the Mobilight DC-600/1000 is 600 Joule. It has a built-in slave and can also be triggered by the test button, sync cord, or wireless radio or infrared signals. Photo courtesy of the JTL Corporation.

RIGHT—On location with JTL's Mobilight 301 with a Westcott Halo lightbank mounted. *Safety note:* It might appear that we are on railroad property, but that is not true; we are at the end of a public street that ends at the railroad property. One of the resultant images shows a locomotive in the background, but the model's feet were firmly and safely placed on that same street. © 2010 Mary Farace.
ABOVE—Lighting for this photograph was provided by a JTL Mobilight 301 with a Westcott Halo lightbank mounted. It was powered by JTL's lithium battery pack. I used a Canon EOS 1D Mark II and EF 28–105mm lens. The exposure was 1/60 at f/18 and ISO 200.

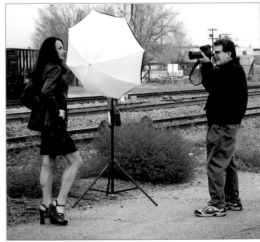

In most cases, AC current provides the electrical power for a monolight. You can plug the monolight's power cord into a wall and start shooting, but there are times when you're on location or out in a field where an AC outlet may not be so conveniently located. There's a whole new breed of monolights that offer a DC option that connect to battery power packs available either directly from the company or third parties such as Quantum Instruments (www.qtm.com).

Monolights almost always have a sync cord for connecting to your camera using a PC cable (Prontor-Compur, not personal computer). This means that you can trigger the light when you trip your camera's shutter.

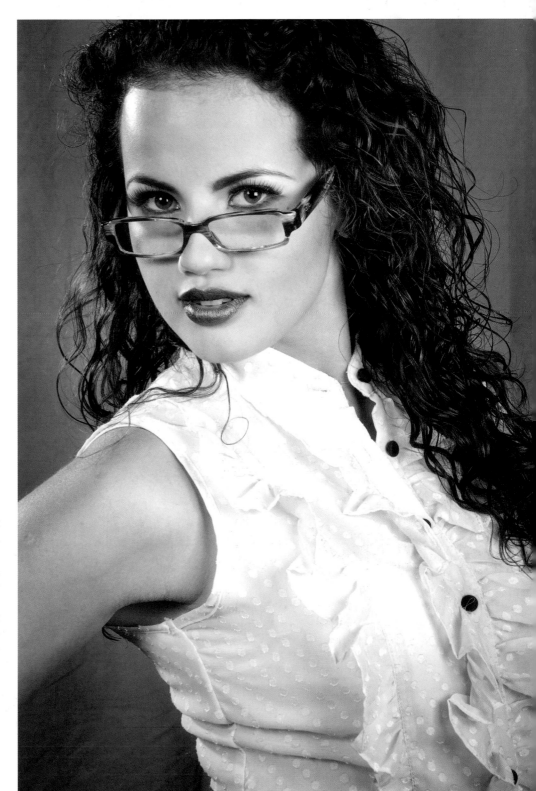

Here's an on-location portrait made using three monolights. The main light (at camera right) was a Flashpoint II 620A with square lightbank attached. Fill was provided by a Flashpoint II 320 with a 32-inch umbrella used because of a low ceiling. A second Flashpoint II 320 with snoot attached was placed behind and at camera left. The camera was a Nikon D90 with AF-S Nikkor 18–105mm lens. The exposure was $1/60$ at f/14 at ISO 200.

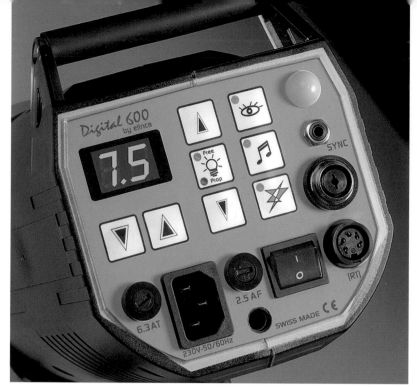

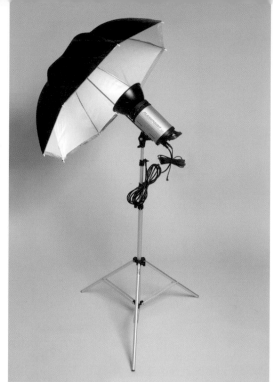

Alas, not all digital SLRs have a PC connection, so you may need to use a hot shoe-to-PC adapter to connect the sync cord from camera to main light. *Tip:* Because of the high voltages across the tip of a sync cord, using a cheapo adapter can fry the electronics inside your digicam. Don't do it! Instead, choose one like Booth Photo's (us.boothphoto.com) high-voltage-safe hot shoe adapter, which only allows 3 volts to touch the camera's sync circuit.

Most monolights also have a built-in optical "slave" that can be set to trip the flash when it sees another flash go off. If you want to eliminate the sync cord entirely, here's another suggestion: I'm a bit of a klutz when working in the studio and have, more than once, stumbled over a power cord or a sync cord. For me, and others like me, a wireless trigger is the best and safest solution for tripping the light fantastic. Flashpoint's (www.adorama .com) infrared remote trigger will trigger any standard flash or even multiple flashes that have a built-in or plug-in slave. The remote trigger slips onto a standard camera hot shoe and has an active range of about thirty feet. The trigger works outdoors, but since it uses light, albeit infrared, its effectiveness will vary based on the day's brightness. Radio-controlled slaves are a popular option that allows a monolight to be wirelessly triggered without a flash or cable. You'll find more information on wireless methods for tripping studio lights in chapter 3.

A MONOLIGHT SHOPPING LIST

Here are a few features to keep in mind when selecting a monolight for your studio lighting needs. As in all photography, this involves a series of trade-offs between functionality, ease-of-use, and cost.

LEFT—With the ability to interface with Mac OS or Windows computer systems, Elincrom's (www.manfrottodistribution .us) Digital Style RX monolights offer 6-stop variable flash power in $\frac{1}{10}$-stop increments. Image courtesy of Manfrotto Distribution. **RIGHT**—One of the best ways to get everything you need for a home studio lighting setup is to purchase a kit. The Flashpoint II 320A monolight kit includes the 320A monolight, light stand, umbrella, and lots of useful accessories such as a reflector and sync cord. As of this writing, the kits are less expensive than many high-powered speedlights. Photo courtesy of Adorama Camera Inc.

Continuously Variable Output. Most monolights have individual power settings of ¼, ½, ¾, and full, because sometimes when working with a single subject, you don't want to blast them with enough light for an exposure of f/64 and melt their false eyelashes—and sometimes you need more control than fixed power settings can provide. Having the output continuously variable allows you to fine-tune the exposure to get precisely the aperture and depth of field you want.

Proportional Modeling Light. Less expensive monolights may not have a modeling light or just provide a simple on and off light that will give you some idea of how the final lighting will look but will not show the true effect of the power setting being used. More importantly, when working in a dark room it will make it possible for your camera's autofocus to work faster. Monolights with proportional settings allow the modeling light output to vary with the flash output. Keep in mind that although the modeling light may be bright, it is not as bright as the flash. Also note that when you use a low power setting when working with high ambient light levels, the effect of the modeling light may be difficult to see.

Fan Cooling. Placing the modeling light, power supply, and flash tube (that's the glass tube that produces the actual flash from a capacitor filled with energy from the power supply) inside a single housing creates heat. A fan-cooled monolight is better than an air-cooled model, but it makes the monolight bigger, heavier, noisier, and more expensive. Is it worth it? That's up to you and your credit card.

Portability. To many photographers, the ability to have the power supply and light head in a single package makes for simple setup and greater portability. That's why lots of companies offer packages consisting of monolights, umbrellas, light stands, and even a case, adding up to a single ready-to-go package.

Light Modifiers. Raw light from monolights is not always usable as-is. To photograph a person, you're going to have to modify the quality of that light. You'll need to ask questions, such as, "Does the monolight have a shaft to allow attachment of an umbrella?" If so, what size is it? Umbrellas come in various diameter sizes, and the shafts of European models are different than others. Make sure that the umbrella shaft or attachment is large enough to accommodate the umbrellas you plan to use, and don't forget about attachments such as reflectors, lightbanks (see chapter 2), or accessories such as snoots. Are any available, or will third-party accessories fit the monolight?

Denny Manufacturing's (www.dennymfg.com) BPK3 pro lighting kit includes three Zebra monolights. The two Zebra 320 monolights are intended for use as the main light and fill. The Zebra 160 can be used as a background or hair light. The two higher-output lights fit on 10-foot, heavy-duty Air Cushion light stands, while the smaller light perches on a lighter weight 10-foot stand. The kit also includes a 28-inch square softbox and an adapter ring

Monolights with proportional settings allow the modeling light output to vary with the flash output.

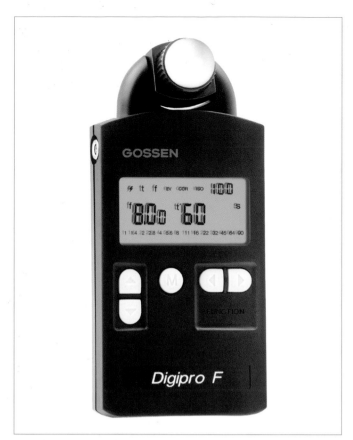

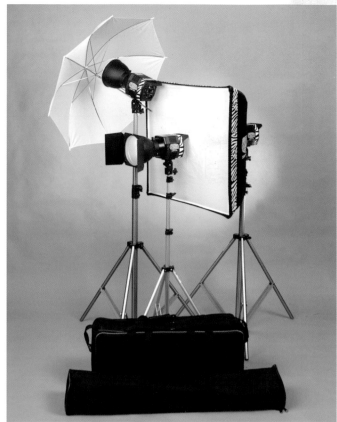

LEFT—The Gossen (www.bogenimaging.us) DigiPro F is a digital incident and reflected light flash meter (consult the glossary if you're not familiar with those terms). When you push the button, flash and available light are measured simultaneously, so it's easy to determine a balance between the two. This lightweight meter is small enough to fit in a pocket and can be operated using a single hand. Photo courtesy of Manfrotto Distribution. **RIGHT**—All of the components in Denny's pro lighting kits are mix-and-match, and you can use one, two, or three lights in any combination. Unlike a lot of starter kits that cut corners to meet a price point, the light stands included in the BPK3 kit are heavy-duty and of professional quality. Keep in mind that these are the product and job assignments that seem obvious to me, but everything in the world of lighting is wide open to interpretation and implementation. For example, traditional metal reflectors are provided for each of the monolights, and Denny's catalog shows several inexpensive accessories, including two different kinds of snoots and a honeycomb grid. Photo courtesy of Denny Manufacturing Company, Inc.

RIGHT AND FACING PAGE—I made this shot with an EOS 50D. The manual mode exposure was $1/80$ at f/11 and ISO 125. A Zebra 320 monolight with softbox attached was placed at camera left. Another Zebra 320 monolight was set at camera right with the 36-inch white umbrella mounted. Both monolights were set at $1/4$ power. A Zebra 160 monolight with barn doors attached was placed at right rear to accent the model's hair. It was set at $1/2$ power.

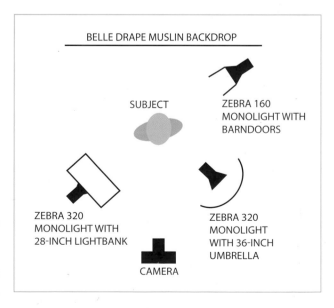

BELLE DRAPE MUSLIN BACKDROP

SUBJECT

ZEBRA 160 MONOLIGHT WITH BARNDOORS

ZEBRA 320 MONOLIGHT WITH 28-INCH LIGHTBANK

ZEBRA 320 MONOLIGHT WITH 36-INCH UMBRELLA

CAMERA

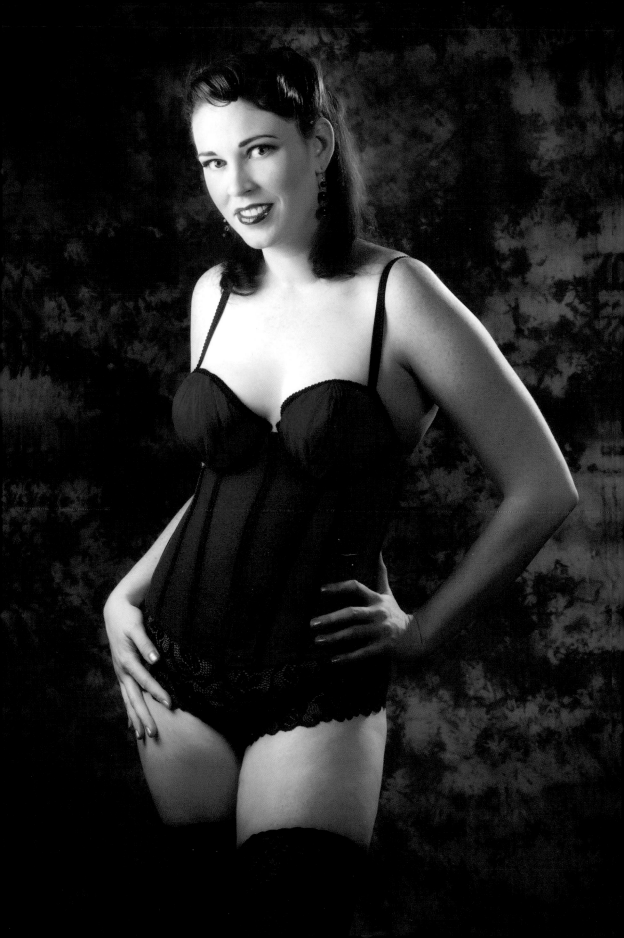

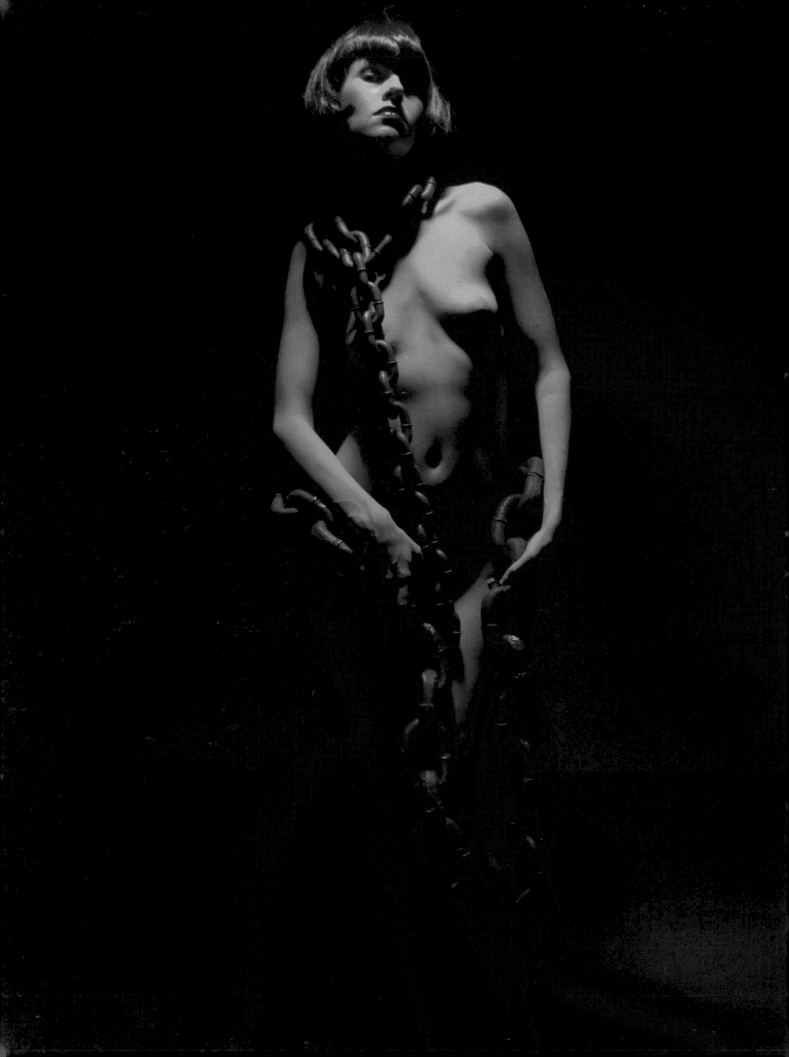

that lets you mount it on a Zebra 160 or 320 monolight to serve as the main light. A 36-inch white umbrella mounted on the other Zebra 320 monolight can provide fill, and there's a set of barn doors (see chapter 2) for use as a background or hair light when attached to the Zebra 160 monolight.

Because most cameras have built-in meters you may not own a separate meter. Flash users will need to purchase a handheld unit that reads flash, but photographers shooting with continuous light sources can get by with their in-camera meter. There's more about using flash meters in chapter 6.

POWER PACKS AND LIGHT HEADS

While monolights combine power supply and flash head in a single unit, some manufacturers of AC power packs and flash heads offer these components as individual units that can be mixed and matched to create an array of lighting setups. Because there's no internal power supply, flash heads can be small in

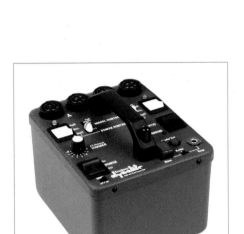

LEFT—Dynalite's (www.dynalite.com) Roadmax Series Packs and Heads includes the MP500 power pack, which weighs just 4.6 pounds, produces 500 watt-seconds of power, and permits connection of multiple flash heads producing output that is variable over 6 stops. Photo courtesy of Dynalite Inc. **BELOW**—To photograph Cristal Matthews, Kent Hepburn used three Elinchrom 1200RX heads, powered by two Micro 3000 asymmetrical generators and triggered by an FRC-1 radio transmitter. One head was placed to the model's right and aimed at the background with some spill onto the model. Another head was placed to the model's left and aimed just behind her. The third light—the main—was in front of the model but behind the photographer. It was mounted with a 74x74-inch Octa Lite lightbank. The camera was a Canon EOS 20D with EF 28–135mm lens. The exposure was $^1/_{125}$ at f/16 and ISO 100. © 2011 Kent Hepburn.

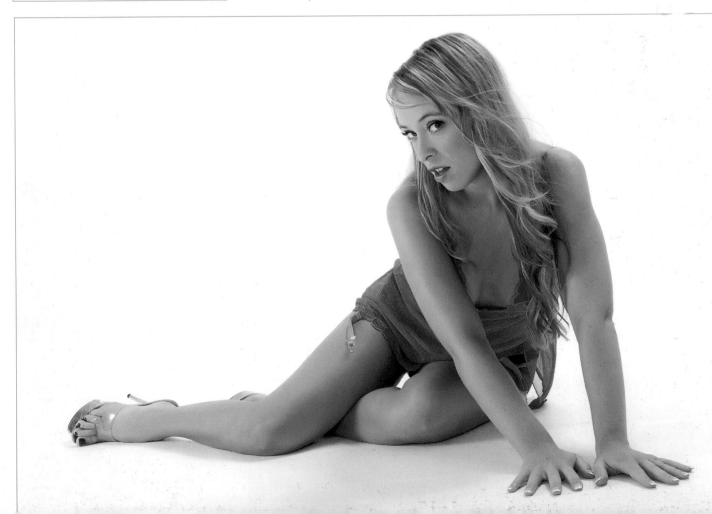

size. Some of them are downright tiny, allowing you to place them in locations where larger monolights might not fit. Because these heads are smaller than a monolight, there's also room for adding cooling fans without the head size getting too large or the fan too big and noisy.

Another advantage is that having the power supply in a single unit lets it control more than one head. Usually the output for each flash is controlled separately in either symmetric or asymmetric configurations. The power supply itself can be larger because the design needn't be concerned as much about heat buildup affecting the flash head (as with a monolight). This allows more flash heads to be connected and also provides for a higher overall output.

When using multiple flash units or heads you encounter a new buzzword: lighting ratio. It's especially important with those power packs that offer asymmetric control. A lighting ratio describes the difference in the brightness between the main and the fill light, as it strikes the model. Note that there can also be tertiary lights that serve other purposes, such as adding highlights

Lighting for this photograph of Victoria was made using a Dynalite SP2000 power pack and a four-head setup. The main light at camera right had a Chimera (www .chimeralighting.com) large lightbank. Fill was provided by a Chimera striplight at camera left. A hair light had a small Chimera lightbank. Instead of a background light, the fourth head was aimed at the subject's back to backlight her hair. The camera was a Canon EOS 1D Mark IV and EF 85mm f/1.8 lens with an exposure of $^1/_{80}$ at f/9 and ISO 100.

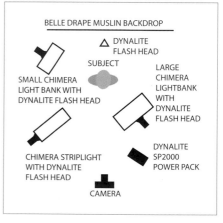

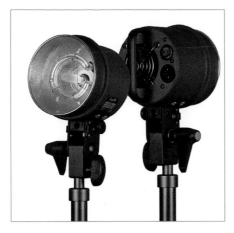

Dynalite's MH2050 flash head is fan cooled and can handle up to 2000 watt-seconds output, yet it weighs only 2.4 pounds. Photo courtesy of Dynalite Inc.

to the subject's hair or illuminating the background. (See chapter 6 for more information about lighting ratios and styles.) A lighting ratio of 3:1 is considered "normal" for color photography, but photographers can be flexible in applying this rule. In truth, I seldom worry about hitting a specific ratio.

Like monolights, power packs have an input for a sync cable, allowing the light to be directly triggered when connected by cable to your SLR's PC outlet. Some also have an optical "slave" that can be set to trip the flash when it sees another flash; others can be triggered by an infrared source. Radio-controlled slaves are a popular option that allows a power supply to be wirelessly triggered without requiring a camera-mounted flash or cable connection, and some power packs offer a built-in radio receiver.

A POWER PACK CHECKLIST

Here are a few things to keep in mind when considering a power pack and head system for your studio lighting applications. You may find yourself faced with a series of trade-offs between functionality, ease of use, and cost. You'll want to carefully reconcile your wish list and your budget.

Continuously Variable Output. Many power packs allow you to adjust power settings to suit the lighting setup you have. If you're concerned about lighting ratios, they can be controlled using a light modifier such as a lightbank (see chapter 2) or by varying the subject-to-lamp head distance.

Power Control. When doing high-volume portraiture, such as in-store or school photography, it's important to properly expose each subject without altering background exposure and still be able to make adjustments depending on the subject. This is where power control and consistency are most important and where you'll find that bigger (more power) is better.

Dynalite's AC XP 1000 is a battery-powered power pack that lets you take your studio on location without having to worry about finding a place to plug it in. It offers up to 1100 watt-seconds of power, and you'll get up to 200 flashes per charge with a 1.5-second recycle time. Batteries are interchangeable and the unit weighs 23 pounds. Photo courtesy of Dynalite Inc.

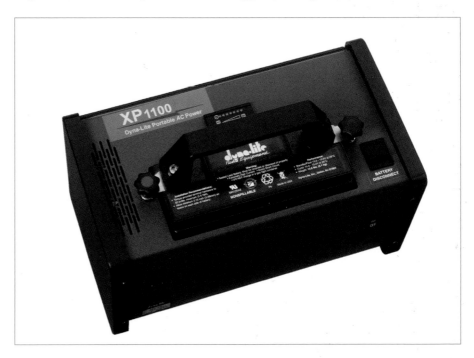

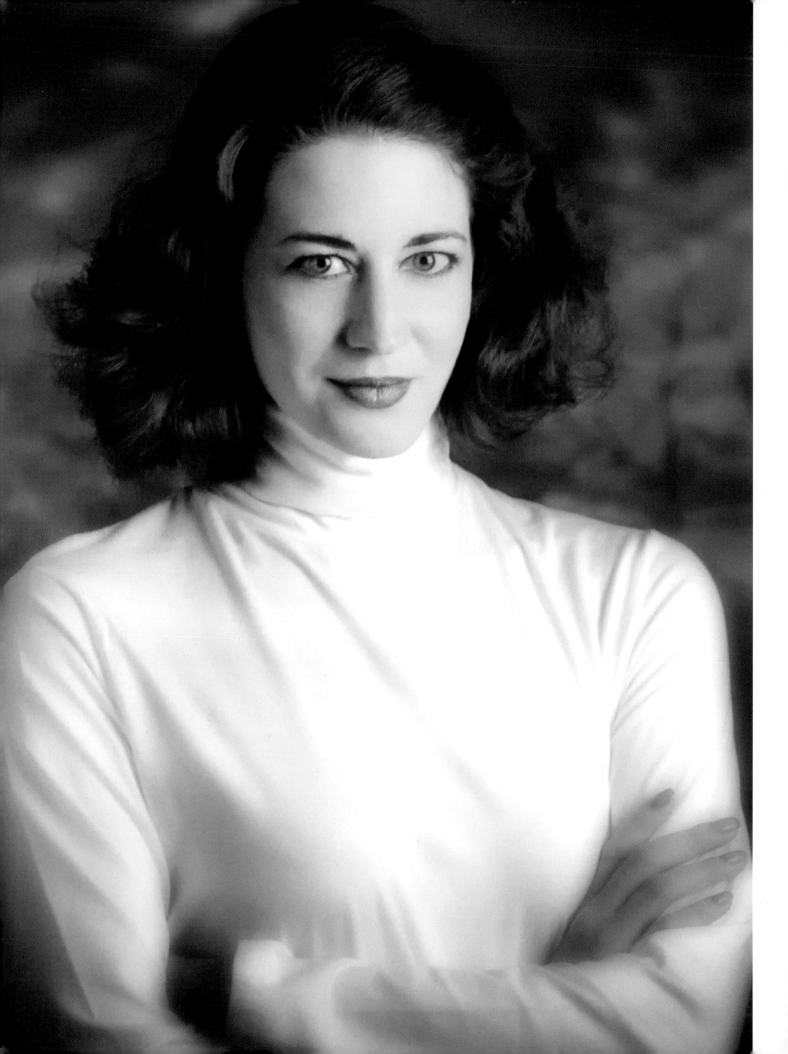

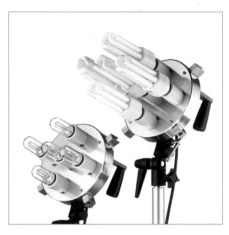

The Spiderlite's fluorescent lamps provide smooth, continuous light, and by looking at each image file's histogram, you can use your digital SLR's Exposure Compensation feature to gradually increase exposure in $\frac{1}{3}$-stop increments to make sure exposure is balanced. Photo courtesy of F.J. Westcott.

FACING PAGE—Tia has the classic look and elegance of a young Katherine Hepburn in 1939's *The Philadelphia Story*. At camera right, I placed a Westcott Spiderlite TD5 with a medium (24x32-inch) Westcott lightbank to soften the light. A 32-inch Sunlight Westcott Illuminator reflector was placed on camera left to bounce light into the shadow side of Tia's face. I originally photographed her in color against one of Adorama's custom Bella Drape scenic muslin backgrounds that has a retro feel. The image was captured with a Canon EOS 1D Mark II and EF 70–300mm IS zoom lens. The exposure was $\frac{1}{200}$ at f/5 and ISO 640 in program mode.

Portability. Opting for a DC power pack will allow you to take your flash system out into a cornfield or racetrack to create real studio lighting in the "middle of nowhere." Most power packs are AC powered, but DC powered units like Dynalite's AC XP 1000 are popular too. Many studio light systems give you a choice of using AC or DC power packs so you can have both options in your studio lighting kit and be able to use the one that fits the assignment or project you're working on. If you're thinking about the requirement for DC power, ask yourself the big question: What is the distance to the nearest AC outlet? If the answer is a distance greater than your longest extension cord, it's time to think DC.

There are a few drawbacks to power pack and head systems that may or may not be important to you depending on how, what, and where you shoot. First, you'll need to run a cable from the power pack to each head to make it all work. This isn't a big deal in the studio, where you can tape them down or place them safely under cable runs, but on location, remember to be careful where you walk. This warning should be extended to your assistant and subjects. Knocking over a light stand and flash head almost always results in a disaster and can be expensive too. Second, when working with a two-light system, for example, if a power pack fails, you can't shoot. If you have two monolights and one's power supply fails, you still have one light to finish the shoot. It won't be perfect but fulfills the old newspaper adage of "f/8 and be there."

A CINEMATIC APPEAL: CASE STUDIES

People often ask about my photographic influences. While I have many, the most influential is motion pictures. In collecting images for this section, I decided to use portraits that were made in the style of the directors of past and present films. Keep in mind that only one light (and sometimes a reflector) was used for the next photographs. Being able to see the results in the viewfinder and on your camera's LCD screen means better feedback—not just for the photographer but also the subject, who can respond with more enthusiasm when he or she sees what the photos look like.

The Philadelphia Story. F.J. Westcott's Spiderlite TD5 is designed for still or video image-makers. It has a built-in speed ring for attaching a lightbank and three separate switches that permit multiple combinations of the lamps to be turned off and on to vary the output quantity. A handle allows for quick and easy rotation for a head that accepts either halogen or fluorescent lamps. Halogen lamps produce a consistent but hot 3200 degrees Kelvin, and the fluorescent lamps are rated at 5100 degrees Kelvin, although that seems to vary a bit as the lights warm up.

After first using a color meter to determine the color balance, I found the Canon EOS 1D Mark II used for sessions with the Spiderlite produced the best results when set in auto white balance mode.

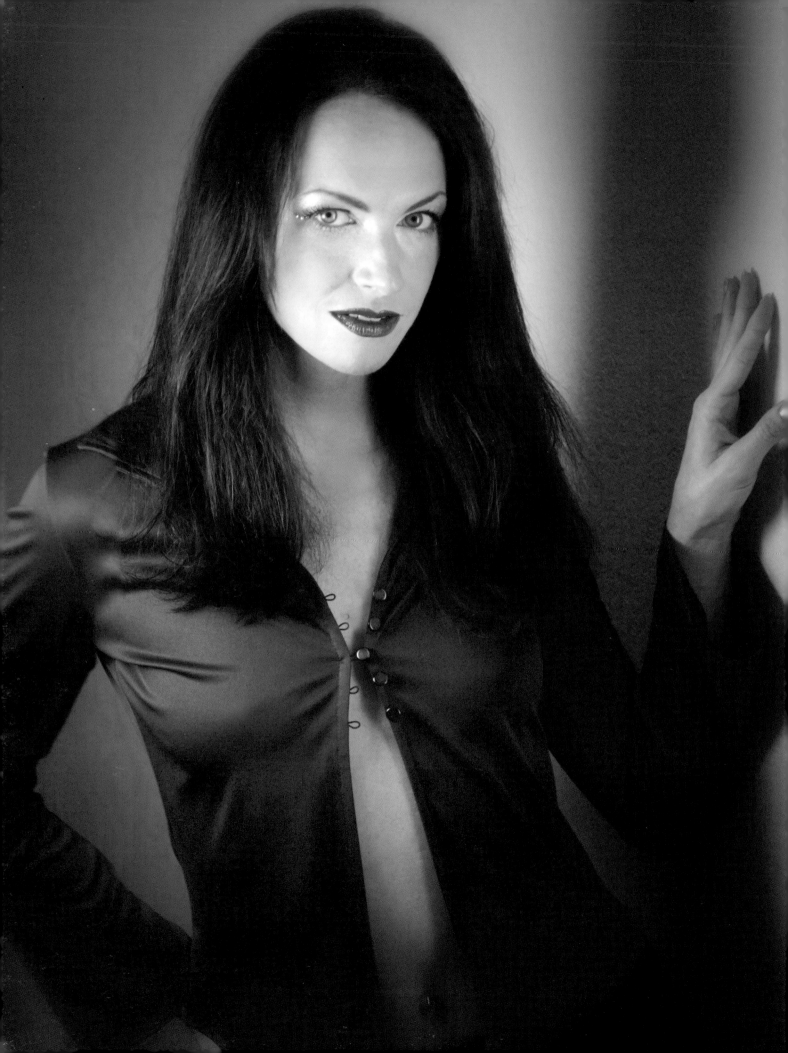

RIGHT—The slim profile and daylight color balance of Sunpak's DigiLite make it ideal for use as a main light for location photography. Here I'm photographing Ashley Rae using the DigiLite as a main light with window light as fill. This is also a perfect example of achieving a studio look using just my dining room wall as a background. © 2005 Vinnie Ariniello.

FACING PAGE—In *Out of the Past,* Jane Greer portrays a woman running to escape her future, while Robert Mitchum is trying to forget his past. Ashley Rae has the perfect look of a 1940s film noir heroine and was photographed using a Sunpak DigiLite 600 placed at camera left. No reflectors were used because I wanted to create shadows, which are a hallmark of the film noir genre. The image was captured using a Canon EOS 20D and EF 85mm f/1.8 lens. The exposure was $1/200$ at f/2.5 and ISO 400. The exposure was made in program mode, with a $-1^1/3$ stop exposure compensation.

Out of the Past: Film Noir. I do a lot of shoots with new and inexperienced models and big lightbanks, and the constant popping of electronic flash units can distract them. The Sunpak (www.tocad.com) DigiLite is a cold "hot light" and creates the kind of working environment that helps the model relax. The DigiLite is solidly built and easy to move around if your light stand has casters. The DigiLite uses fluorescent tubes that are balanced for daylight and do a good job of emulating the real thing. *Note:* The DigiLite is no longer shown on the company's web site (www.sunpak.jp/english/index .html), but as of this writing, some dealer sites, such as B&H Photo (www .bhphotovideo.com), still have it in stock.

I often use the DigiLite as a main light or sometimes as a beauty light placed below the model's face. I also use it where I would have used a reflector back in the old film days, to create the kind of look that requires the least amount of gear possible. There are some who shoot with available light, but what they really means is "every light we have available." I hate to schlep all that stuff. That's why these lights work so well for my "shoot and scoot" style of photography.

Moulin Rouge. Lowel's (www.lowel.com) Ego is a tabletop sized fluorescent light that looks like a lamp from the set of Steven Soderbergh's film *Solaris.* Setup is a breeze: Attach it to a light stand and turn it on. The Ego comes with two 27W screw-in daylight fluorescent lamps that have a 5000–10,000-hour rating. Their Color Rendering Index (CRI) provides a more natural and realistic color balance than standard fluorescent lamps. Lowel includes a small white card that can be used as a reflector.

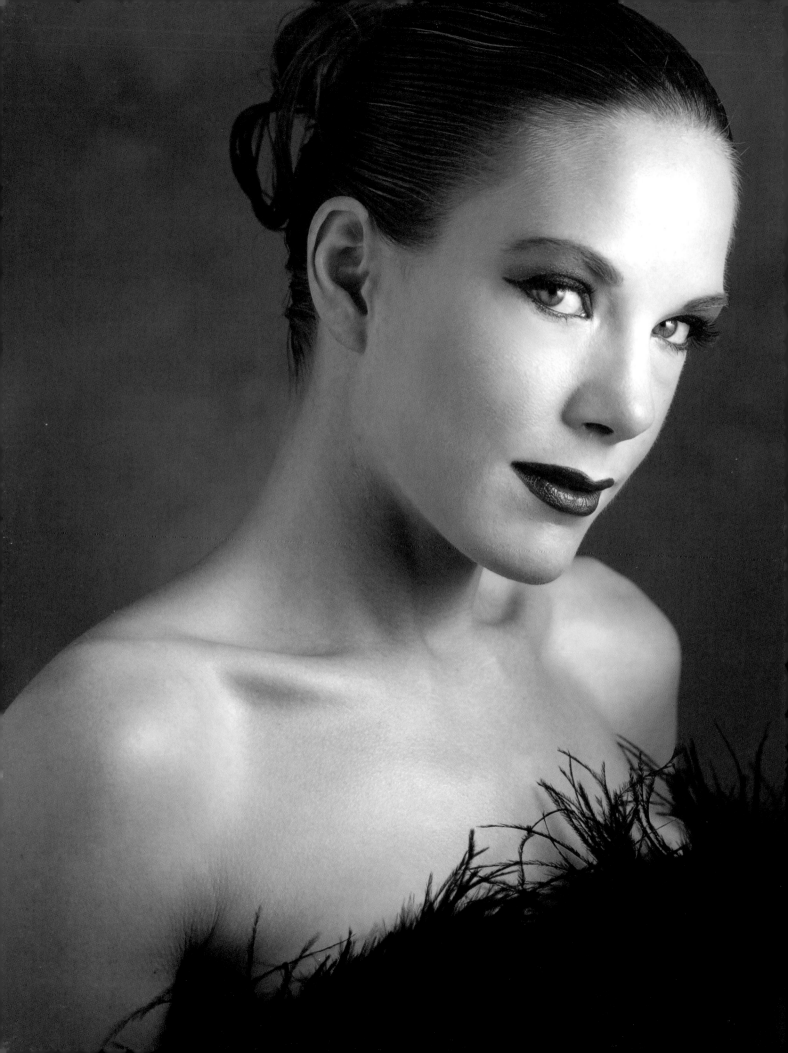

Tip: When using the Ego as a main light for portraits, be sure to place the light as close as possible to the subject without getting it in the shot. Because of its small size, the Ego is probably best suited to headshots. I used to hate headshots; it just took too much time fiddling to get the light looking like I wanted. The Ego sets up quickly, and when used with a larger-than-provided reflector like Westcott's Illuminator placed close to the subject on the opposite side of the subject's face, it makes an ideal headshot setup.

RIGHT—Lowel's Ego is a tabletop sized fluorescent light that's a breeze to set up: Attach it to a light stand and turn it on. Lowel also includes a small white card that can be used as a reflector. When using the Ego as a main light for portraits, be sure to place the light as close as possible to the subject without getting it in the shot. Photo courtesy Lowel-Light Mfg.
FACING PAGE—I'm a big fan of Australian filmmaker Baz Luhrmann's films, especially the look of *Moulin Rouge.* For this portrait, I placed a Lowel Ego light at camera right, just inches from the model's face and barely out of camera range. She is sitting in front of a Westcott "April Showers" collapsible background and told me the light felt "soft." A 32-inch Sunlight Westcott Illuminator was placed on camera left for fill. I used a Canon EOS 20D with EF-S 60mm macro lens. Exposure in Program mode was $^1/_{160}$ at f/4 to minimize depth of field. The ISO was 400.

KELVIN TEMPERATURES AND CRI

During the 19th century, Lord Kelvin (1824–1907) suggested the elimination of negative values when measuring temperatures and that an absolute zero temperature should be the basis for the scale. Higher Kelvin color temperatures are at the cool (blue) end of the spectrum, while warmer (red) temperatures are at the lower end of the spectrum. On a clear day at noon, the sun typically measures 5500 degrees Kelvin. On an overcast day, that temperature rises to 6700 degrees Kelvin, while you'll experience 9000 degrees Kelvin in open shade on a clear day. Traditional "hot" lights have a temperature of 3200 degrees Kelvin. Household lightbulbs measure about 2600 degrees.

Color Rendering Index (CRI) is a unit of measure that defines how well colors are rendered under different lighting conditions and uses a scale from 1 to 100. A low CRI number causes colors to look washed out or take on a different hue, while light sources with a high CRI make colors look natural and vibrant.

2. USING LIGHTING MODIFIERS

"Lighting is really common sense and personal observation. This is applied to a few rules of photography which cannot be broken and to others which I tend to bend a little."—*Paul Beeson*

In chapter 1, we looked at the technical aspects and use of electronic flash and continuous light sources and focused somewhat on the quantity, color, and touched on the quality of light that they can produce. In this chapter, you'll be introduced to how to modify the quality of that light produced by different kinds of lighting hardware to create a different kind of light than the equipment produces right out of the box. When working with the lighting equipment mentioned in this chapter, it's important to keep in mind that the closer and larger a light source is to a subject, the softer it is. The converse is also true: the smaller and farther away from the subject the light is, the harder it becomes.

UMBRELLAS

Umbrellas are the simplest and least expensive form of light modifier, and that makes them the most popular too. Photographic umbrellas look and act just like the kind of umbrella that keep raindrops from falling on your head, except that in a studio lighting situation, they are usually reflective and light is bounced into them, creating a bigger, softer light source that is then aimed at the subject.

That old lighting rule that "size matters" is important here too because a bigger umbrella will produce broader, softer light for your photographs. Umbrellas come in various sizes ranging from small to large, and some are collapsible (like those tiny rain umbrellas), allowing you to create a compact lighting kit to take on the road. The main reason for selecting anything smaller than the biggest one you can find is space; how much space do you have to carry the umbrella, and how much space do you have to set it up?

I like to place umbrellas fairly high—the higher the better—but larger umbrellas can run into the ceilings in some residential (think *basement*) applications, so something smaller will have to do. *Tip:* When working in a tight space, like a basement, I like to place umbrellas high to keep shadows from the subject from falling on the background. If you do this, you must also be

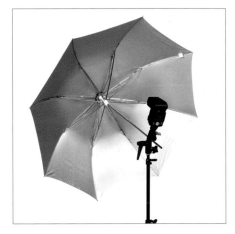

ABOVE—Umbrellas are passive devices and don't care what kind of light you bounce into them. The flash can come from a monolight, flash head, or even a speedlight, as shown here. (See chapter 3 for more on shoe-flash use.) © 2010 Paul Peregrine/Joe Farace. **FACING PAGE**—This photograph was made by my wife Mary in our basement studio. She liked the way that the model's outfit matched a metal prop chair, inexpensive and from Target, and used it here. The setup included a Zebra 320 (www.denny mfg.com) monolight placed at camera left, set in a softbox and a Zebra 320 at camera right with a 36-inch white umbrella mounted. The main light was set at $^{1}/_{4}$ power and the fill was on $^{1}/_{2}$ power. A Zebra 160 with barn doors was placed at right rear to accent the model's hair and was set at $^{1}/_{2}$ power. Mary used an Olympus E-30 to capture the shot. The exposure was $^{1}/_{60}$ at f/10 and ISO 125. © 2011 Mary Farace.

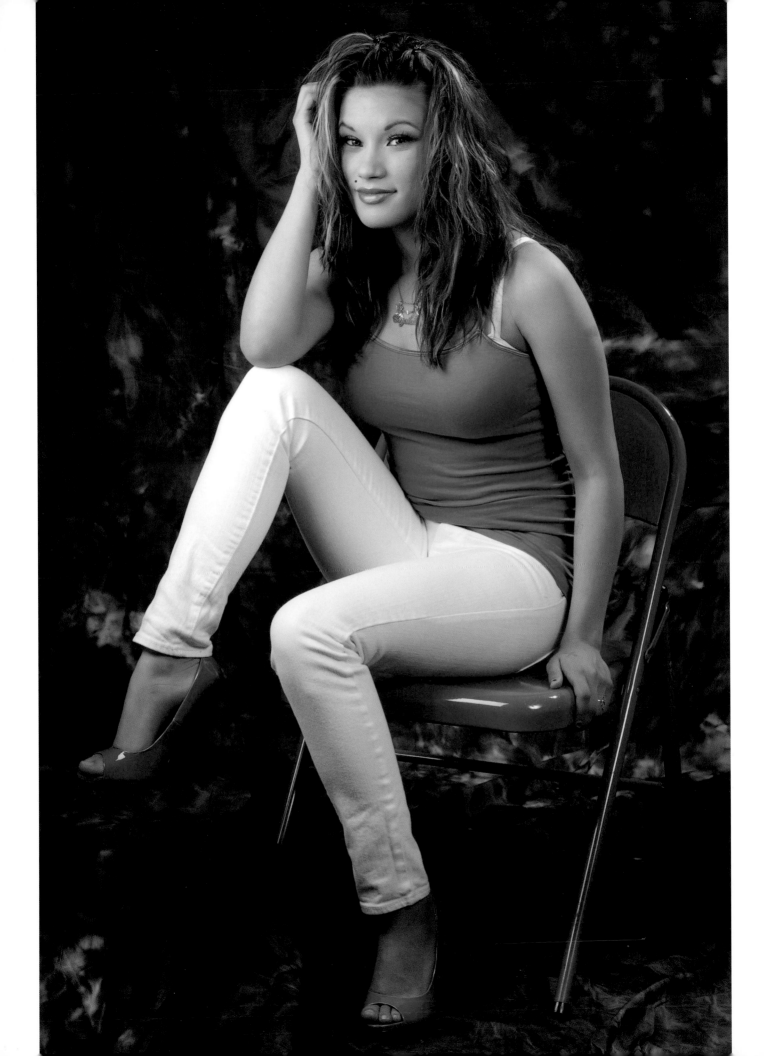

careful that the umbrella is not so high that the subject loses light in their eyes—the most important part of the photograph! Admittedly this is harder to do with umbrellas than other light modifiers since they produce such a broad source of light, but it's not impossible. It's something to keep in mind when setting up your lighting.

While most umbrellas are white, that color can be interpreted in many different ways. Sometimes the umbrella is a dense white, even having a black backing, so all that bounced light is captured and directed at the subject

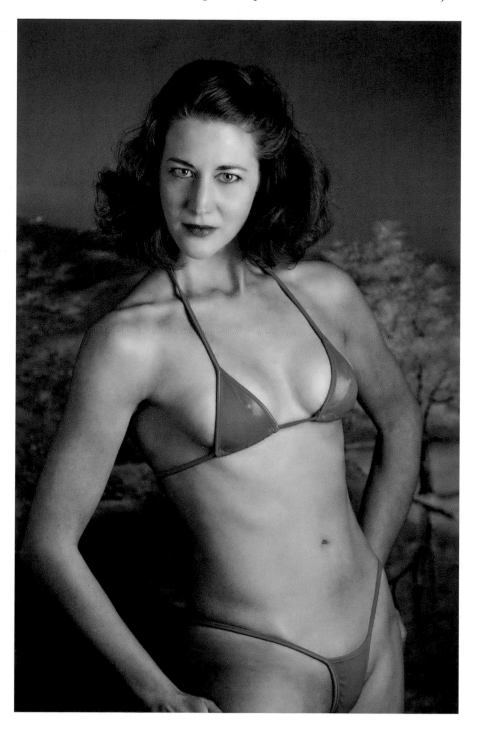

For this photograph of Tia Stoneman, made in my first basement studio, I used two small 32-inch Westcott (www.fjwest-cott.com) umbrellas because that's all the space—especially ceiling height—that was available. Two inexpensive and no longer available monolights were used at rough-ly 45 degrees from one another, with the light at camera left set at $1/2$ power to give some modeling effect, although the light *is* on the flat side. The background was a Belle Drape scenic muslin from Adorama (www.adorama.com). A Canon EOS 1D Mark II with a 28–105mm lens mounted was used to capture the shot. The expo-sure was $1/60$ at f/5 and ISO 640 because these lights weren't all that powerful.

I photographed Jewel not in a studio but in a condominium clubhouse using a single monolight with a 45-inch Westcott umbrella (with removable black cover) reversed and used in shoot-through mode. Few lights mean more dark areas in the shot, and to minimize that I used ISO 400. Also, using a slow shutter speed opened up the background. The camera was a Canon EOS 1D Mark II N with a 85mm f/1.8 lens. The exposure was $^1/_{30}$ at f/6.3 in manual mode at ISO 200.

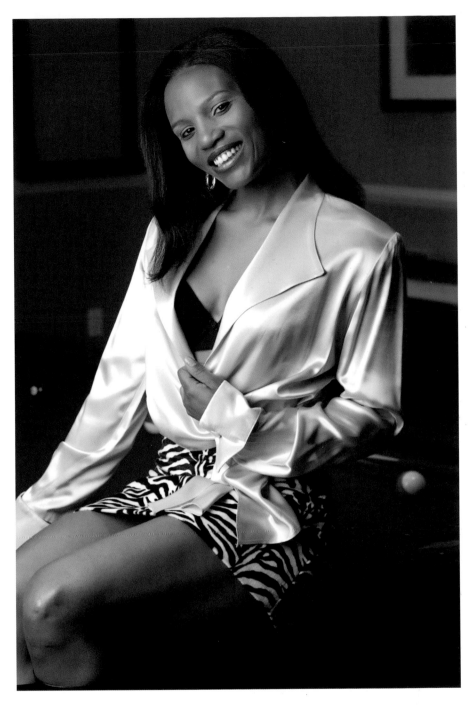

Since more light is being directed at the subject, you can shoot at a smaller aperture.

rather than leaking out the back. Some umbrellas have removable black covers that accomplish the same thing but once removed let you reverse the light and change the umbrella from a bounced light source into a direct one. Instead of mounting the umbrella so light is bounced into it, turn it backward and fire the light through it, producing more direct light (the light is not as diffuse as it is when it is bounced). Since more light is being directed at the subject, you can shoot at a smaller aperture. While some light is lost shooting through an umbrella, it is much less than when a light source is bounced into an umbrella. Because they provide a broad lighting source, umbrellas make a

perfect source for fill light. Of course, that doesn't mean you can't use umbrellas as a main light.

The color of the fabric also has a bearing on the color temperature of the output, and in addition to neutral-colored white umbrellas, there are gold umbrellas that can be used to "warm up" a portrait subject. There are even "zebra" umbrellas that alternate stripes of gold and silver to give some warmth—but not *too* much. Shiny silver fabrics create sparkly looks, and soft white produces a softer effect.

If you use umbrellas, you'll need some kind of metal reflector to focus and spill the light into the umbrella. (*Note:* There's more information on other reflectors later in the chapter.) Most electronic flash units come with a reflector that's either built-in or optional and whose job it is to focus light on the subject. The size and shape of that reflector and where you place the light will determine the quality of the lighting and follows that same rule of "bigger is softer." The often removable reflector aims the light from the flash tube into the umbrella (or through it) instead of it just spilling out everywhere into your shooting space. The inside of a reflector is typically covered with reflective material and should also have an open slot in the rim to allow the umbrella's shaft to pass through and attach to the flash head or monolight.

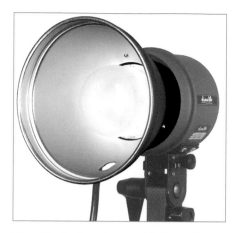

The 7-inch Dynalite parabolic reflector produces a light spread of 65 degrees and is designed to work with umbrellas, as can be seen by the slot that allows an umbrella shaft to fit through. Photo courtesy of Dynalite Inc.

REFLECTOR ACCESSORIES

You can mount additional accessories on a reflector or use them instead of a reflector. They all have different names but accomplish the same goal: focusing the light where you want it.

Barn Doors. This device attaches to the front of a light and has two or more pivotable (usually) black panels that you can use to control where the light goes and, just as importantly, where it doesn't go. Some barn doors come with a filter holder so you can use filters, such as Rosco's (www.rosco.com/us/filters/roscolux.asp), to change the color of the light.

Grids. These look a lot like an egg-crate or ice-cube tray insert and produce a broad, shielded, and more directional light source, ensuring the light falls exactly where you want it. Metal grids can be used with barn doors, and cloth versions are used with lightbanks to provide less softening.

Snoots. These tube-like devices project a narrow and targeted circle of light on the subject or background. The opening of the snoot, its length, and the distance to the subject will determine the size of the focused circle of light. They also reduce spill.

Tip: Don't use a snoot in conjunction with a modeling lamp. It captures too much heat and can create unsafe working conditions, so remember to turn the modeling light off.

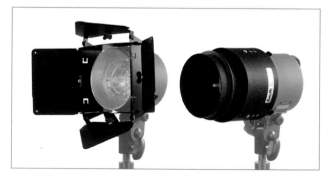

Dynalite's (www.dynalite.com) four-leaf barn door set (on left) fits all Dynalite heads and also interfaces with Lowel (www.lowel.com) Omni hot light accessories. The Dynalite snoot/light-angle reducing ring is shown at right. Image courtesy Dynalite.

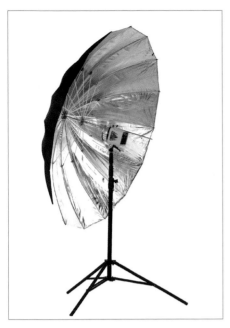

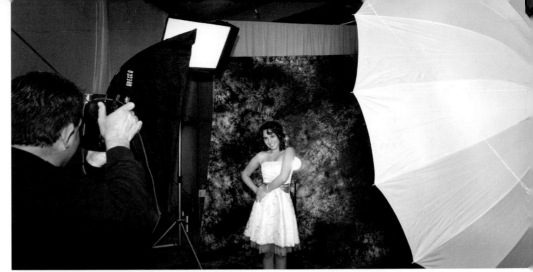

TOP LEFT—White Lightning's parabolic light modification system (a.k.a. parabolic umbrella) is a best buy for this kind of lighting modifier. The sixteen-rib umbrella shown here has silver fabric inside and black fabric outside. It projects a soft beam of light with a pattern and high output similar to a 40 degree reflector. It produces two to three stops more output than a typical lightbank. Photo courtesy of Paul C. Buff, Inc. **TOP RIGHT**—Here I am at work using White Lightning's 86-inch white, sixteen-rib parabolic umbrella. The lighting setup can be seen here. The main light used the parabolic umbrella, and fill light was from a second Dynalite flash head with a large Chimera lightbank attached. A third Dynalite head inside a medium-sized Chimera lightbank served as a hair light, and a fourth light (not visible) was aimed at the subject's back to rim light her hair. © 2011 Jack Dean Photography. **BOTTOM**—What does the final image look like? Here it is. I love the soft light that these big umbrellas produce, and I'm guessing you will too! Photograph was made with Canon EOS 1D Mark IV and EF 85mm f/1.8 lens and an exposure of $1/80$ at f/9 and ISO 100.

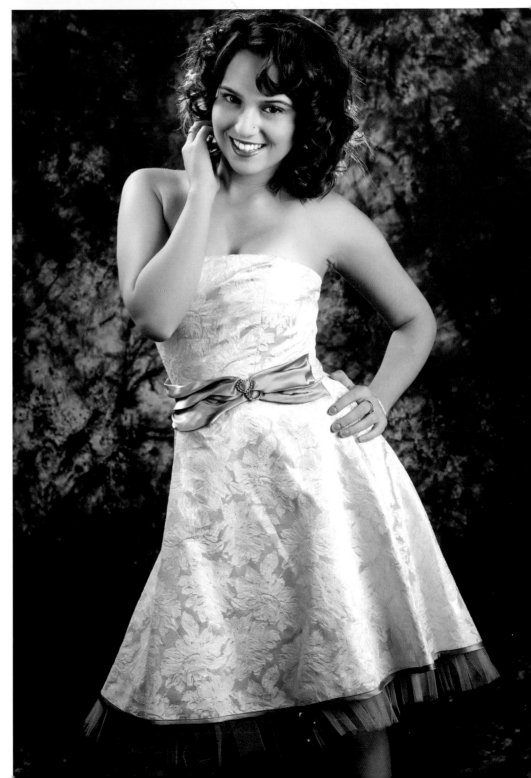

PARABOLIC UMBRELLAS

This type of umbrella is often overlooked by the average shooter because the typical European-made parabolic umbrella can cost $6000 or more. No, that's not a typo; they have a four-figure price. The advantage of using a 6- or 8-foot parabolic umbrella is threefold: First, a big light source, especially when placed next to the subject, is going to create soft lighting. Second, because of the umbrella's parabolic shape, light falloff toward the edges is negligible. Third, the parabolic design yields high light efficiency, allowing you to produce high-contrast directed light or extremely soft light.

So, big umbrellas are good—but if you don't have that kind of budget, why am I talking about them? There are a few (darn few) inexpensive options. Plume Ltd.'s (www.plumeltd.com/jumbrella.htm) Jumbrellas have a telescoping boom, so you can use your light heads to fill the umbrella with even light or direct the light on only one part or half of the Jumbrella, allowing the remaining surface to act as a concave graduating reflector. With a camera position in front of the Jumbrella, you can create a giant ring light. You can also use multiple light sources to increase total light output from a single soft source or use different types of light sources for stop/blur effects from the same source of diffusion. As of this writing, Jumbrellas are available in 7-, 10-, and 13-foot sizes and are priced from $1200 to $1400.

The best buy in parabolic umbrellas has to be White Lightning's (www .white-lightning.com/plm.html) PLM (parabolic light modification) system, which can be configured as a large, high-output round parabolic reflector, as a wide or narrow beam softbox, or as a bounce or shoot-through umbrella. Because umbrellas are generally specified by the arc dimension rather than across the face, the PLM system comes in three sizes: 86-inch (75 inches across the face), 64-inch (55 inches), and 42-inch (39 inches), with prices starting, as I write this, at $44.95 for the 86-inch white model. And yes, the decimal point is in the right place.

LIGHTBANKS

A lightbank is basically a black box with one side covered in diffusion material that lets light pass through. That's why you will occasionally hear them called light boxes or softboxes (for some time, Larson Enterprises has produced a trademarked "Soff Box"). The light inside a lightbank can be aimed to shoot through toward the subject or bounce into the back of the box before exiting the front. Some lightbanks let you use them either way so you can have more powerfully direct, yet softened light for the ultimate soft light experience.

There are lots of reasons to use a lightbank to diffuse the raw light produced by an electronic flash or other light source. One is the clean, unobstructed highlight that's reflected in the subject, whether it's a reflective subject like a product or a portrait subject's eyes. The other is the ability to use a shorter distance between the light and the subject, maximizing the light-

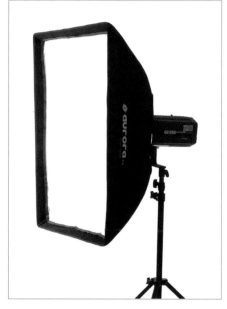

ABOVE—Lightbanks such as Aurora's (www.boothphoto.com) rectangular box control the edge transfer between highlights and shadows and preserve light that is ordinarily lost to scattering and absorption. (Sometimes that can be up to one f-stop.) Softboxes or lightbanks are also more efficient than umbrellas and can provide more even illumination across a single lighting plane. Image courtesy of Booth Photographic. **FACING PAGE**—Jerry Bolyard made this photograph with three Alien Bees monolights. A B800 monolight with 40-inch octagonal lightbank was the main light. It was placed at camera right at about seven feet in the air. Two other Alien Bees B400 monolights were used to illuminate the white background. Jerry seldom uses three lights because of the limited shooting space in his 10x14-foot dining room. © 2010 Jerry Bolyard.

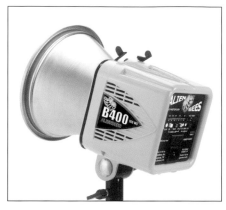

LEFT—Lighting for this studio shot included two White Lightning's (www.white-lightning.com) X1600 monolights. The main light (camera left) had a medium-sized Paul C. Buff foldable medium softbox, while the light on camera left has a foldable stripbox attached. (More about striplights later.) The camera was a Nikon D300s with Nikkor 18–200mm f/3.5–5.6 lens attached. The exposure was $\frac{1}{80}$ at f/5 and ISO 200 in manual mode. RIGHT—Alien Bees' B400 is a self-contained studio flash unit that produces 160 true watt-seconds and 400 effective watt-seconds of power with 7000 lumenseconds of output. Output is adjustable over a stepless 5-stop range from full to $\frac{1}{32}$ power. The power is adjusted on the back control panel using a sliding fader that shows f-stop increments. Photo courtesy of Paul C. Buff, Inc.

bank's broad light modeling. You also obtain improved control of the light because a lightbank's flat, two-dimensional diffuser and opaque shell keeps light from spilling onto surrounding objects or directing flare into the camera.

One of the downsides of using lightbanks is as they get bigger they also get deeper. Noted lighting innovator Gary Regester decided to create a lightbank that had a thinner-than-normal profile and produced the Plume Wafer. The

narrow profile, silver-with-white interior, and graduated inner baffles create efficiencies with a choice of light contrast across the front diffuser panel. The narrow profile results from using a combination of aluminum tent tubes with fiberglass fishing rods (no kidding). Special pole pockets reinforce the corners. Inner baffles, rear closures, and flash ring adapters are interchangeable.

Lightbank Shapes. Lightbanks come in different sizes that are based on the kind of lighting hardware used and the specific photographic application, and although lightbanks work equally well with monolights or electronic

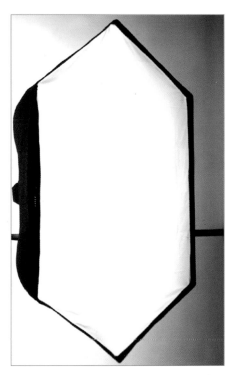

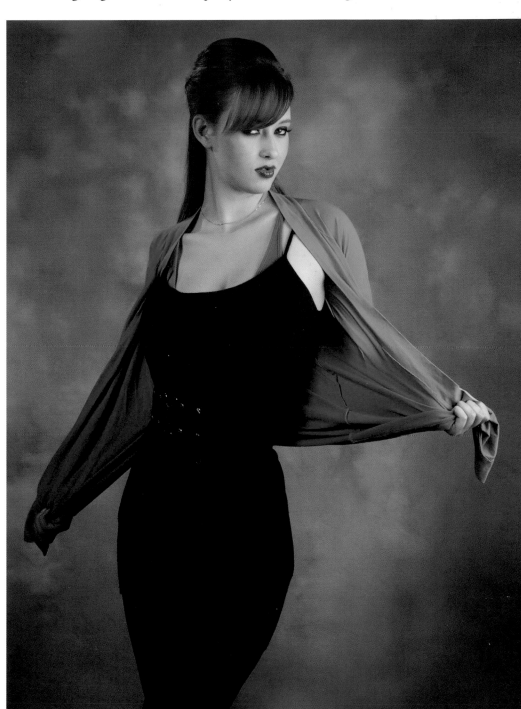

ABOVE—The Wafer Rectangle is a 3:4 proportioned diffusion lightbank for general use and is my personal favorite. It creates the artificial lighting equivalent of a broad window, making it ideal for use as a classic portrait and product light used off-camera or overhead on a boom. Photo courtesy of Gary Regester/Plume Ltd. **RIGHT**—This photograph was made with three Flashpoint II (www.adorama .com) monolights: The main light on camera right had a Plume Ltd. Wafer mounted; the fill light used a 42-inch Flashpoint white umbrella. The third light was behind and camera left and had a Flashpoint snoot attached. The background was a Westcott "April Showers" collapsible muslin background. Camera was an Olympus E-620 with Zuiko Digital 17.5–45mm lens and an exposure of $^{1}/_{60}$ at f/6.3 and ISO 125. © 2010 Mary Farace.

flash with separate power pack and heads, they can also be used with continuous light sources, including tungsten "hot" lights. Lightbanks come in various sizes and shapes from square, to rectangular window-shaped models (the reflections these create in a subject's eyes make it look a lot like window light) to striplights whose long, skinny shape produces dramatic lighting with more emphasis on shadows than highlights. Lightbanks don't have to be rectangular. They can also be round or octagonal. A round diffuser creates perfectly round catchlights for portraiture or even, round reflections for everything else.

These days, one of the most popular shapes is octagonal, and many companies, including Elincrom (www.manfrottodistribution.us) and Westcott (www.fjwestcott.com) offer a version, sometimes bearing a trademarked name. Octagonal lightbanks are popular because when used close to your subject, they produce soft, even, wraparound lighting effects. Another perk is that their efficiency allows even the smallest flash units/monolights/head to produce big-bang-for-the-buck exposure readings. They usually produce an even spread of light, often with less than $\frac{1}{2}$-stop light loss from center to edge. Some have a silver interior, removable internal baffle, and a removable exterior diffuser panel to allow for even more control.

The striplight, as we know it today, was invented by Paul Peregrine and Gary Regester when they were associated with Chimera and was based on the time-honored stage lighting tool known as the footlight. A striplight make s the ideal hair light or accent light, as it requires minimal setup space and is shallow in depth. Some striplights come standard with an outer removable diffusion panel and two inner baffles to allow you to produce two distinct lighting patterns. The solid white baffle offers a hot spot, while the baffle consisting of the silver circular center evenly spreads the light to less than $\frac{1}{2}$-stop light loss from the center to the edge.

Lightbanks attach to your choice of lighting instrument using an adapter, sometimes called a "speed ring," which allows the lightbank to be firmly connected to your light. These adapters are manufacturer-specific, so when you switch lighting systems, your lightbanks will work, but you'll need new adapter rings. Since these adapters can cost from $50 to $100 each, the cost of buying new adapters is something you should keep in mind when considering switching lighting systems.

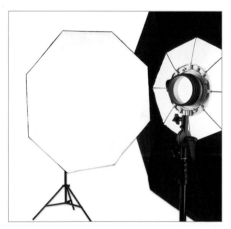

Westcott's Octabank is only 26-inches deep and weighs less than five pounds. The internal baffle offers two layers of diffusion for an even light spread of less than $\frac{1}{2}$ stop of light loss from center to edge. Photo courtesy F.J. Westcott Co.

Booth Photo's Strobist kits include a lightbank, mounting bracket, light stand, and a carry bag, all for an attractive price. The stripbox kit features a purposefully built oblong softbox essential for hair lighting in a group portrait. Photo courtesy Booth Photographic.

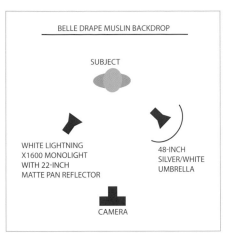

BELLE DRAPE MUSLIN BACKDROP

SUBJECT

WHITE LIGHTNING
X1600 MONOLIGHT
WITH 22-INCH
MATTE PAN REFLECTOR

48-INCH
SILVER/WHITE
UMBRELLA

CAMERA

For this full-length photograph of Victoria, the main light (at camera left) was a White Lightning (www.white-lightning .com) X1600 monolight with a 22-inch matte pan reflector with diffusion sock mounted. The second X1600 with an umbrella mounted was placed at camera right. The background was an Adorama (www.adorama.com) Belle Drape muslin. The shot was made with a Canon EOS 7D with an EF-S 18–135mm f/3.5–5.6 IS lens at 70mm. The manual mode exposure was $^1/_{80}$ at f/6.3 and ISO 125.

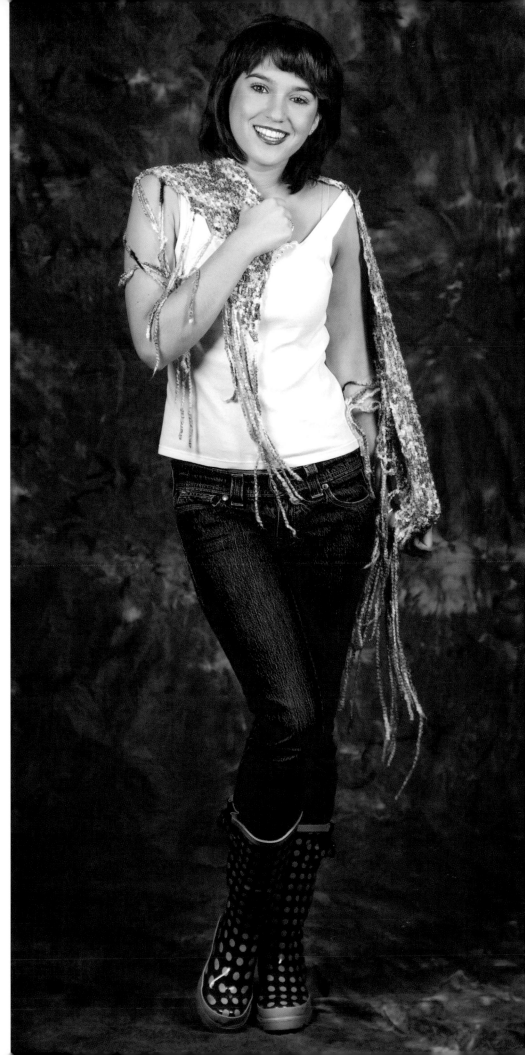

LEFT—"Speed rings" is what their inventor Gary Regester called them, but they go by many names, including "adapter rings." Photo courtesy of Booth Photographic. RIGHT—Westcott's Halo and Apollo lightbanks are designed using umbrella frames and require no adapter ring. Halos and Apollos produce softbox-like lighting without the hassle of using and buying an adapter ring. They set up in seconds, fit just about any studio light or speedlight, and are relatively inexpensive. What's the difference between the two? Halos are round and Apollos are square. Both are available in variations. Photo courtesy of F.J. Westcott Co.

RIGHT AND FACING PAGE—I set up three Flashpoint II monolights in my tiny basement studio to make this photograph. The main light at camera right was mounted with a Westcott Halo, while the fill light at camera left had a 32-inch Westcott satin optical white umbrella attached. The third light was placed behind the subject and to camera left with the standard reflector attached. Exposure with a Canon EOS 5D with EF 135mm f/2.8 SF lens was 1/50 at f/9 and ISO 100.

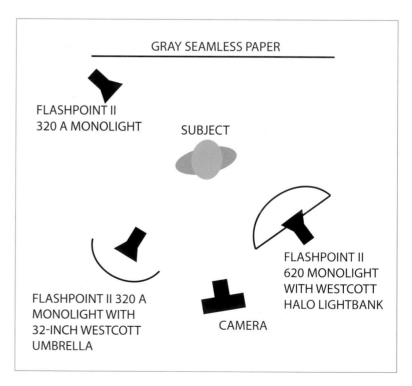

GRAY SEAMLESS PAPER

FLASHPOINT II
320 A MONOLIGHT

SUBJECT

FLASHPOINT II 320 A
MONOLIGHT WITH
32-INCH WESTCOTT
UMBRELLA

CAMERA

FLASHPOINT II
620 MONOLIGHT
WITH WESTCOTT
HALO LIGHTBANK

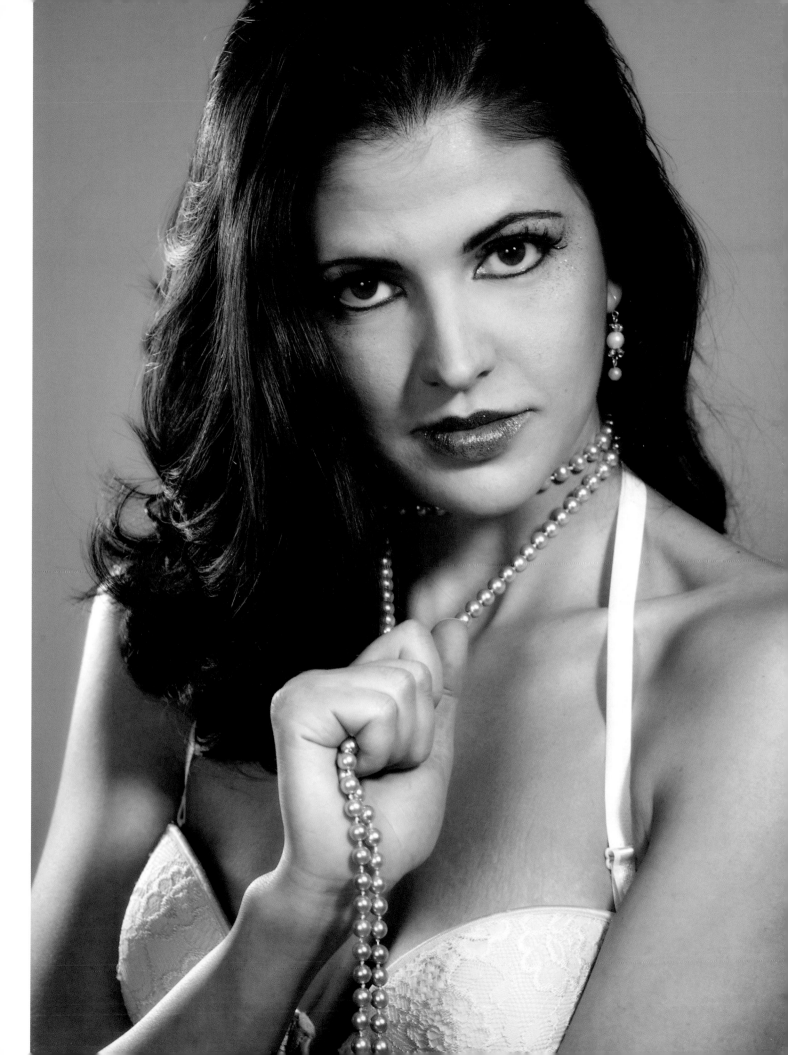

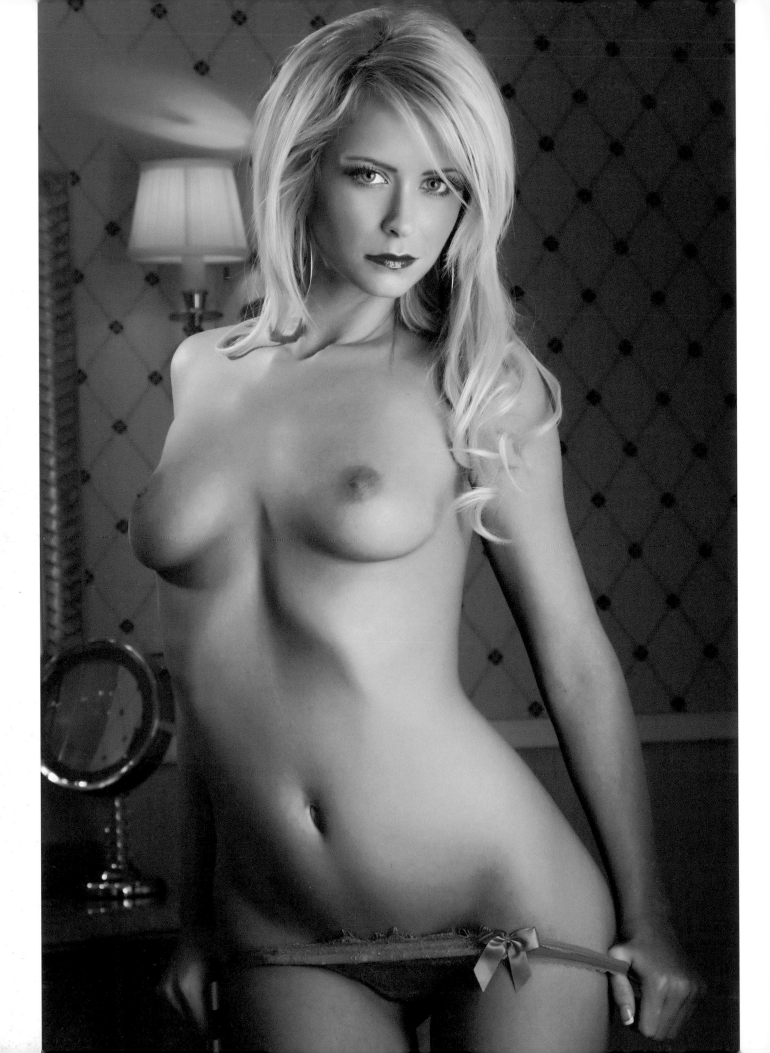

REFLECTORS

In the world of photography there are products that have similar, even identical, names but are quite different. A reflector can be a flat surface that "reflects" light from any light source. As mentioned earlier in the chapter, the rigid metal device that attaches to the front of a studio light and focuses the light so it goes where you want it is also called a reflector.

A beauty dish is a parabolic reflector that distributes light toward a focal point and creates a lighting effect that's somewhere between that of a direct flash and a softbox, giving the image a wrap-around and sometimes contrasty

A beauty dish is a parabolic reflector that distributes light toward a focal point . . .

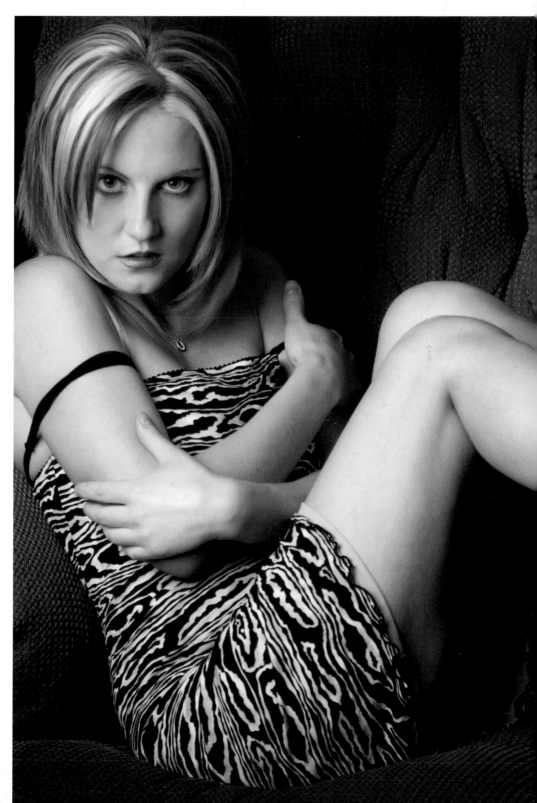

FACING PAGE—Dave Hall created this Playboy style image while photographing a model in an upscale hotel's bathroom using only a lightbank "jammed in the little hallway" along with a slow shutter speed to add available light and warmth. Exposure with a Canon EOS D30 was $^1/_{80}$ at f/5.6 and ISO 100. © 2011 Dave Hall, Hall Photographic. **RIGHT**—This photograph was made with a single Photogenic (www.photogenic.com) monolight with standard reflector and a 45-inch Westcott umbrella mounted. It was made with a Canon EOS 1D Mark II and EF 135 f/2.8 SF lens with an exposure of $^1/_{30}$ at f/5.6 and ISO 400.

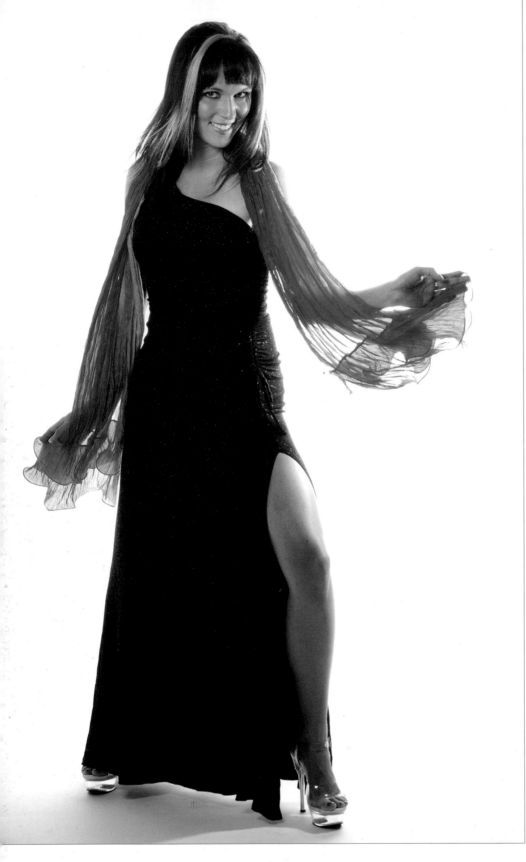

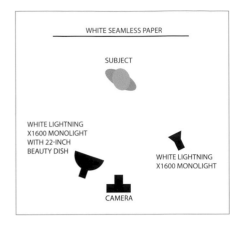

For this high-key shot, the main light was a White Lightning X1600 monolight with a 22-inch beauty dish that White Lighting (www.white-lightning.com) calls a matte pan reflector. It has one of their diffusion socks mounted to soften the light even more. A second X1600 monolight was aimed at the white background to overexpose it as much as possible. The camera used was a Nikon D300s with Nikkor 18–200mm f/3.5–5.6G lens. The exposure was $^1/_{125}$ at f/5.6 and ISO 200.

The Dynalite SR-SE beauty dish captures and focuses light with maximum efficiency. Its deep, narrow profile increases contrast and delivers a directional quality, which is perfect for black & white and for color images that require a distinct edge. Photo courtesy of Dynalite Inc.

look that can add a very dramatic effect. Many times the reflector has a center section that covers the flash tube so no direct light from it hits the subject. The light that is emitted fills the reflector, creating softer yet still direct light.

RING LIGHTS

The ring light (a.k.a. ring flash) is generally thought to have been originally invented by Lester A. Dine (www.dinecorp.com) in 1952 for dental photography. Many people today use small ring lights for all kinds of photography. I use a Canon MR-14EX macro ring light to photograph butterflies.

A ring light is a circular photographic flash that fits around the lens and produces even illumination and few shadows. It can be used to photograph people but, to paraphrase *Jaws'* Chief Brody, "You're gonna need a bigger light." In addition to softening shadows when photographing people, the unique way that a ring flash renders light produces a shadowy halo that fashion photographers seem to like.

For larger ring flash units, like those used for fashion photography, power is delivered by a power pack that can be battery or AC powered but some, such as Alien Bees' (www.alienbees.com) 320 watt-second ABR800, are con-

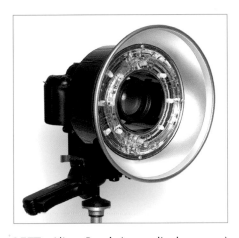

LEFT—Alien Bees' (www.alienbees.com) ABR800 is a self-contained ring flash system that is extremely compact, lightweight, and easy to use with professional or semi-professional cameras and lenses up to 4 inches in diameter. The ABR800 produces essentially shadow-free lighting, revealing unique catchlights in the eyes of subjects when used for fashion or portrait work. Photo courtesy of Paul C. Buff, Inc. **RIGHT**—Photojournalist Matthew Staver was assigned to photograph a business executive at a press conference. He arrived early and found a location suitable for a quick portrait in the ballroom where the press conference would later be held. Matt hung a red tablecloth on the wall, set up an Alien Bees ABR800 ring light, and made about ten exposures. The camera was a Nikon D2X with 17–55mm lens. The exposure was $1/250$ at f/5.6 and ISO 100. © 2009 Matthew Staver.

structed like monolights. Within the circular flash unit, there can be one or more flash tubes, each of which can be turned on or off individually. Some ring flashes have focusing (modeling) lamps for helping low-light focusing.

REFLECTORS AND SCRIMS

A reflector is a device used to catch and bounce light onto the subject. Reflectors are usually made from some kind of reflective fabric and are available in different colors to change the color of the reflected light and, more often than not, these reflectors collapse into a more portable form for travel. Reflectors follow the same rules as all lighting devices: bigger sources close to the subject produce soft light; smaller sources farther away produce harder light.

I typically rely upon an assistant to hold a reflector. When photographing models who bring their husbands or boyfriends to a shoot, I always get them to hold a reflector. It gives them something to do and keeps them out of my hair and from disrupting the session. If you shoot alone or don't have an assistant to hold that reflector at just the right angle, you're going to need a way to mount the reflector on a light stand. *Tip:* You can never have too many light stands.

A scrim is a screen-like metal mesh that's used in front of a light to reduce light, not necessarily to diffuse it, but devices that produce a diffusion effect are often called scrims as well. Westcott's Scrim Jim is a durable, versatile diffusion and reflector system that includes a series of frames, diffusion and

> A reflector is a device used to catch and bounce light onto the subject.

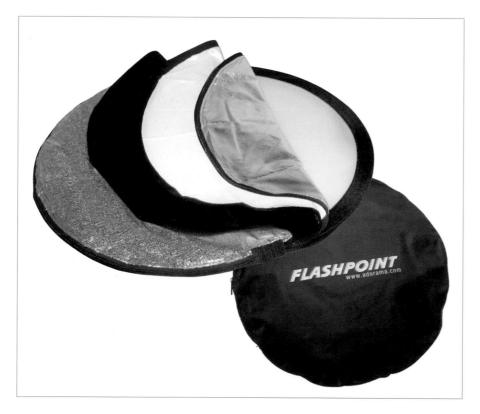

My favorite reflector is Flashpoint's very versatile 32-inch 5-in-1 collapsible disc reflector, which lets you switch the surface material to suit the situation. The basic reflector is covered in diffusion material that's useful for removing hot spots from a portrait subject's face while softening overall lighting. You can also cover the reflector with a reversible skin that includes black to block light, gold to warm light, silver for strong fill-in light, or white for softer fill light. The reflector is also available in a 22-inch version that folds into a package small enough to fit in your camera bag. There's also a 42-inch version that works great if you have an assistant or a light stand.

To get you started, Westcott offers four version of the Scrim Jim standard kit. Each one includes one frame, $^3/_4$-stop diffusion fabric, silver/white reflective fabric, and a carrying case. The Scrim Jim clamp lets you attach the optional grip head for 360-degree rotation. The system includes sixteen different diffusion fabrics, eleven "nets" for a true scrim application, and fourteen reflective fabrics. Westcott also offers a large, reversible blue/green chroma key (see chapter 5) fabric that you can use as a background for special effects photography.

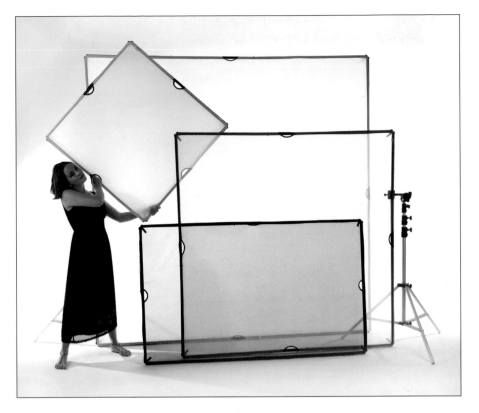

There are a number of choices you'll have to make in order to produce an image that makes a statement.

reflector fabric, and grip accessories that make it work the way you want. The square-section frames are made of lightweight aircraft aluminum that look much heavier than they are and are easy to assemble using the built-in connector. Their modular construction lets you create four easy-to-handle frame sizes (42x42, 42x72, 72x72, and the super-sized 96x96). The modular design allows for easy portability as well as quick setup and tear down. The high-quality fabrics have hook and loop tape sewn around their perimeter that produce an even, snug, and secure fit to the frame, even during windy conditions outdoors. The system is equally at home on location or in the studio.

MIX AND MATCH

You can use a reflector with a lightbank and an umbrella. You can use an umbrella and a lightbank. You can also light a subject with nothing but lightbanks. The choice is yours. Each of the modifiers mentioned in this chapter has its own characteristics, and once you get past the "throw every possible kind of light at a subject" phase of your lighting learning curve and decide to create a specific effect, you'll want to choose specific light modifiers that create or enhance that mood. Lighting is more art than science. To start, you have to make sure the exposure is correct, but after that there is considerable latitude in producing the final result, and there are a number of choices you'll have to make in order to produce an image that makes a statement.

3. WHERE DO SPEEDLIGHTS FIT IN?

"The thing that's fascinating about portraiture is that nobody is alike."—*Imogen Cunningham*

When compared to a monolight, the biggest advantage of using speedlights is that they're small and portable, which means you can take them anywhere. Today's shoe-mount flashes—or speedlights as camera manufacturers like to call them—are sophisticated. When using them, you can

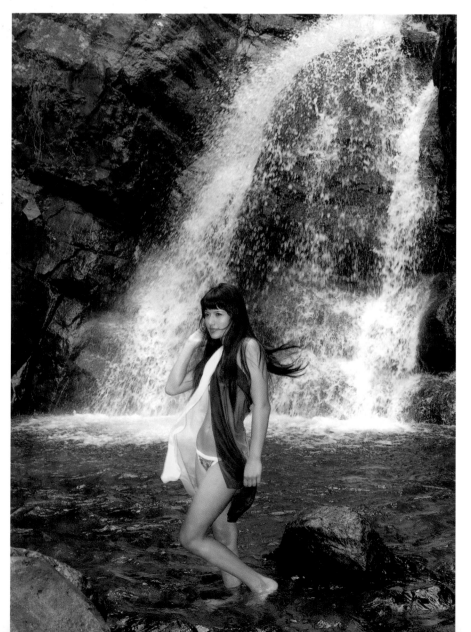

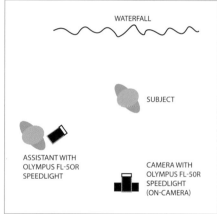

This image was made at the bottom of the La Mina falls in the El Yunque rain forest in Puerto Rico. In case you're wondering, you're free to splash in the water at the base of the falls, or make photographs if you like. It was captured with an Olympus E-3 camera and Zuiko Digital ED 12–60mm f/2.8–4.0 SWD lens with an exposure of $^1/_{160}$ at f/8 and ISO 400. An Olympus FL-50R flash was on the hot shoe and a second FL-50R was at camera left and tripped wirelessly by the on-camera flash.

ABOVE—Nikon's SB-800 features i-TTL flash control, allowing for automatically balanced fill flash and advanced wireless lighting capabilities. Other features include wireless control for multiple SB-800 speedlights, Auto FP high-speed sync, Flash Value (FV) lock, flash color information communication, and optical wireless out-of-sight data transmission they call pulse modulation, that lets these flashes work with other lighting systems, including studio lights. Photo courtesy of Nikon USA. **RIGHT**—Dave Hall used a single on-camera speedlight to make this dramatic photograph of Jeanette in a swimming pool at sunset. The camera was a Canon EOS 30D. The exposure was $^1/_{200}$ at f/4.5 and ISO 100. © 2011 Dave Hall, Hall Photographic.

seamlessly blend natural light and flash, and you have the ability to group several flashes together, trip them wirelessly, and automatically calculate the correct exposure. You can use some manufacturers', notably Nikon's, speedlights as part of a studio-style setup where they can be assigned ancillary lighting functions such as hair and background lighting and trip them optically using anybody's on-camera flash. All Nikon Speedlights, including the SB-600, SB-800, and SB-900 offer this feature while, as I write this, Canon's

Speedlites (yes, they spell it differently) do not. This sometimes means you can illuminate the subject using Nikon Speedlights and take the photograph with a Canon camera. (We'll take a closer look at this later in the chapter.)

LIGHTBANKS TO GO

There is no denying that over time shoe-mount flash units have become increasingly more sophisticated. They now feature built-in electronic links that make producing correctly exposed images, even under outdoor or difficult lighting conditions, much easier. While the exposure accuracy and quantity of output from on-camera flash units have increased, one factor that's changed little is the quality of the light these units produce. Sure, you can always rubber band

ABOVE—Booth Photographic Mini/Max is a family of easy-to-use, inexpensive light modulating products that include small, on-flash lightbanks and even a pair of replacements for that rubber band and index card. The Mini/Max family consists of two lIghtbanks that fit your shoe-mount flash: The bigger (6x8-inch) BHB model has a large front panel for "more dramatic effects" and the (3.5x4.75-inch) QLB features a smaller sized front panel for quick and easy shooting. The lightbanks attach easily and fold flat for storage. Both follow the old rule: the bigger the light source and the closer it is to the subject, the more diffuse the light. Image courtesy Booth Photographic. **LEFT**—While waiting for a model to arrive for a shoot, I made this test shot of Mary in our living room using two windows for backlighting and a Mini/Max 6x8-inch BHB lightbank attached to a Canon 550 EX flash as the main light. It was captured in Tv mode with an EOS 50D and EF 28-135mm IS lens. Exposure was $1/30$ at f/4 and ISO 400 because I wanted to pick up the backlighting and the ambient light in the room as well.

Small lightbanks can be used outdoors too. Mary photographed Caitlyn using an Olympus E-30 and Digital Zuiko 14–54mm zoom lens with an exposure of ¹/₁₆₀ at f/6.3 and ISO 125. A Mini/Max 6x8-inch BHB lightbank was attached to an Olympus E-50R flash unit, which served as the main light. © 2011 Mary Farace.

an index card to the flash head to act as a bounce "kicker," and some speed-lights even provide built-in slide out reflectors—no rubber band required. If you want to soften and broaden the light source, you're going to need something bigger and better. These kinds of lighting modifiers are available from many different sources, including the Flashpoint Q-series (www.adorama .com), Booth Photographic (www.boothphoto.com), LumiQuest (www .lumiquest.com), and others.

One of the most clever design aspects of some small lightbanks, such as the Mini/Max, is that they have flaps in their top and bottom that can be opened for multi-directional lighting effects when working indoors. You can use these flaps to add bounce lighting off a wall or ceiling depending on the orientation of the camera and flash, or you can use the lightbank as bounce and open the flap to aim semidirect light at your subject.

One of the cheapest, most time-honored, and simplest light modifiers is a 4x6-inch index card attached with a rubber band to the top of a shoe-mount flash in bounce positions. This crude but effective method adds some bounce light along with some light that's "kicked" at the subject. If you want some-thing more solidly built, you can purchase one of the sturdier bounce cards

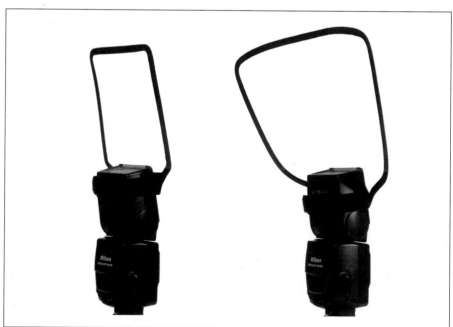

ABOVE—As you can see with Mary's photograph of Kelsy, the larger FBC bounce card works wonderfully indoors when used in a horizontal position. Photo made with Olympus E-3 and 40–150 Digital Zuiko lens with an exposure of $1/40$ at f/4.5 and ISO 400. © 2011 Mary Farace. **LEFT**—Mini/Max's 8x3-inch SS (snoot) should be useful when working with more than one light using the wireless lighting control systems that are built into Canon, Nikon, Olympus and other shoe-mount flashes. It lets you target light to specific areas of the portrait and adds dramatic lighting effects. Photo courtesy of Booth Photographic.

available from Booth Photographic, LumiQuest (www.lumiquest.com), Sto-Fen's Two-Way Bounce (www.stofen.com), and others. One of the biggest variables in the Mini/Max devices is size and shape. Larger ones produce broader and softer results and remind me of the lighting produced by an old Vivitar 283 accessory that attached a Kodak Gray Card (the flipside is white) to the flash as a bounce accessory and produced deliciously soft lighting effects with on-camera flash. If you fondly remember that device and want to get the same kind of lovin' feelin' with your camera's system flash, you can produce similar results using the Mini/Max FBC card. *Tip:* If you use the camera and flash vertically, be sure to move the subject away from the wall. Otherwise, the big kicker will produce big shadows. If you can't move the subject, switch to the smaller card.

LEFT—Outdoors, the smaller Mini/Max QBC bounce card mounted on an Olympus FL-50R shot in FP mode served to add just a little extra fill light on Kelsy's face. I know many photographers keep small bounce cards on their flashes at all time. If that's you, you'll love the QBC. **RIGHT**—Mary photographed Tatiana on location using the larger Mini/Max bounce card mounted on an Olympus FL-50R flash to provide wide coverage for the wide-angle shot. The camera was an Olympus E-30 with 14–45mm Digital Zuiko lens at 20mm. The exposure was $1/60$ at f/3.5 and ISO 200. © 2011 Mary Farace.

All of the Mini/Max devices install on your flash in the same way: you wrap the provided Velcro mounting strap around the flash head at least one inch from the front of the flash, slip the device on, and press. If you'd prefer working without the strap, you'll appreciate that the package includes glue-backed Velcro tabs that can be attached to the flash. For me, the joy of any of these products is that the strap avoids having sticky (and hard to remove) things on my flash. To use either lightbank, all you have to do is open up the back end of your lightbank, slide the opening over the flash head onto the Velcro strap or tabs, and you're ready to go. The bounce cards mount just as quickly: just use the Velcro strap and press on to secure.

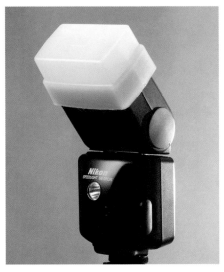

LEFT—While there was natural light coming in the window behind this model, the main light was from a Canon 550EX Speedlite attached to an EOS 10D. Because a Sto-Fen Omni Bounce was attached to the flash, light was bouncing off the ceiling as well as the walls to create a soft, diffuse look. The exposure was $1/60$ at f/4.5 and ISO 400. RIGHT—The Sto-Fen Omni Bounce diffuser. The Omni Bounce creates a soft barebulb effect and is easy to use. It is custom fit and slips onto your speedlight in seconds with no Velcro attachments required. Photo courtesy of Sto-Fen Products.

My first take on this concept was a lighting kit with all the gear shown. Everything expect the background would fit in the case that Mary is holding. It was based on using the tiny monolights you see, but since they are no longer being produced, I decided to re-imagine the kit, this time using speedlights.

ON-FLASH DIFFUSER

While Sto-Fen (www.stofen.com) makes several different kinds of flash diffusers for shoe-mount flash, they are most famous for the simple and simply wonderful Omni Bounce diffuser. Nowadays, some camera companies include a similar product with their speedlights, but not every shoe-mount flash comes with one. Some of these complementary units, especially the Olympus, are a bit flimsy, so you should consider the Omni Bounce anyway. At less than twenty bucks, it's inexpensive and does so much to improve your flash photographs.

When slipped over your shoe-mount flash head, the Omni Bounce creates a diffused barebulb effect, with light going in all directions and providing even coverage across the entire frame with lenses in focal lengths from 15mm to 200mm (35mm format). Because of its custom fit, the Omni Bounce is easy to use and goes onto and off of your flash in seconds. It is designed for years of service and is small enough to fit easily into your camera bag or pocket. The Omni Bounce is available in colors too. Why? When you are working under mixed lighting and want to use fill flash, the solution previously required taping gels to the speedlight. Sto-Fen's green Omni is useful for shooting under fluorescent lights, and the gold Omni is helpful for warming flash-filled available light shots made under tungsten lighting.

ASSEMBLING A SMALL LOCATION LIGHTING KIT

I hate to schlep heavy lighting gear to off-site shoots and, in my quest to find the smallest, lightest, and most versatile three-light system for on-location portraits, I came up with a kit that uses speedlights. I'd like to take all the credit for the idea, but it's based on a concept that Plume's (www.plumeltd.com) Gary Regester came up with more than twenty-five years ago called "lighting kit in a shoebox." My kit is larger than a shoebox, but it contains more stuff. It is even small enough to meet airline carry-on guidelines!

No monolight or power pack and head system is as small as a speedlight, and today's sophisticated units from Canon, Nikon, Olympus, etc., also make it easy to wirelessly control multiple lights from the camera position. I wanted to be able to use the lights with umbrellas and keep the package as tiny as possible, producing something that would allow photographers to travel light.

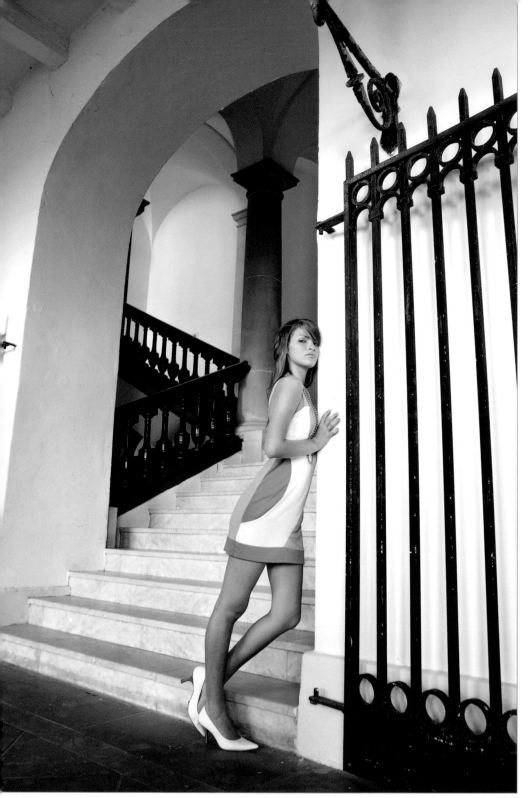

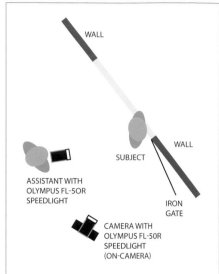

WALL

WALL

SUBJECT

ASSISTANT WITH
OLYMPUS FL-50R
SPEEDLIGHT

IRON
GATE

CAMERA WITH
OLYMPUS FL-50R
SPEEDLIGHT
(ON-CAMERA)

LEFT AND TOP RIGHT—The Olympus wireless flash system is so dependable that I used the Olympus E-3's popup flash along with two FL-50Rs to photograph a model outdoors on Plaza del Quinto Centenario in Old San Juan and they always fired. The exposure was $1/80$ at f/2.8 and ISO 200. **BOTTOM RIGHT**—The Olympus FL-50R speedlight will sync with either the Olympus E-3 or E-30's popup flash or another FL-50R in the hot shoe. Control is possible directly from the camera without cables or connection to an AC source, making it ideal for outdoor use. Photo courtesy of Olympus America.

 The key ingredient is the lights themselves, and my client for this particular kit was my wife Mary, an Olympus (www.olympusamerica.com) SLR shooter. The decision was easy: the wireless FL-50R flash has multiple adjustment modes including TTL Auto and manual, high-speed synchronization up to $1/4000$, and a fast recycle time of less than 1.3 seconds when using the optional Olympus SHV-1 flash high-voltage set. The FL-50R has a guide number

of 28 at 12mm (24mm equivalent; ISO 100) and 50 at a 42mm (84mm equivalent; ISO 100). Olympus includes a Sto-Fen-like bounce adapter that works quite well but doesn't seem as sturdy as the real thing. If you happen to crack the somewhat thin Olympus diffuser, which is easy to do, the Sto-Fen replacement is model OM-C.

LITTLE THINGS MEAN A LOT

The next part of the kit is something to support those lights—a light stand or three. Light stands are humble photographic accessories, but they serve an important purpose: they support the lights. *Tip:* Avoid the impulse to buy cheap light stands. Don't forget they are holding an expensive light. Also, a well-made stand will last a lot longer than a cheap one. Purchase the best light stand you can afford but in this case, I recommend the specific model that fits my portable lighting kit concept: the Manfrotto (www.manfrottodistri-bution.us) Nano (001B) is a rugged five-section black aluminum light stand that extends to 74.8 inches or down to a minimum height of 19.29 inches.

> Avoid the impulse to buy cheap light stands. Don't forget they are holding an expensive light.

You don't have to use a Manfrotto Nano light stand in your version of my portable speedlight kit. There are lots of different light stands available from many different manufacturers. The key to finding the right one is to pick a light stand that is small, sturdy, and affordable.

The current version features retractable legs and, unlike previous models, has a ⅝-inch stud on top. Its closed length (important to the shoebox concept) is 18.90 inches, producing a footprint with a maximum diameter of 39.37 inches. The Nano's stated load capacity is 3.31 pounds, and the whole light stand weighs 2.05 pounds, also important to the kit's appeal.

THE RIGHT GRIP GEAR

Now that you have a light stand, you need something to hold the flash and an umbrella or another kind of light modifier. One answer is the Adorama Universal Swivel Holder (LTUSH). There are several similar adapters available, some at the same price, some that cost more—but the LTUSH stands out. Not only is the entire housing a metal casting, but the shoe is metal as well. Some adapters use a plastic shoe (no kidding). The shoe is removable, but for our purposes, we'll leave it alone. However, we will be sure to use its small knob to lock the shoe-mount flash securely in place.

There is a slot underneath the flash-mounting shoe to insert an umbrella, and a sturdy knob lets you lock it in place. Depending on your flash, you might have to slightly reposition the shoe to have it aim directly into the umbrella. A big knob on the top of the LTUSH lets you loosen, move the shoe, and then lock it into place. The LTUSH tilts 180 degrees horizontally and swivels a complete 360 degrees left and right, allowing you to aim the umbrella at your subject and position it where you want in order to achieve the desired lighting effect. A sturdy lever allows you to lock the LTUSH into place and reposition it easily. As of this writing, the LTUSH costs less than fifteen bucks, so three of them won't break the piggy bank.

Now that we have the lights, light stands, and a way to mount the lights, the next step is finding the right umbrellas.

You might have to slightly reposition the shoe to have it aim directly into the umbrella.

LEFT—The Adorama Universal Swivel Holder will mount on ¼ or ⅜-inch threaded light stands or studs up to ⅝-inches. (*Note:* The current Manfrotto Nano stands have a threaded top, while previous versions do not.) If you prefer, you can remove this stud from the adapter and slip the LTUSH over the top of the light stand. Photo courtesy Adorama Camera, Inc. **RIGHT**—Grin&Stir's FourSquare speedlight mounting system is a hard-anodized aluminum block designed to handle up to four speedlight flashes. The flashes can be mounted into a softbox, umbrella, or an umbrella dome setup to provide not just excellent light quality but a lot of light output as well. Photo courtesy of Grin&Stir.

The keystone of the Grin&Stir's FourSquare speedlight mounting system is a T6061 hard anodized aluminum block that's designed to handle up to four speedlight flashes. Attaching the FourSquare to a light stand can be done using the standard Manfrotto umbrella stand adapter or similar attachment device, using either the $\frac{1}{4}$-inch twenty or the $\frac{3}{8}$-inch sixteen standard threads. Photo courtesy of Grin&Stir.

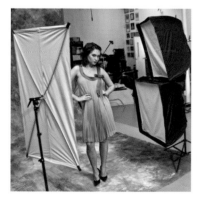

ABOVE AND RIGHT—For this shot of Victoria, two Grin&Stir's 30-inch FourSquare kit lightbanks, each with a single Nikon Speedlight mounted, was used. A reflector was placed at camera left. I used the "Joe Farace" carbonite muslin background that's exclusively available from Silverlake Photo (www.silverlakephoto.com). The camera was a Canon EOS 1D Mark IV with an EF 28–135mm f/3.5–5.6 IS lens. The final exposure was $\frac{1}{100}$ at f/5.6 and ISO 200.

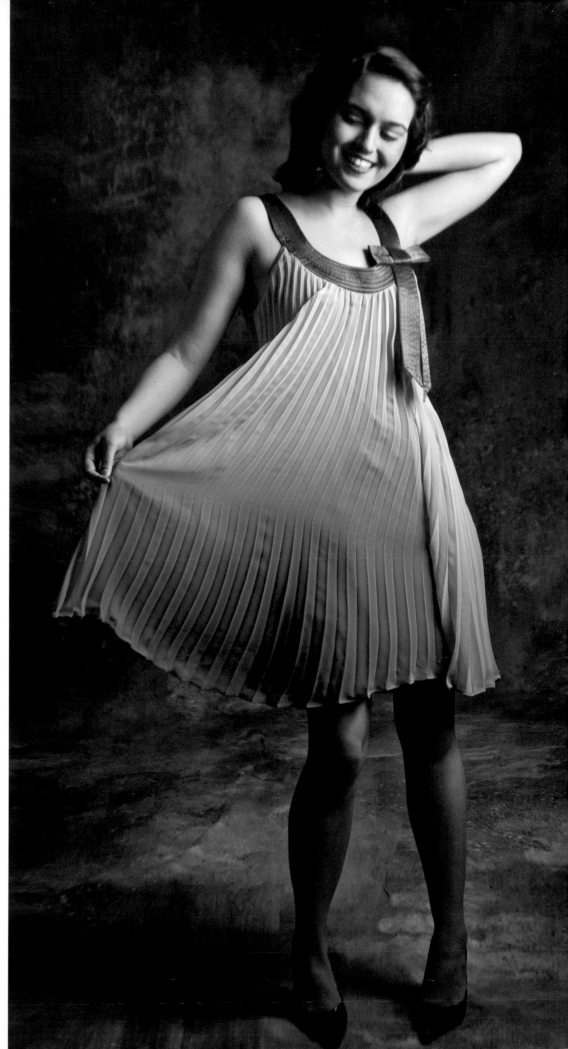

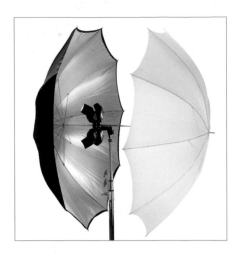

An option for attaching a speedlight to a light stand, although it does require a standard Manfrotto umbrella adapter, is the Grin&Stir (www.light waredirect.com) FourSquare speedlight mounting system, which uses a hard anodized aluminum block that can handle up to four speedlights. The flashes can be mounted into a matching lightbank, umbrella, or even two umbrel-las. The ability to control the flashes remotely via the camera or radio slaves makes this a versatile and unique system for the location photographer. The design allows the user to freely rotate any of the (potential) four flash heads to fire directly into the lightbank's front diffuser, side panels, or any position in between. Travel is easy with the FourSquare because it is delivered ready to fly. It packs to fit in any standard-sized airline carry-on case.

COLLAPSIBLE UMBRELLAS

Because you need to control the quality of the light, not just its quantity, let's add some photographic umbrellas to the location lighting kit. We won't choose just any umbrellas. To save space, you're going to need collapsible umbrellas.

Everybody is familiar with collapsible umbrellas for keeping the rain off your head; well, the photographic equivalent is based on the same need to save space. The collapsible umbrellas I chose for this kit are from Westcott, who offers three different models. The Westcott 43-inch (when fully opened) soft silver collapsible umbrella provides soft yet snappy light and is the one I use for the main light in a two- or three-light setup. Also available are the white satin umbrella and the white satin umbrella with removable black cover. All Westcott collapsible umbrellas have a rated capacity up to 1000W, which is a lot more power than any shoe-mount flash can throw at them. They open to 43 inches (a size that's appropriate for the shoe-mount flashes in the kit) and collapse to just 14.5 inches. Each umbrella weighs one pound, another important ingredient in creating a portable lighting kit. Since I am building a three-light kit, I include one of each of the models for maximum versatility. (Note: Similar products are available from Photek [www.photekusa.com] or

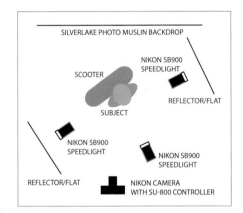

SILVERLAKE PHOTO MUSLIN BACKDROP

NIKON SB900 SPEEDLIGHT

SCOOTER

REFLECTOR/FLAT

SUBJECT

NIKON SB900 SPEEDLIGHT

NIKON SB900 SPEEDLIGHT

REFLECTOR/FLAT

NIKON CAMERA WITH SU-800 CONTROLLER

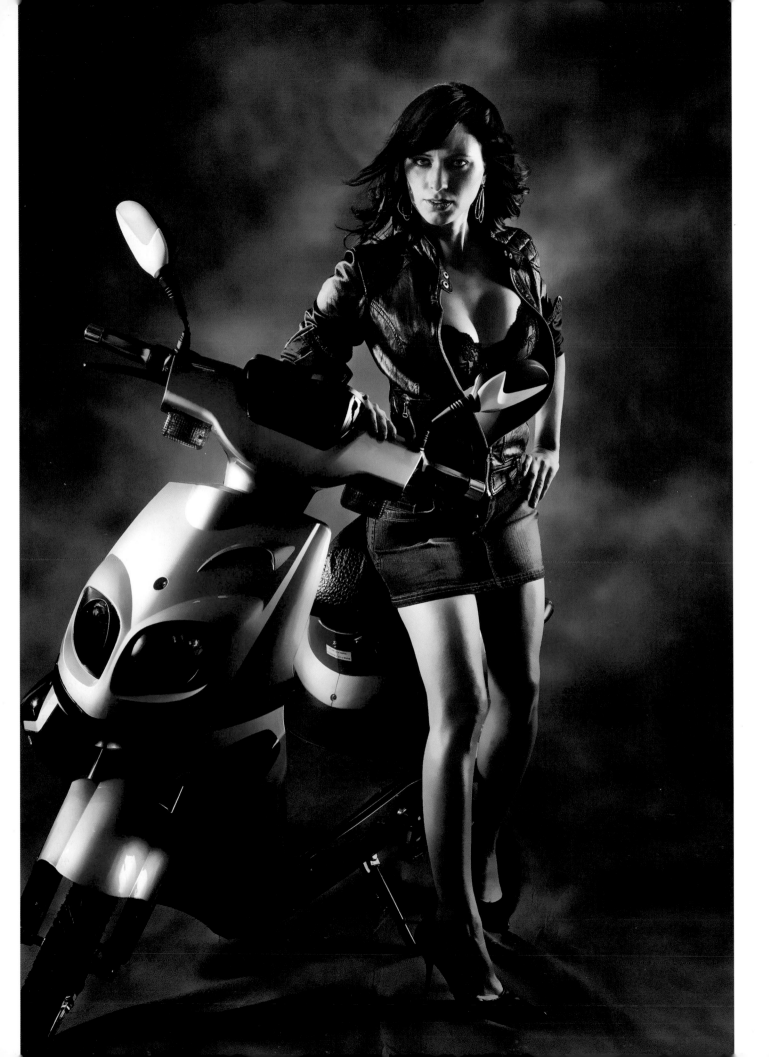

Lastolite [www.lastolite.com].) All that's left to finish the kit is a case to put the gear in.

A CASE TO PUT IT IN

You know the punch line to the old joke: "What do you buy the photographer who has everything?" A case to put it all in. Any case for the location lighting kit must be rugged and lightweight and, most importantly, must conform to airline requirements for carry-on luggage. For all of those reasons I chose Lightware's multi-format closed-cell foam equipment case with dividers (MF-2012).

The MF-2012 is a versatile case that's sized to fit through the 9x14x22-inch template at the airport terminal's security check-in point. It's made with the same high-quality interior superstructure as all Lightware multi-format cases, so your equipment will be well protected even if you decide to check it as luggage. It comes with a set of dividers that you must cut to match the equipment you need.

The MF-2012 case has an exterior slash pocket to attach other Lightware accessories as well as an exterior zippered pocket to securely store flat items. The inside lid has two nifty mesh stash pockets for small accessory items, and that's where Mary stores flash user's manuals and a folded sheet of Rosco (www.rosco.com) Matte Black Cinefoil. This aluminum material soaks up light and can be quickly molded to make barn doors, flags, or snoots. Lightweight yet durable, Cinefoil is easily kept in place with gaffer's tape.

I selected the Lightware MF-2012 because it fits Mary's requirements, but you can choose something you may have laying around or a case with a different configuration. The choice is ultimately up to you and your budget. The same is true of all of the components used in my location lighting kit. You can use any or all of my suggestions to assemble a similar kit that fits your specific application.

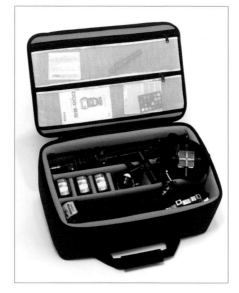

The location lighting kit concept is, if anything, flexible. Mary Farace's kit uses Olympus FL-50R flashes, but a similar kit put together for my friend Paul, a Nikon shooter, holds three SB-800 flashes and somewhat different accessories than used for Mary's kit. © 2008 Farace/Peregrine.

4. SETTING UP AN IN-HOME STUDIO

"I always kept my equipment down to a minimum two cameras, each with three lenses, a flash that would clip onto the camera body, and one assistant. I did not want to spend time thinking about hardware; I wanted that time to concentrate on the girl and the world around her."—*Helmut Newton*

As I said in the Introduction, much of my portrait, glamour, and fashion photography is done on location, but when you live in Colorado, you sometimes find the models (and the photographer too) aren't in the mood to go stomping around in the cold weather and snow. That's when a studio comes in handy. Also, some photographers just prefer the control that's only possible in the studio. Instead of the hassle and cost of renting a studio, why not create one using a room you already have?

SPACE: A FINAL FRONTIER IN LIGHTING TOO

The first thing you need for an in-home (or in-apartment) studio is space. You don't need much, but more is always better than less. You can put a studio in a basement, garage, spare bedroom, or just use the living room as Mary and I did when we got started many years ago. Back then, we would

LEFT No matter where you set up your studio and what kind of space you use, some compromises are inevitable. Using the basement means the gear can remain set up from shoot to shoot, saving time, but it also means I have to deal with low ceilings. Shooting in the garage, which I've also done, offers high ceilings and provides more flexibility in lighting set-ups, but that is not a viable option for me because of winter weather. In more temperate climates, this could be an ideal solution, if your cars don't mind being outside. **RIGHT**—This is a photograph of a businesswomen who wanted a sexy portrait for her boyfriend. The shot was made in that tiny basement studio space using two small monolights and a pair of inexpensive 42-inch Flashpoint (www.adorama.com) umbrellas. I shot it with a Canon EOS 20D with EF 85mm f/1.8 lens. The exposure was 1/60 at f/20—what was I thinking?—and ISO 100.

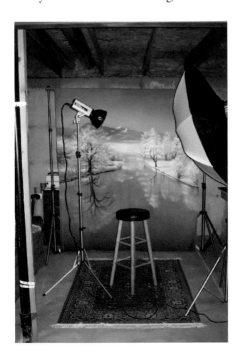
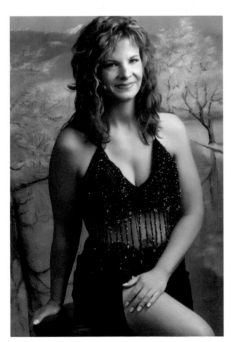

set up the lighting equipment and background for each shoot and knock it down and pack it away afterward. That's not the best way to shoot, but it worked. When creating a studio in an existing space, you need to be both inventive and flexible. Some of the images in this chapter were made in an 8x9-foot space in my basement—sandwiched between my model train layout (at camera right) and an old sofa (at camera left).

In the first portraits made in my original 8x9 foot basement space, studio lighting was provided by the two small, inexpensive, and no longer manufactured Adorama monolights that are shown in the illustration. You could accomplish the same kind of lighting using speedlights (see chapter 3). In addition to the studio equipment, the only amenity my original basement studio offered was a stool and a 4x5-foot rug purchased at Target. It's not a "real" photographic posing stool but one I sit on to run my model trains. This setup wasn't fancy, but it worked. Over time, I've expanded the studio and changed most of the equipment.

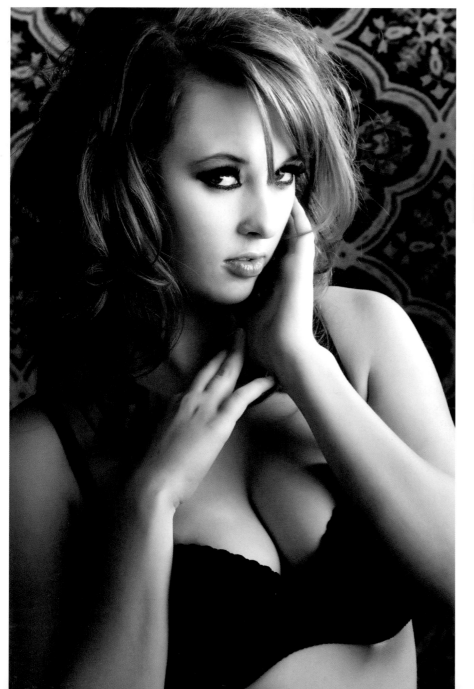

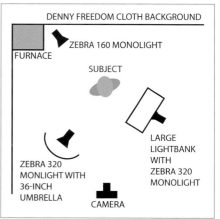

This photograph was made in my basement with the model literally two steps away from the furnace. A monolight with softbox attached was placed at camera right. Another monolight was placed at camera left with a 36-inch white umbrella attached. A third monolight with barn doors was used at camera right near the edge of the background to accent the model's hair. The camera was a Canon EOS 50D and EF 100mm f/2.8 macro lens. The exposure was $1/60$ at f/11 and ISO 125. The image was originally captured in color and converted to black & white using techniques I'll explain in chapter 8.

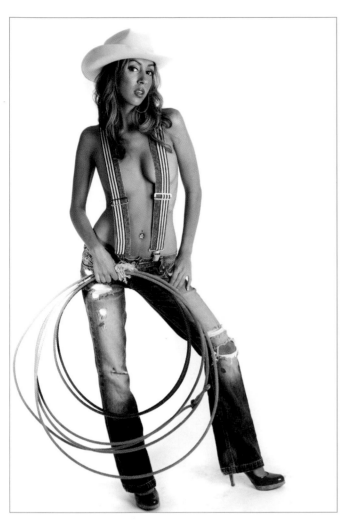

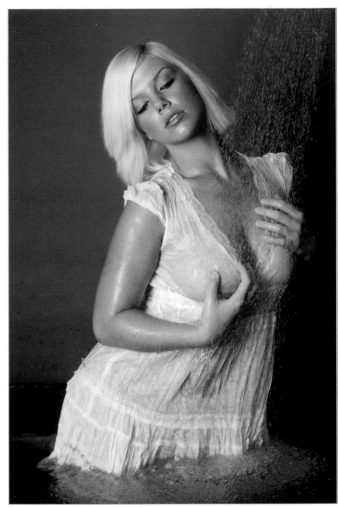

ABOVE LEFT—If there's a secret about setting up an in-home studio, it's to use the space that you have. Jerry Bolyard uses his dining room, which is where he made this photograph of Kayla using one Alien Bees unit as the main light with a 40-inch octagonal softbox placed to the right of the camera. Two Alien Bees B400 monolights illuminated the white background. Jerry seldom uses three lights because his dining room measures only 10x14 feet. © 2011 Jerry Bolyard. ABOVE RIGHT—Who's to say that your in-home studio has to be indoors? Jerry Bolyard shot this oh-so-wet glamour image outdoors. Lighting was from one Alien Bees B400 monolight with 24x20-inch foldable medium softbox placed at camera left and 36-inches off the ground. Another Alien Bees B400 monolight with gel was aimed at a seamless paper background. The camera was a Canon EOS 40D with 18–50mm lens. The exposure was $^1/_{125}$ at f/11 and ISO 200. © 2010 Jerry Bolyard. LEFT—The Alien Bees (www.alienbees.com) B1600 monolight produces 640 watt-seconds and 1600 effective watt-seconds of power, with 28,000 lumenseconds of output. Power is independently adjustable over a 5-stop range from full power to $^1/_{32}$ stop. The B1600 minimizes heat buildup by using advanced durability flash capacitors coupled with axial-flow thermodynamics, which results in increased durability and short flash durations. Photo courtesy of Paul C. Buff, Inc.

After shooting so long in a cramped basement space where I couldn't shoot full-length shots, I cleaned up some of the junk opposite my original studio space and posed the models where I used to stand. This realignment produced a clear 10x10-foot space. That's not a huge increase, but it's

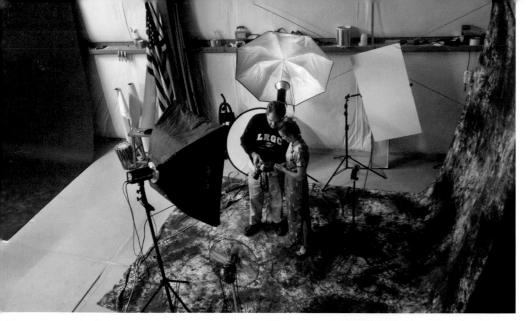

Jack Dean's studio space is so big that he can have two setups working at once. In this photograph, I'm shooting on the right-hand side, and you can see the low-key background set behind me on the left. I am showing the model some of the photos we'd just made. My purpose in doing this is twofold: to show her how great she looks and to show her a pose and discuss some of the changes I would like her to make in subsequent shots. © 2010 Jack Dean Photography.

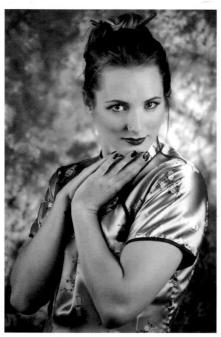

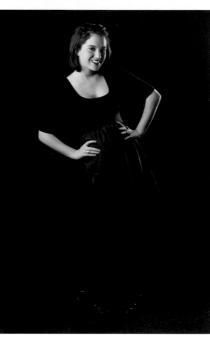

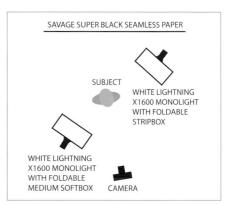

LEFT—I must have been in a filmic mood during this studio session, and this photograph conjured up images of Frank Capra's 1937 classic film *Lost Horizon*. A White Lightning X1600 monolight with Paul C. Buff foldable medium softbox attached (camera right) and another X1600 at camera left with an umbrella was used as fill. One Nikon SB800 Speedlights was used as a background light. The manual mode exposure was $1/100$ at f/5.6 and ISO 200. **CENTER AND RIGHT**—Stepping out of my comfort zone and using the low key area in Jack Dean's building, I shot this "black on black" image of Victoria using two White Lightning (www.white-lightning.com) X1600 monolights. The main light at camera left had a Paul C. Buff foldable medium softbox attached, while the light on camera right (and behind the model) was mounted with a foldable stripbox. The camera was a Canon EOS 7D with EF-S 18–135mm f/3.5–5.6 IS at 62mm. The manual mode exposure was $1/80$ at f/8 and ISO 125.

bigger than my first try and one that will have to work for a while as I contemplate moving to a new home. As I write this, the space is being used to test some lighting products for *Shutterbug* as well as to shoot photographs for this book. Full-length poses require wider-angle lenses than I might prefer to use or would have used outdoors, but when working in smaller spaces, as I said, compromises are required.

Tip: Making wider-angle lenses work in tight shooting spaces requires close attention to camera height. I find that sitting in a chair while photographing the model can help keep the camera angles lower. You can use whatever contortionist trick works for you as long as you are not shooting down on your subject with a wider-angle lens. If you do, your lens will create unflattering, foreshortened and distorted portraits with disproportionate head sizes. Some people like this look; I don't. If you do, go for it!

PUTTING IT ALL TOGETHER

To put some perspective on what equipment can be used to create studio lighting effects in a temporary space, here's a look at all of the gear I'm currently using for portrait sessions in my 10x10-foot basement studio:

Lighting. While there are 40-inch square windows immediately out of camera range to the right and back of my studio, they open into window wells that are three feet underground, so there is no strong direct available light. In my basic setup, lighting is provided by three monolights. The main light is a Flashpoint II 620 monolight that produces a 300 watt-second output. It has continuously variable power that lets me tweak exposure by adjust-

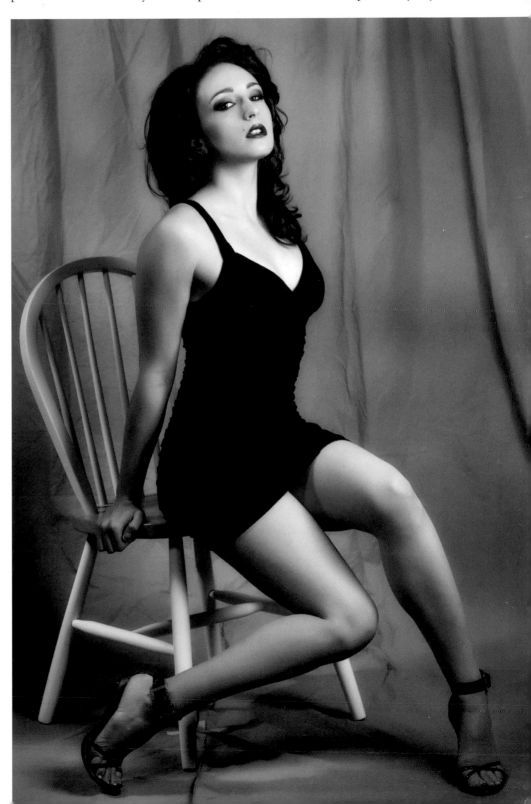

I photographed Kelsie on a subtle Belle Drape muslin backdrop in the 10x10-foot basement studio. The main light was a Flashpoint II monolight with Plume Wafer and a 45-inch Westcott (www.fjwestcott .com) optical white satin umbrella for fill. The camera was a Canon EOS 5D and EF 85mm f/1.8 lens. The exposure was $\frac{1}{60}$ at f/8 and ISO 100.

ing the flash power instead of my camera's aperture so I can control depth of field. Fill light is another Flashpoint II 620a that produces 150 watt-seconds and features stepless power output control from full down to ⅛ power. A Flashpoint II 320a monolight is used as a hair or background light.

Umbrellas and lightbanks have a big effect on the quality of the light produced in your temporary studio. For portrait sessions in my temporary studio, the main light was fitted with a Plume Ltd. (www.plumeltd.com) Wafer lightbank. Its slim profile makes it practical for use in small spaces and on location, yet this compact device produces amazing light quality. Plume does not offer a speed ring to attach the Wafer to the Flashpoint II monolights but does so for many other brands. The one I use was custom made by adapting a Photogenic speed ring and sawing off the mount of a Flashpoint II's reflector. (As I mentioned earlier, flexibility and adaptability come in handy.)

One old studio rule of thumb is that you can never have too many light stands. Most of the heavy lifting in my basement studio is done with two Flashpoint Heavy-Duty Pro 10-foot ($59.95) and two Flashpoint Heavy-

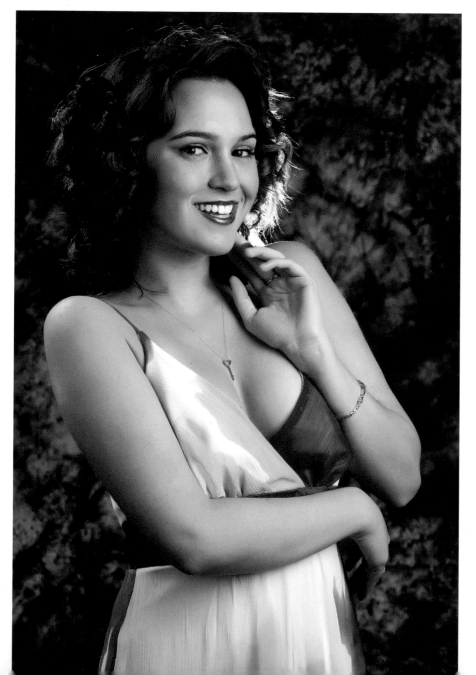

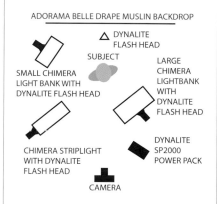

Lighting for this colorful photo of Victoria posed against one of Adorama's Belle Drape backdrops was made using a four-head setup connected to a Dynalite SP2000 power pack. The main light (at camera right) used a Chimera large lightbank, fill was provided by a Chimera striplight (at camera left), a hair light on a boom had a small Chimera lightbank mounted, and instead of a background light, the fourth head was aimed at the subject's back to backlight her hair. The exposure was 1/80 at f/8 and ISO 100.

I photographed Vivian against a Belle Drape muslin backdrop in my basement studio. The main light was a Flashpoint II monolight with Plume Wafer and a 45-inch Westcott (www.fjwestcott.com) optical white satin umbrella for fill with an inexpensive Flashpoint II snoot on the third Flashpoint monolight that acts as a hair light. The camera was a Nikon D90 and AF-S Nikkor 18–105mm f/3.5–5.6 VR lens. The exposure was $^{1}/_{60}$ at f/14 and ISO 200.

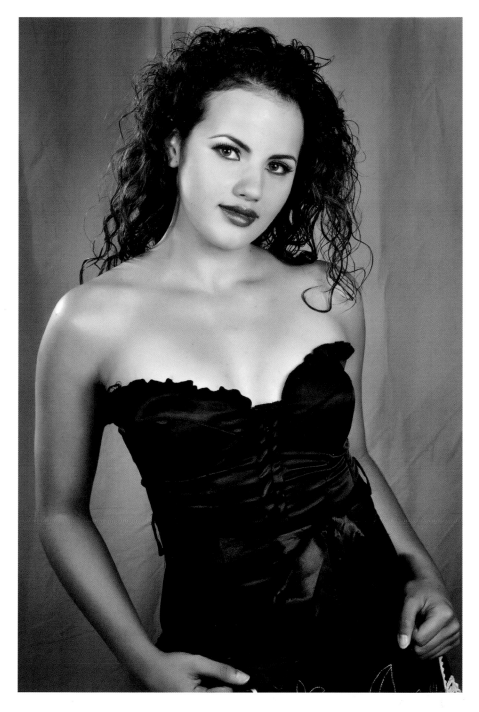

I can rarely extend any of these stands to their full height because of the low basement ceiling.

Duty Pro 9-foot Air-Cushioned light stands ($49.95). I probably have another half-dozen stands that I use to hold reflectors and scrims, but the Flashpoint stands are my workhorses because of their low price and rugged construction—even though I can rarely extend any of these stands to their full height because of the low basement ceiling.

The best deal I've found so far when shopping for muslin backgrounds is Adorama's affordable Belle Drape backdrops. JTL Studio System's (www.jtl corp.com) B-1012 stand is the perfect complement to the Belle Drape muslins. It expands to 12.6 feet wide using the four extension poles provided. For

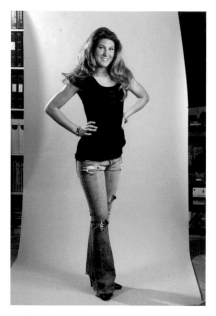

STEP 1—I photographed Haley standing in front of a Savage soft gray seamless paper background and used three Flashpoint II monolights to light her. Because of her full-length pose and the narrow 53-inch seamless paper, I was unable to capture a full background in the same frame as the model.

STEP 2—I used Photoshop's rectangular Marquee tool to select an area between the left edge of the seamless paper and Haley's elbow. Then, using Photoshop's Content Aware Scaling feature (Edit>Content-Aware Scale), I dragged one of the selection "handles" until the original frame was filled with gray background. I clicked Enter and was finished with this part of the background. *Tip:* If you have an older version of Photoshop that lacks the Content Aware Scaling feature, you can just select and drag one of the handles. It works with solid backgrounds like this one but can't be used with anything more complex.

the 70-inch wide scenic background shown in the setup photograph, only two of the support sections were required. When I set up a 10x12- or 10x24-foot Belle Drape, I use three or four sections of the support tube. There's more information about backgrounds in chapter 5.

DIGITAL DARKROOM TO THE RESCUE

Many, but not all, of my problems in shooting full-length poses in my basement studio were partially solved when I cleaned and flipped my studio space. While muslin backgrounds can be softly shaped to fit the available space, seamless paper backdrops firmly resist such treatment, so while a 53-inch paper background fits my shooting space, the 107-inch version won't. I can shoot on the narrow background, but the images have to be rescued later in the digital darkroom. The image sequence above and on the facing page shows how I did it.

Building a studio of your own using a small space first begins with an attitude that says you can do it! All of the tips, tools, and techniques that I have shown here are just the beginning. Use them as a springboard and expand these concepts to fit your available space, gear, and imagination. It all begins with the right attitude, so start clearing space for your new in-home studio today!

STEP 3—Next, I used the rectangular Marquee tool to select an area between the right edge of the seamless paper and Haley's other elbow. Then, using the same technique as on the left-hand edge of the seamless background, I used Content Aware Scaling (Edit>Content-Aware Scale) to drag one of its "handles" until the frame was filled with gray background.

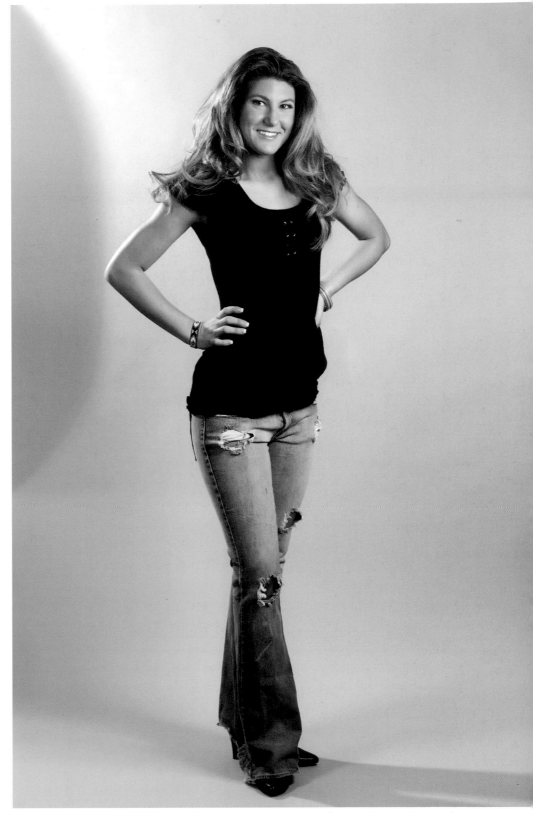

STEP 4—We're finished. Here's the final image with some minor retouching and a few overall tweaks.

5. BACKGROUNDS AND OTHER TOOLS

"Ultimately, simplicity is the goal in every art. Achieving simplicity is one of the hardest things to do, yet it's easily the most essential."—*Pete Turner*

They may not be the main focus of a photograph, but backdrops and props can enhance an image and help emphasize the subject. A scenic background can be as much an important part of the photograph as the person standing or sitting in front of it. Then again, using that same background, unlit and barely visible, the subject becomes more highlighted and the background is reduced to a supporting role. There are other less obvious advantages of using backdrops. If the selected background helps the person being photographed feel special, the final product is improved. By working with different kinds of backdrops, you can experiment with different designs and textures so you're ready for anything.

A new background or prop can get a photographer's creative juices flowing. There's something about adding a new element to an image that can help you climb out of a rut. Look for backgrounds and props that challenge you to think imaginatively about making images and are something that your paying clients might enjoy. While your needs may vary depending on the project or budget, variety is the single most important factor to consider when purchasing a background to complement your subject and tell a story.

PAPER OR PLASTIC?

The most classic of all backgrounds is solid-colored seamless paper. After all, you want a background that complements your subject and does not compete for the viewer's attention. Photographers have used Savage (www.savagepaper.com) seamless background paper for more than sixty years. Their Widetone paper has a nonreflective surface that's available in sixty-eight different colors and in 26-inch x 12 yard, 53-inch x 12 yard, 107-inch x 12 yard, and 107-inch x 50 yard rolls. Savage seamless paper rolls are core wound and come wrapped in a plastic sleeve. Seamless backgrounds are also available from the BD Company (www.bdcompany.com) and feature a nonreflective surface that's available in an array of vibrant colors and in rolls from 26-inch x 12 yards, 53-inch x 12 yards, and 107-inch x 50 yards.

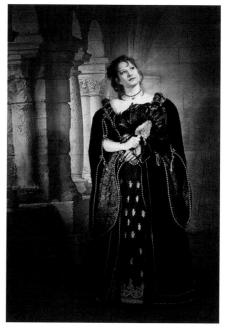

If you've got a big enough vehicle, even large painted canvas backgrounds can be portable. Because you can't always make it to Venice for Carnivale, I captured Toni in a pensive moment at an ice equipment manufacturing plant, but the photograph could have been made anywhere. Lighting for this image used only the modeling light from a single monolight with an umbrella, located at camera right. The camera was a Canon EOS 10D with 28–105mm lens. The exposure was $^1\!/_{15}$ at f/4 and ISO 800.

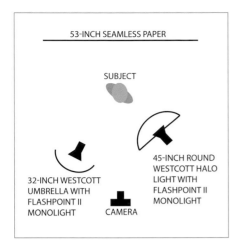

As part of a series of models wearing corsets, I photographed this model in my basement studio against a 53-inch roll of Savage light-gray seamless paper. Lighting was from a Flashpoint II monolight with a Westcott Halo attached at camera right; fill was from a Flashpoint II monolight with a 32-inch Westcott umbrella at camera left. The camera was a Canon EOS 5D and EF 85mm f/1.8 lens. The exposure was $^1/_{60}$ at f/20 and ISO 200.

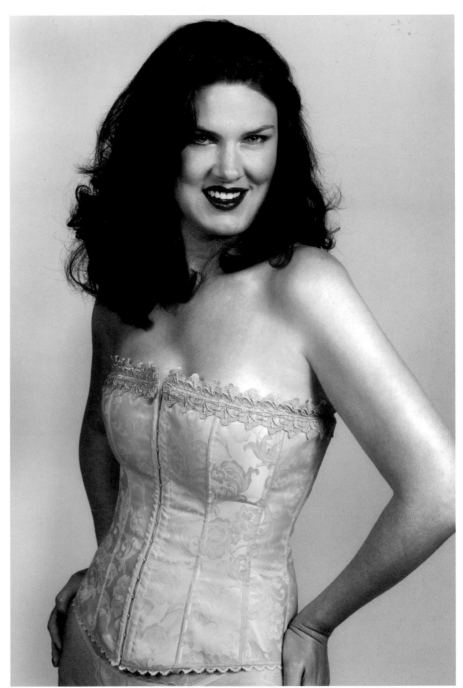

Savage also offers vinyl backdrops, and their Infinity Vinyl series provides a matte, glare-free background that is ideal for portrait or commercial photography. These backdrops come in rolls on strong cores and can be used on most support systems. These vinyl backgrounds have several advantages over seamless paper: they are durable; the white version creates a pure white when properly lit, making it ideal for high key photography; they are easy to clean with a damp sponge; and because of their weight, they hang straight. Lastolite (www.lastolite.com) offers Superwhite Vinyl Backgrounds that wipe clean and can be used over and over again. Simply wipe away any dirt or footprints

at the end of your shoot, roll it up, and you're ready for next time. Try that with seamless paper, especially if the model is wearing stilettos. While you can always use gaffer's tape (*never* duct tape) to tape a piece of seamless paper to a wall—and that's not a bad solution for a quickie on-location portrait—I don't think it's the best solution for a small, in-home studio.

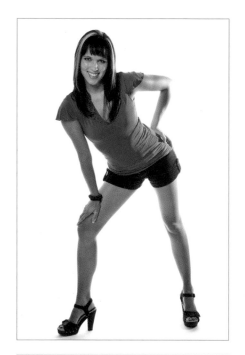

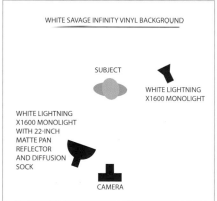

WHITE SAVAGE INFINITY VINYL BACKGROUND

SUBJECT

WHITE LIGHTNING X1600 MONOLIGHT

WHITE LIGHTNING X1600 MONOLIGHT WITH 22-INCH MATTE PAN REFLECTOR AND DIFFUSION SOCK

CAMERA

ABOVE—The high-key look was produced with a pure-white Savage Infinity Vinyl backdrop. In this lighting setup (seen in the diagram), a White Lightning X1600 monolight with a 22-inch matte pan reflector and diffusion sock mounted was the main light. A second X1600 was aimed at the background. The camera was a Nikon D300s with Nikkor 18–200mm f/3.5–5.6G lens. The manual mode exposure was $^1/_{125}$ at f/8 and ISO 200.

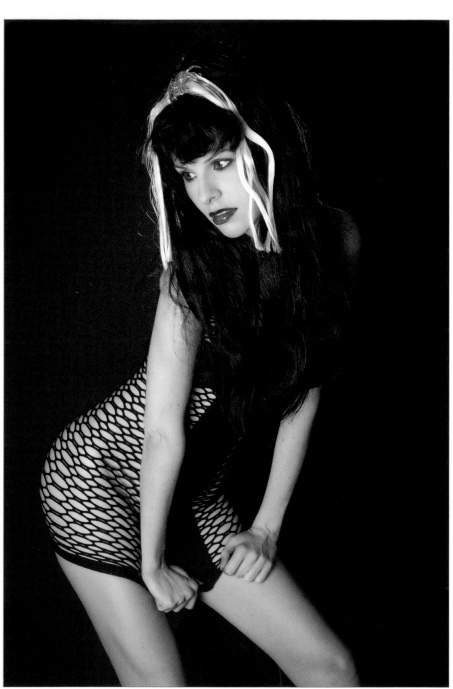

Want the opposite look? Use a black backdrop as Jerry Bolyard did here. The lighting was provided by one Alien Bees (www.alienbees.com) B400 monolight with a 24x24-inch lightbank placed below the camera and another B400 monolight with blue gel filter, to camera left, backlighting the model. The camera was a Canon EOS 40D and EF 18–50mm lens. The exposure was $^1/_{125}$ at f/8 and ISO 200. © 2010 Jerry Bolyard.

Here's a posing tip that works no matter what kind of background you decide to use: *always* keep your subject away from the background the same distance as their height. (At the end of the last chapter, you can see what happens when I don't follow my own advice.) This will cause any shadows created by the flash to fall behind the subject and not onto the background. If space is a problem, you can always raise your lights—but in small spaces, the ceiling height may be an issue too. In a case like this, you'll need to find a balance between the subject-to-background distance and the height of your lights, no matter what kind of lighting you use.

You'll need to find a balance between the subject-to-background distance and the height of your lights.

DIGITAL TRICK: STAMP OUT GRAY SEAMLESS

The use of texture screens is nothing new for portraiture and has been around for more than seventy years. In the traditional darkroom, a texture screen is a piece of film that has a texture printed on it and is placed over photographic paper or sandwiched with the negative during exposure. In the digital darkroom, you can accomplish this same effect using Layers in Photoshop.

IDC Photography (www.idcphotography.com) offers a set of Photoshop Actions and a plug-in that not only makes the job painless but lets you be creative too (see chapter 8 for more information about plug-ins). Textures with Actions volume 1 is a set of sixteen textures that add interesting surface effects to your photographs, producing a layered file for further processing. Also included in the package are workflow actions called Hollywood Glam, Silent Movie B&W, ShowBiz Snap, Faded Technicolor, Colortone, and Uninhibited Resize.

GAFFER'S TAPE, NEVER DUCT TAPE

Gaffer's tape is a strong, tough, cotton-cloth, pressure-sensitive tape that sticks to what it's fastened to. The adhesive is a high-quality synthetic rubber that leaves little or no residue when removed. It usually comes in 2-inch wide rolls, and the cloth composition allows a consistent tear, which means it can be easily torn into two 1-inch strips.

There are two grades of gaffer's tape. Permacel's Professional Grade is thicker, stronger, and leaves less residue than less expensive choices. Permacel P-665 is an economic alternative to the Professional Grade and is thinner and less reflective. P-665 is a good choice for people on tight budgets or in warmer climates. I purchase my gaffer's tape from Denver's Film and Video Equipment Service Company (www.fvesco.com), but there are many online sources as well, including BuyTape.com.

The tape is named for the gaffer, the head of the lighting department on a film crew, and its most common use is securing cables to the sound stage's floor or other surface, either for safety or to keep them out of view of the camera. Gaffer's tape generally costs three times more than duct tape of equivalent length because it's not manufactured in large quantities and is made to different specifications.

Why all the fuss over tape? Because if you ever plan to come back to a particular venue, it's a good idea to use tape that's easily removable so you don't do damage to someone's facility.

STEP 1—This photograph was made using an inexpensive generic gray muslin background and was shot with a Canon EOS 5D and 85mm lens. The exposure was $^1/_{60}$ at f/8 and ISO 100. The image was opened in Adobe Photoshop and the model was slightly retouched.

STEP 2—IDC Textures v2 was selected from Photoshop's Filter menu, which displays an interface giving you access to two groups of nine textures. Your filter selection should, of course, depend on the subject and the mood you want to create in your final image. For this photograph, I selected "Cracked Stucco."

STEP 3—The texture files are large and will need to be repositioned and resized (or not) depending on the look you want to create. Use your mouse to move it and use Shift-Drag to resize.

STEP 4—After resizing, click the Enter key, and you'll see instructions on how to finish the image. IDC suggests using a Brush opacity of 20 to 40%, and the plug-in has already selected the tool and proper color (black). Painting on the top (texture) layer allows the bottom (background) layer to show through. You can change Brush attributes such as size, opacity, and hardness to affect the final look. *Tip:* Use a big, soft brush, varying its opacity, and finished effects can be produced in seconds!

STEP 5—Here's what the texture layer looks like with the subject painted out. Notice also that I have lowered the opacity level on the overall texture to 90%, allowing some of the muslin background to bleed through the texture. This made it look more like a real background.

STEP 6—After a few touch-ups to make sure there wasn't too much texture bleeding through onto the subject (I think a little is okay, but it's up to you), I'm finished changing that drab backdrop into something much more interesting. Using both volumes of Textures provides almost endless options in stamping out blah backgrounds. The good news productivity-wise is that it takes less time to do this than reading this section of the book!

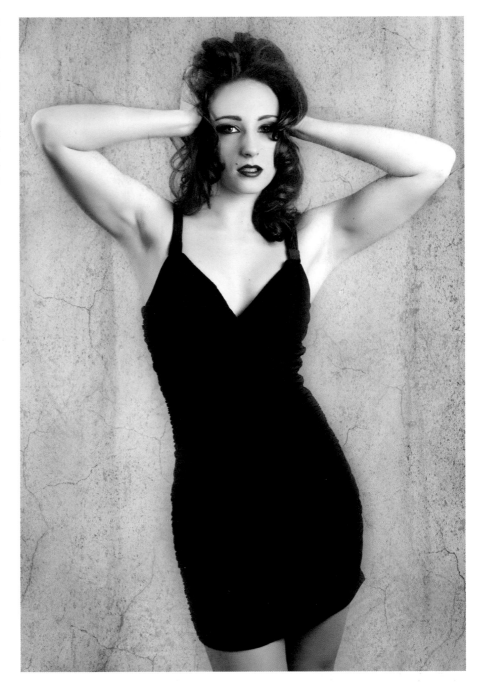

Textures v2 is a Photoshop-compatible plug-in that includes eighteen different textures and requires Adobe Photoshop CS3 or later. The interface provides a reference thumbnail for each one. All you have to do is click on the texture you want to apply, position it for the best effect, and brush away texture where you don't want it!

In addition, for its use on location shots, I found Textures v2 to be a useful tool for adding life to boring backgrounds. This can be a useful technique for those photographers on a budget who are using seamless paper or a generic gray muslin, as in the example shown, allowing them to add panache to an otherwise boring background.

LEFT—For this shot with the model placed in front of a Belle Drape muslin background, I used a White Lightning X1600 monolight with a Paul C. Buff foldable medium softbox attached (camera right) and another X1600 with an umbrella used as fill on camera left. A Nikon SB800 Speedlight was used as a background light. I created the shot with a Pentax-DA 50–200mm f/4–5.6 ED lens on a Pentax K-X camera. The manual mode exposure was $1/100$ at f/6.3 and ISO 200. RIGHT—I made this photograph with the model posed against a 6x7-foot F.J. Westcott "April Showers" collapsible muslin background. The lighting was from a Flashpoint II monolight with a Westcott Halo attached at camera right. Fill was from a Flashpoint II monolight with 32-inch Westcott umbrella at camera left. The camera was an Olympus E-620 5D and 55mm macro lens. The exposure was $1/60$ at f/6.4 and ISO 125.

MUSLIN BACKGROUNDS

Muslin is a type of finely woven cotton fabric that was introduced to Europe in the 17th century from the Middle East and became popular at the end of the 18th century in France. Muslin is typically a closely woven, unbleached or white cloth that is produced from corded cotton yarn. Wide muslin is sometimes called sheeting. It is often used to make dresses or curtains but may also be used with foam for bench padding. Muslin breathes well and is a good choice of material for clothing meant for hot, dry climates. What has endeared it to photographers is that many kinds of dyes can be applied to it. Also, because of its light weight, it is easily compressed into a small space, making it ideal for location photography and storage.

One of the biggest advantages of using muslin is that it is a less expensive material than canvas and, consequently, muslin backdrops tend to cost less. Adorama's (www.adorama.com) Belle Drape backdrops are a particularly good value, but there are other manufacturers who produce great, inexpensive backgrounds as well. Another advantage of using muslin backgrounds is that they are easier to transport than canvas and can be stuffed into a bag and tossed in the trunk of your car. For a casual style or maybe just something different than the last time you used a particular background, a muslin backdrop can be draped to provide a whole new look.

CANVAS BACKGROUNDS

Canvas backdrops are rugged, but their heavier weight makes them best suited for use in permanent locations. They can be expensive, but the surface lets the artist produce realistic-looking backdrops, although more and more scenic muslin backgrounds are being produced to challenge that notion. They can also be large, with a 10x10-foot background is required to produce

LEFT—Asylum is part of Silverlake Photo's Abstract series of muslin backgrounds. It is a mid-key design that's available in sizes from 10x12 feet to 20x20 feet, and while suggested for senior photography, it works equally well, I think, for portraiture and fashion. Photo courtesy of Silverlake Photo. **RIGHT**—Travis Gadsby made this image using Silverlake Photo's Asylum using a Nikon D200 and 80–200mm f/2.8 lens. The exposure was $^{1}/_{100}$ at f/8 and ISO 100. © 2011 Travis Gadsby, photo courtesy of Silverlake Photo.

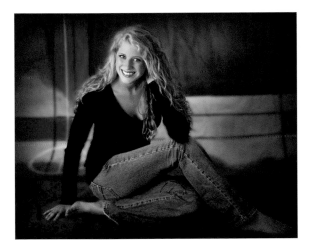

ABOVE—Backgrounds by Cole (www.coleandcompany. com) produces muslin backdrops, including scenic, abstract, and old master backgrounds along with draping material, tricot, and cloudscape backgrounds. All of the backdrops are manufactured in the USA. Dennis Kyser used Cole's Converge background to make this image. © 2011 Dennis Kyser. Photo courtesy of Cole & Company. **RIGHT**—Backgrounds by Cole offers iDrop backdrops designed for the iPod generation. Each one is hand-painted on fine muslin and have several areas on them that you can shoot into. For a different look, you can photograph its back. Terry Dunlap (www.dunlapphotography.com) used the Mallory iDrop for this photograph. © Terry Dunlap. Image courtesy of Cole & Company.

coverage for full-length portraits of two people. Canvas backgrounds must be kept rolled up between uses or when transporting to avoid creasing the material. All these factors combine to create a background that is expensive and more difficult to transport than muslin, yet many companies still make canvas backdrops, and the selection of available designs is unsurpassed.

There are many advantages to using a canvas backdrop. The colors tend to be more intense. The fact that the background is perfectly flat means that the appearance of a canvas backdrop is more consistent than muslin from one photograph to the next. This is especially important to wedding photographers and those photographing corporate employees during the year, since the background always looks the same, no matter when the portrait was made. Some photographers, especially those committed to a traditional portrait style, feel that canvas gives a more formal look. Canvas also has another advantage for the artistically inclined photographer: you can paint your own. A well-painted canvas drop will last many years if well cared for. For many years I schlepped large canvas backdrops and set them up in locations as diverse as a client's living room or at convention centers for on-location corporate portraits, and I have no doubt that my old canvas backgrounds are still out there somewhere working for another photographer.

I made this portrait many years ago using a background that I no longer own. Can you tell if it is a canvas or muslin background? Lighting was from a medium (14x56–inch) Chimera (www.chimera-lighting.com) Super PRO Plus lightbank at camera right and a 42-inch umbrella on the left for fill. Shot on color negative film with Contax 167MT with 85mm f/1.8 Carl Zeiss lens.

ALTERNATIVE FABRICS

Denny Manufacturing is famous for their photographic backdrops. I've used Denny backgrounds since 1982. After moving out of a permanent studio, I sold all of our canvas backgrounds because they took up too much space. I began using muslins but I missed the color and style that "real" backgrounds provide. While at the Imaging USA conference, Mary and I had a chance to see Denny's new Freedom Cloth backdrops. These feature bold and stylish designs while folding and unfolding—wrinkle free—into a traditional background. The backdrops are made with brass grommets at the top, which

THE RENTAL OPTION

Not surprisingly, really nice looking canvas and muslin backgrounds can be expensive, but for the shooter looking for variety and low cost, there is always the rental option. If you live in a large enough metropolitan area, chances are any company that rents pro photo gear will also rent backdrops. If you're not so lucky, there are solutions such as The Backdrop Exchange (www.thebackdropexchange.com)—the Netflix of backgrounds. The Backdrop Exchange offers memberships where you can rent unlimited backdrops for one low monthly fee. You can rent up to three backdrops at a time for the entire duration of your membership or can swap out the backdrops as many times as you like. Membership starts at $49.95 per month plus a per-background $10 flat rate shipping charge. Another rental option is Rent Scenic Backgrounds (http://rentscenicbackgrounds.com), a company that offers seven-day background rentals for $49.99, including free return shipping. Check their web site for details.

allows you to hang them on any background stand using shower curtain hangers. My wife is always changing shower curtains, so it was easy to find an extra set of low-key rings to hang the Garden Pattern backdrop that Denny provided. While not inexpensive, Freedom Cloth backdrops are the ideal solution for the location photographer or the shooter who lacks a permanent studio. They are beautiful, store in little space, and open virtually wrinkle free. The truly picky (you know who you are) might want to use a small hand steamer to knock out any pesky wrinkles, but they will be small and only appear after long storage or less-than-careful handling.

This model was photographed in front of one of Denny Manufacturing's (www .dennymfg.com) Freedom Cloth backgrounds (this one is called "Garden Pattern"). A Zebra 320 with a softbox attached was placed at camera right. Another Zebra 320 was at camera left with the 36-inch white umbrella attached. Both monolights were set at $^1/_4$ power. A Zebra 160 with barn doors attached was placed at right rear to accent the model's hair and was set at $^1/_2$ power. The camera was a Canon EOS 5D with a 100mm f/2.8 macro lens. The exposure was $^1/_{60}$ at f/11 and ISO 125.

Superlite Backdrops (www.superlitebackdrops.com) are created using a patented process to achieve a synthetic background that is lighter and easier to use and transport than either muslin or canvas. I'm not a chemist, but it has some of the look and feel of Tyvek, a synthetic material that is strong, soft enough to be used as a car cover, and extremely lightweight. With Superlite backdrops, all that's needed is a quick snap out before hanging, then you can softly drape or pull the material as flat as canvas with just a few clips. When you're finished, just re-crush the background into a storage bag and go. They are supplied with a 3-inch hem for crossbar mounting (they will make it wider if requested), but there are alternative ways to hang these backdrops since weight is not an issue. I buy background clips at Home Depot. They are not just useful for hanging backgrounds; they can be used to gather up fabric when sweeping it to one side or pulling it flat. You can even hang the backgrounds over a tightly pulled string or bungee cord. *Tips:* Superlite backgrounds are flame retardant, but you should avoid placing hot lights closer than two feet, since this material can melt under certain conditions and a hot bulb can burn a hole in the background if it touches it directly. While your subjects can walk on these drops, have them avoid walking on a backdrop with high heels when it's placed over a pile carpet.

> A hot bulb can burn a hole in the background if it touches it directly.

GREEN SCREEN

Blue or green (chroma key) screens allow you to create a photograph of your subject against any background you can imagine. Chroma key is a video term for electronically inserting an image from one camera into the picture pro-

F.J. Westcott's Green Screen Digital Photo Kit includes everything you need to get started in green screen photography in one box. The kit includes a 5x7-foot green screen background, PhotoKey Lite software, and 100 digital backgrounds. Photo courtesy of F.J. Westcott.

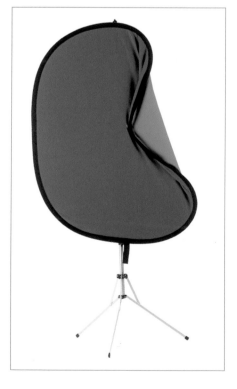

F.J. Westcott also offers a collapsible and reversible blue and green screen backdrop that quickly collapses to one-third of its open size, and the kit even includes a stand. Collapsible muslin backgrounds are perfect for on-location photography. Just unfold the background, hang it on a compact background stand like this Westcott model designed for collapsible backdrops or lean it against a wall and you're ready to go. Photo courtesy of F.J. Westcott.

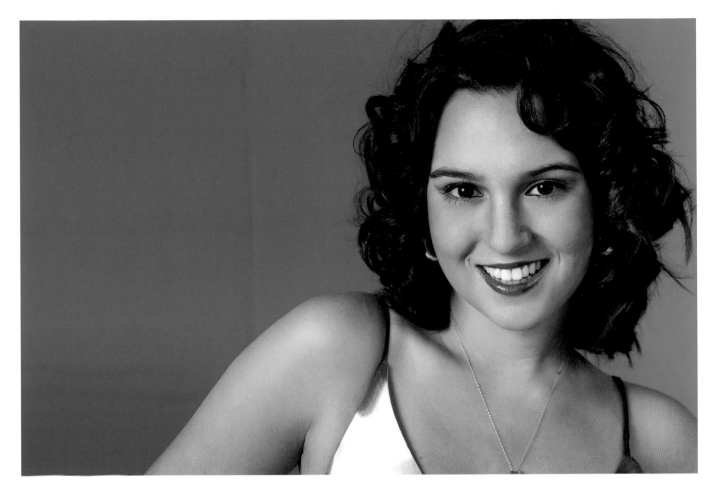

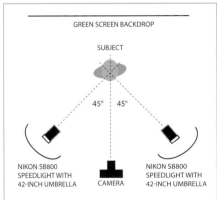

GREEN SCREEN BACKDROP

SUBJECT

45° 45°

NIKON SB800
SPEEDLIGHT WITH
42-INCH UMBRELLA CAMERA

NIKON SB800
SPEEDLIGHT WITH
42-INCH UMBRELLA

Green turned out to be the best choice for this subject. If Victoria had been wearing a green blouse, a blue background would have been the best choice. The shot was made using a Canon EOS 1D Mark IV with an EF 85mm f/1.8 lens. The lighting was provided by two Nikon SB800 Speedlights aimed into 42-inch umbrellas. The lights were set to ensure the lighting was as even as possible so the subject could be easily extracted. The exposure was ¹/₈₀ at f/7.1 and ISO 100.

duced by another. When you see a weather person on the news pointing out weather conditions on a map, the map isn't really there. The weather person is simply posed in front of a green screen and the map is added electronically. We photographers can do that too. Simply photograph your subject against a chroma key backdrop, import the image into digital editing software, extract the chroma key background, and replace it with another image.

Lighting is critical when shooting against a green or blue screen. Your lighting ratios will become flatter as you strive to make the light on the backdrop as even as possible so that there's not a wide variation in background tone. Keeping the lighting as even as possible might not make for a dramatic portrait, but it will make extracting the blue or green screen background a lot easier.

When to use blue or green? The general rule of thumb is to use the background that doesn't have a predominate color that your subject is wearing. There's just a little more to it than that, and I'll get back to the topic shortly.

One of the easiest ways to create composite images is Digital Anarchy's Primatte (www.digitalanarchy.com). Primatte is a chroma key and image compositing Photoshop-compatible plug-in that lets you create a transparent mask that can be placed over any background image. While you can use it to create photographs that look like they were made in a studio, I decided to

STEP 1—I started with two files: The foreground image was made in my kitchen. The lights were set to keep the chromakey blue Westcott background as even as possible so the subject could be easily extracted from it. I had previously photographed the full-size T-Rex image at the Utah Field House in Vernal, Utah.

STEP 2—I launched Primatte from Photoshop's Filter menu and used its masking tools to create a clear mask for my subject. *Tip:* When photographing a subject against a blue or green screen you need to keep a good distance between them and the background to avoid any color from it spilling onto the subject. Digital Anarchy provides several tools to remove color spill, and I used their Spill Sponge tool to remove some blue highlights from Mary's hair to create a near-perfect mask.

STEP 3 (LEFT)—When you click on the check mark button the mask is applied, revealing the background layer where the blue screen used to be. To make your background look more realistic, you can soften it first to give an appropriate depth-of-field look to the finished image. My favorite method is to use Photoshop's Blur or Blur More commands. The composite you see here was completed in less than five minutes. **RIGHT**—I liked the photograph because you could see more of the T-Rex's body and the setting. However, he didn't seem to be menacing Mary to produce her reactions, so I expanded and moved the background layer to get him into position so he looks like he's getting ready to bite her head off! Mary likes this version better too.

In the final King Kong touch, I used Nik Software's (www.niksoftware.com) Silver Efex Pro to convert the image into black & white. There's more about monochrome conversions and even a background trick in chapter 8.

have fun with a photograph of my wife doing her best imitation of Fay Wray (from *King Kong*) being chased by a T-Rex.

A digital backdrop is ideal when you can't make it to a site for a location shoot or the weather just won't cooperate. You can always shoot your own backgrounds, but if you don't have a big file of suitable photographs, you may appreciate the fact that companies such as Creative Sparx Studios (www.creativesparx.com), EZbackgrounds.com, and Photomorphix (www.photomorphix.com) offer a wide variety of digital backdrops at affordable prices in either download or disc formats.

Any discussion of virtual backgrounds would be incomplete without at least a shout-out to the man who invented the concept well before any digital cameras were available—Dr. Henry J. Oles (www.virtualbackgrounds.net). While originally designed for the studio pro, the company's Scene Machine family of products allows you to shoot "on location" while in the studio. Visit their web site, and you'll see what I mean.

ABOVE—This is one of the digital backgrounds that are available from Creative Sparx Studios. Like all their backgrounds, it's a 2400x300 TIFF file in RGB color mode that's compatible with Mac OS or Windows computers.

LEFT—Using Digital Anarchy's Primatte software, I applied the Creative Sparx Urban background to a portrait that appears earlier in this chapter. Middle: Want to change the look? Switching to a wooded background from Digital Sparx' Enchanted series produces a completely different mood. Bottom: For a studio look, why not use a digital backdrop that looks like a canvas or muslin background, such as this one from Digital Sparx' Studio series, Volume 1? These three images show the power of using digital backgrounds and green screen photography. From a single image made using an inexpensive background, you can make any photograph look like it was made anywhere, which is, after all, the theme of this book.

6. MEASURING LIGHT AND LIGHTING STYLES

"I am convinced that any photographic attempt to show the complete man is nonsense. We can only show, as best we can, what the outer man reveals. The inner man is seldom revealed to anyone, sometimes not even the man himself."—*Arnold Newman*

Ansel Adams said that the difference between a good picture and a bad one was "knowing where to stand." For studio photography, you can add that the difference is also knowing where to place the lights. Below are two photographs made in the same place—a friend's living room—with the subject in almost an identical pose. Any imaging tweaks I made after capture were identical for both photographs. While one image was shot slightly looser than the other and I used a slightly different camera angle for the second one, the biggest difference is where I placed the single light in both shots. This is what this chapter is all about: knowing where to place the lights.

DETERMINING EXPOSURE

Metering studio lighting is accomplished in the same way as natural light: by using a light meter. As mentioned in chapter 1, you're going to need a hand-

LEFT—In the first shot of Jamie-Lynn I used a Canon EOS 1D Mark II with an EF 85mm f/1.8 lens. The exposure was $^1/_{80}$ at f/7.1 at ISO 400. I used an EX 550EX Speedlite on camera. It was used with a Sto-Fen (www.stofen.com) Omni Bounce diffuser to produce a soft, flattering light. Fill was from a window at camera left. **RIGHT**—In the second shot I used the same camera and lens with a shutter speed of $^1/_{250}$ to minimize the effect of the available light. A Flashpoint (www.adorama.com) monolight with standard reflector was placed lower and slightly left of the camera to create a different mood. The model, after looking at the test shots, responded with a tougher "don't mess with me" look.

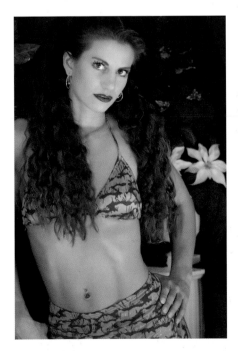 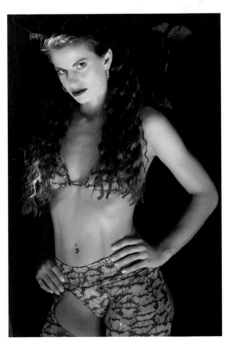

held light meter that reads flash output. Flash users are always going to need a meter that reads flash, but when shooting with continuous light sources you can get by with an in-camera meter. When pointed at a subject, reflected light meters, whether in-camera or handheld, are calibrated to give an accurate exposure with reflectivity somewhere around 18 percent gray; the exact value varies and the details are complex, with some meters measuring 12 percent (the most common) and others measuring 14 percent.

In most cases, the aperture that the flash meter provides will be close enough for your first test shots, but take the time to look at the image file's histogram (more later) and refine the exposure though repeated test shots until you have the exposure where you want it. Then you can concentrate on working with the subject to produce the kind of expression you want. *Note:* If you are not familiar with the histogram function of your digital SLR, take some time to read your camera's manual to determine how it works. Knowing how to interpret these readings will help improve all of your exposures—flash or not.

LIGHTING RATIOS

If you agree that light is one of the key elements that differentiate a good photograph from a snapshot, it's necessary to understand proper exposure. The ability to tweak exposure, even with today's sophisticated digital SLRs, can make or break your image's quality and content. I'm always surprised at the number of people who don't care about correct exposure and use the worn-out phrase, "I'll fix it in Photoshop." Photoshop has become a crutch for photographers who sloppily capture images. A digital image that is too over- or underexposed cannot be completely saved with image-manipulation software. Please re-read the last sentence. You should make minor adjustments to the exposure settings while shooting, including using the different metering patterns available in the camera, but you may still need to pull out the handheld meter from time to time.

There are two basic types of light meters: incident or reflected. Incident meters measure the amount of light falling on the subject. Reflected-light meters measure the light that's reflected by the scene to be photographed. All in-camera meters are reflected-light meters, but most handheld light meters can be used for measuring incident or reflected light, including flash.

By using a light meter, you can calculate the lighting ratio that your setup creates on your subject. The term "lighting ratio" is used to describe the difference in the brightness of light falling on your subject from the main light and the fill light. Of course, you can also use tertiary lights that serve other purposes, such as adding highlights to the subject's hair or illuminating the background. A lighting ratio of 3:1 is considered "normal" for color photography, but photographers can be flexible when applying this rule. There are pros and cons to using any kind of formulas in photography, especially light-

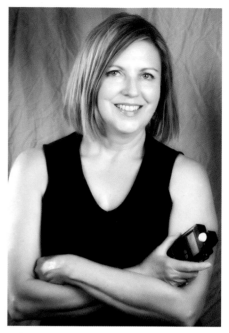

Before the model or subject arrives, I make test shots to determine the proper exposure. Most times I use an assistant, in this case my wife Mary; when working in my friend Jack Dean's studio, we use his mannequin, Anna.

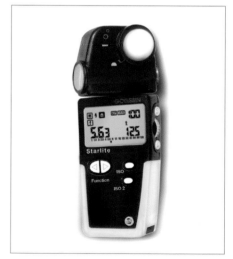

Gossen's Starlite exposure meter is a versatile, high-performance instrument that's ideally suited for all types of measuring tasks—flash, ambient, cine—where maximum precision is required. With its extremely compact format, it unites three completely pre-configured ranges of functions, that the user can switch back and forth between quickly and easily. Photo courtesy of Manfrotto Distribution (www.manfrottodistribution.com).

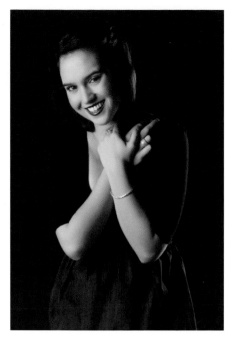

I shot this black-on-black low-key image using two White Lightning (www.white lightning.com) X1600 monolights. The main light at camera left was mounted with a Paul C. Buff foldable medium softbox, while the monolight on camera right and behind the model had a foldable stripbox mounted. The camera was a Canon EOS 7D with an EF-S 18–135mm f/3.5–5.6 IS lens. The manual mode exposure was $^1/_{80}$ at f/7.1 and ISO 125.

The histogram for this image indicates a slightly underexposed shot. However, any additional exposure would have blown out the highlights on the side of her facing the main light, which is why some interpretation of the data is required when shooting high or low key images.

ing, but 3:1 can serve as a baseline to ensure that your images don't look like the "let's throw every light at it" approach often used in television.

In the following paragraphs, we'll take a look at two approaches to setting up lighting ratios that you can try. You can also combine elements of the two to come up with an approach you like.

Ratios Dominate. Start by setting the lights to achieve the look you want. There are many lighting styles that you can use, and they will be examined later in this chapter. Then, turn off all of the lights. Turn the main light back on, meter it, and turn it off. Next, turn on the fill light and measure its output. In this approach, the lights are moved or their power output settings are varied until the desired ratio is achieved. Then all the lights are turned on and the overall lighting exposure is measured. This system works with either flash or continuous lights. The resulting meter reading provides the starting point for a test exposure. Shoot a few exposures, making sure each of the flash units are fully recycled before shooting another one. Examine the image on the LCD screen but also look at the histogram because sometimes the background can fool your eyes. This is especially true when evaluating high or low key images. Adjust exposure based on the histogram and shoot another test.

Lighting Dominates. The basic philosophy here is that you set the lights and worry about ratios later. I choose the lights based on what the model is wearing, what kind of poses I'll be shooting, and how much shooting space is available. In general I prefer—and you may think differently—to work with the broadest, softest lights possible. My method depends on the lights having proportional modeling lights, so changes in lighting are reflected in their output too. That's why this method works for continuous lighting sources as well. I use the light's variable output settings to produce a ratio that looks good to my eyes. (This is why I also like electronic flash units that have continuously variable output. If you skipped ahead, check out chapter 1.) I use my flash meter to determine an exposure and then make a test shot and evaluate the image's histogram. If I need more light, I increase the camera's ISO slightly so I can keep the depth of field exactly as it was in the test shot. *Tip:* With many of today's digital SLRs there is little difference in digital noise whether the ISO is set at 100 or 400. If you're concerned about noise, you can always capture the images in your camera's RAW format to reduce any JPEG artifacts that are often mistaken for noise.

No flash meter? Many pros start by picking a shutter speed (more on that choice in a bit) then choose an aperture based on experience. Since most portrait photographers like to work with mid-range apertures, they choose something in the f/5.6 to f/8 range and make a test exposure. At that point, the process is not so different than some of the methods I just mentioned. The test exposure is evaluated and they might need to fine tune the aperture through additional test shots, including evaluating the histogram to zero in on what's considered the final exposure setting. If you are using continuous

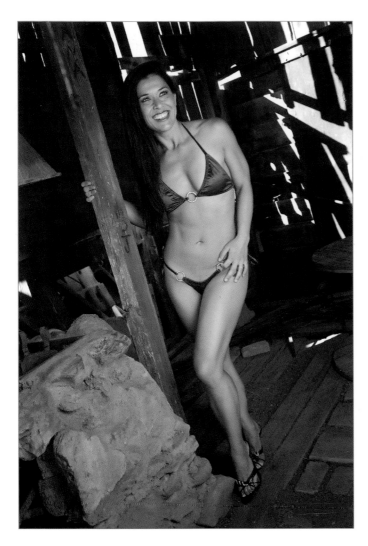

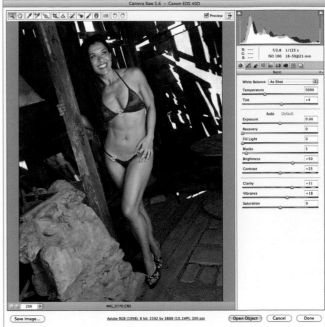

ABOVE—Jerry Bolyard captured Tomiko as a RAW file. Here is what the file looked like before processing in Adobe's Camera RAW software. © 2010 Jerry Bolyard. LEFT—Tomiko wearing a swimsuit on a western movie set's blacksmith shop was captured using a Canon EOS 40D and EF 18–50mm lens. Lighting was provided by an Alien Bees B800 (www.alienbees.com) monolight with 32-inch octagonal softbox above and to the right of camera. Exposure was $^1/_{125}$ at f/2.8 and ISO 100 and Jerry Bolyard measured both flash and ambient light using a Sekonic (www.sekonic.com) Flashmate light meter. © 2010 Jerry Bolyard.

lighting, bracketing is always a good idea. (Bracketing is a time honored photo technique where multiple images of the same subject are made at different exposure levels. The idea is that one of them will be the best but some may still be acceptable.)

The key part of determining any flash exposure is the lens's aperture, but shutter speed plays an important role too. The duration of electronic flash units is quite short—$^1/_{1000}$ second or less is not uncommon. The exposure is made while the shutter is open, but the actual shutter speed will be slower because there is a maximum synchronization speed that varies with each camera. What happens when you shoot at a shutter speed higher than your flash will sync? You only get part of a picture! What's missing depends on which way the shutter travels and how much you get—if anything—is determined by the shutter speed selected. Nowadays, many cameras even have a high-speed sync mode that works with specific speedlights. Check your user's manual to see if your camera offers this feature.

On the other hand, slower shutter speeds allow more of the ambient light to influence the overall exposure, mostly the background because the aper-

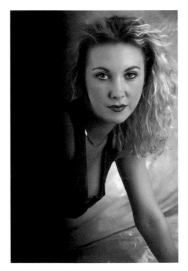

What happens when you shoot at a shutter speed that exceeds your camera's maximum sync speed? Here's an example: You get part of a picture!

Ashley Rae was photographed using a Sunpak DigiLite 600 (with blue gel) to camera left as the only light source. The shot was captured using a Canon EOS 20D and EF 85mm f/1.8 lens. Exposure was $^1/_{125}$ at f/2.8 and ISO 400 as part of a bracketed exposure.

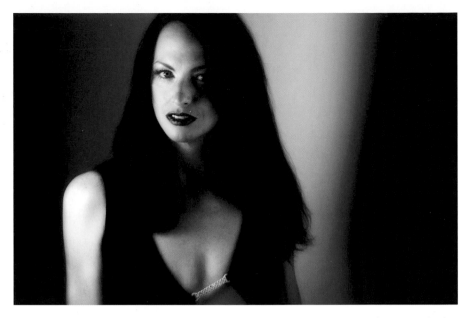

ture you select determines the main subject's exposure. Using a slow shutter speed can "open up" the background, allowing more ambient light to affect the exposure and show more separation between the subject and backdrop. But beware the color temperature of any artificial lights that are part of that ambient light. Depending on how bright they are, using slower shutter speeds can add colors that can pollute the skin tones in your shot. The solution: Increase shutter speed. On the other hand, warmer light sources can add a pleasant warmth to the photographs. Your camera's LCD preview screen should be your new best friend.

LIGHTING STYLES

Let's start at the beginning by showing some of the various lighting techniques that are available and how to use them with your studio lights. While all of the lights used in the examples were electronic flash units, the techniques themselves work with speedlights, flash, or hot lights.

Broad Lighting. This type of lighting is produced when the main light is so close to the camera axis that it illuminates the side of the subject's face that is turned toward the camera. Broad lighting can de-emphasize facial features and is used mostly to make narrow faces appear wider. I sometimes call this the "flat and boring" style of lighting, but many times it can be flattering to the subject, especially when you only have one light available.

Short Lighting. Short lighting is achieved when the main light illuminates the side of the face that is turned away from the camera. This technique is good for subjects who have a more rounded face, as it emphasizes facial contours more than broad lighting does. When you move the light farther from the subject, it will produce the Rembrandt lighting effect, which is characterized by a triangle of light on the cheek of the subject that is turned closest to the camera. There's no Rembrandt effect shown in the photograph

Broad lighting can de-emphasize facial features and is used mostly to make narrow faces appear wider.

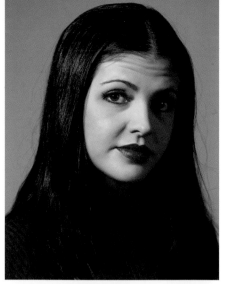
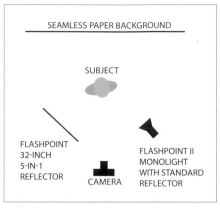
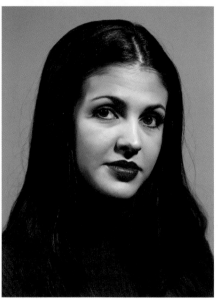
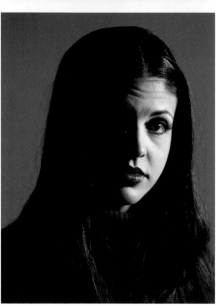

SEAMLESS PAPER BACKGROUND

SUBJECT

FLASHPOINT
32-INCH
5-IN-1
REFLECTOR

CAMERA

FLASHPOINT II
MONOLIGHT
WITH STANDARD
REFLECTOR

TOP LEFT—Here a Flashpoint II mono-light is placed to the right of the subject. To create broad lighting, you don't have to place the light on a specific side of the subject; it is about the way that the subject is placed in relation to the light. Here, the monolight was placed on the right. Fill was provided by the silver surface of a Flashpoint 32-inch 5-in-1 collapsible disc reflector. The image was made in my basement studio against seamless paper. The camera was a Canon EOS 5D with an EF 135 f/2.8 lens. The exposure was $1/15$ at f/7.1 and ISO 100. **BOTTOM LEFT**—A Flashpoint II monolight was placed close to the camera and was raised until the "butterfly" shadow appeared under the subject's nose. The setup and exposure were identical to that described for the previous photograph. **BOTTOM RIGHT**—A Flashpoint II 620 monolight was placed directly to the right of the subject. No fill light was used in order to maximize the split lighting effect. Lighting using the standard metal reflector can sometimes appear hard (although there are times when you want that look). The image was shot in my basement studio against seamless paper. The camera was a Canon EOS 5D with an EF 135 f/2.8 lens. The exposure was $1/50$ at f/8 and ISO 100.

above, as my tiny basement space did not permit moving the light farther away from the subject.

Butterfly Lighting. This lighting style gets its name from the shape of the shadow that forms under and in line with the nose when the light is positioned directly in front of the subject and its height is adjusted until the shadow appears. This lighting style is sometimes called Paramount lighting (as in the movie studio), and it is a glamour style that is best suited for women.

Here is where the monolight's modeling light really comes in handy. Most monolights feature proportional modeling, which allows you to vary the power of the modeling light to match the output set for the flash. Some monolights will also dim the modeling light after the flash is fired and bring it up after the flash has recycled to let you know you can make another shot.

Split Lighting. This technique lights half (either side) of the subject's face, while leaving the other half in shadow. This lighting approach creates a dramatic, film noir style of lighting (sometimes called "hatchet lighting") that may be not be appropriate for all portrait subjects. I softened the light

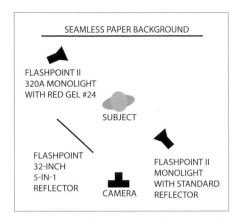

SEAMLESS PAPER BACKGROUND

FLASHPOINT II
320A MONOLIGHT
WITH RED GEL #24

SUBJECT

FLASHPOINT
32-INCH
5-IN-1
REFLECTOR

CAMERA

FLASHPOINT II
MONOLIGHT
WITH STANDARD
REFLECTOR

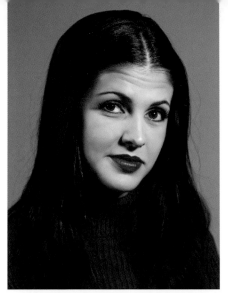

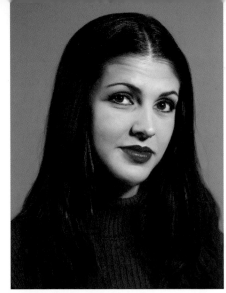

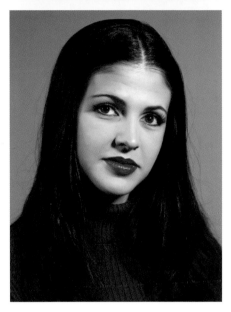

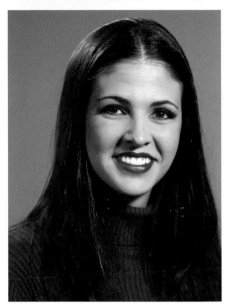

TOP LEFT—This photograph was made with a Flashpoint II monolight with a Flashpoint 5-in-1 reflector used as fill. A second Flashpoint II 320 was aimed at the seamless paper background. Since the monolight has variable power output, the best way is to start with the light at a middle power setting and slightly raise or lower it to achieve a look that you find the most attractive. The image was shot in my basement using a Canon EOS 5D with an EF 135 f/2.8 lens. The exposure was $^1/_{15}$ at f/7.1 and ISO 100. **TOP RIGHT**—Here, a Flashpoint II 320 was placed low and behind the subject. A red Rosco (www.rosco.com) 24 gel filter was clipped to the reflector of the background light to illuminate the background and change its color. The setup and exposure used were identical to those used in the previous photograph (see diagram). **BOTTOM LEFT**—The "before" portrait shows a simple one-light setup with main light provided by a Flashpoint II 2420 monolight and a Flashpoint 5-in-1 reflector used as fill. The setup and exposure were identical to the last photograph. **BOTTOM RIGHT**—In the "after" shot, a Flashpoint II 620 monolight was placed high and behind the subject to skim her hair. Since light aimed at the camera can produce flare, it's always a good idea to use a lens hood on your camera. The setup and exposure were identical to those used in the previous photograph.

in the setup used below and for all the previous setups by using Adorama Strobo-Socks, a nylon fabric diffuser designed for portable strobes that, with a lot of stretching, fits over the Flashpoint II's metal reflector.

Background Lighting. A background light is any light purposefully added to the setup to illuminate the photographic background (paper, canvas, or muslin) for a portrait lighting setup. *(Note:* The main light may partly illuminate the backdrop by spilling past the subject, but this is not a background light.) The job of the background light is to provide separation between the subject and the background. It is placed last and is usually directly behind the subject and pointed at the background. There is no magic formula for which flash setting to use since the amount of power needed to achieve the desired amount of light will vary based on the background's color. Do you always need a background light? The answer is simple: it depends on the backdrop and the effect you want to achieve.

Hair Lighting. According to noted portrait photographer Steve Sint (www.stevesint.com), "One of the best ways to add sparkle to your portraits

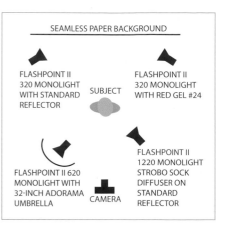

SEAMLESS PAPER BACKGROUND

FLASHPOINT II
320 MONOLIGHT
WITH STANDARD
REFLECTOR

SUBJECT

FLASHPOINT II
320 MONOLIGHT
WITH RED GEL #24

FLASHPOINT II 620
MONOLIGHT WITH
32-INCH ADORAMA
UMBRELLA

CAMERA

FLASHPOINT II
1220 MONOLIGHT
STROBO SOCK
DIFFUSER ON
STANDARD
REFLECTOR

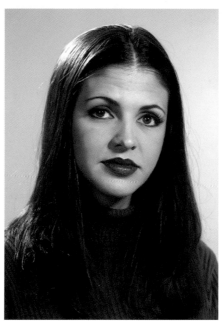

TOP LEFT (ONE LIGHT)—A Flashpoint II monolight was placed on camera right. The light's metal reflector was covered with an Adorama Strobo-Socks fabric diffuser. No fill was used. **TOP RIGHT (TWO LIGHTS)**—A Flashpoint II 1220A monolight was placed on camera right. The light's metal reflector was covered with a Strobo-Socks fabric diffuser. On camera left, a Flashpoint II 620A was placed near the camera with a 33-inch Adorama white interior umbrella. **BOTTOM LEFT (THREE LIGHTS)**—A Flashpoint II 1220A was placed on camera right. Its metal reflector was covered with a Strobo-Socks fabric diffuser. On camera left, a Flashpoint II 620A was placed near the camera with a 33-inch Adorama white interior umbrella. A Flashpoint 320A was placed to the rear and aimed at the back of the subject's head as a hair light. **BOTTOM RIGHT (FOUR LIGHTS)**—A Flashpoint II 1220A was placed on camera right and its metal reflector was covered with a Strobo-Socks fabric diffuser. On camera left, a Flashpoint II 620A was placed near the camera with a 33-inch Adorama white interior umbrella mounted. A Flashpoint 320A was placed to the rear and aimed at the back of the subject's head to serve as a hair light. Another Flashpoint II 320A was placed near the floor and aimed at the background. A red Rosco 24 gel was clipped to the reflector of the background light to illuminate the background and change its color. Do you need a background light? Does it help? The importance of the background light depends on the background used, so only you can decide.

is by using a hair light." A hair light is simply a small light that is placed over and sometimes behind a subject to add highlights (that may or may not add any detail) to a subject's hair. To make the hair light even more focused, you can use a snoot to direct light to a specific area. *Warning:* Modeling lights heat up inside the confined space inside a snoot and can make them hot, so you might want to turn off the modeling light once you've got it aimed where you want it.

PUTTING IT ALL TOGETHER

How many lights do you really need for a portrait? For some photographers, it is the fewest number of lights possible so they don't have to carry so many.

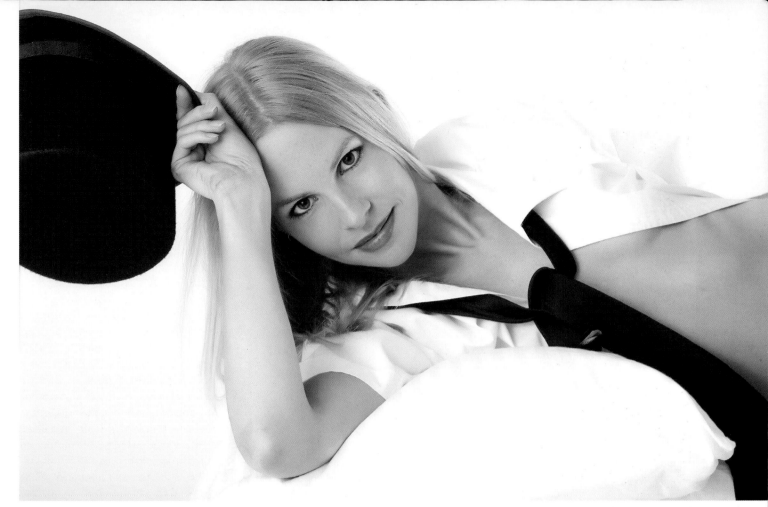

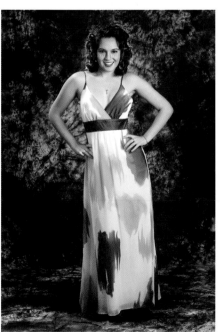

ABOVE—Kent Hepburn photographed Brenna using three 150 watt-second Photogenic (www.photogenicpro.com) monolights: One light with a 42x78-inch white scrim, was placed in front of her; one light with a 24x24-inch lightbank mounted was to her left; and one strobe was aimed at the background to push it to maximum high key. Strobes were tripped using a Calumet (www.calumetphoto.com) radio trigger. The camera was an EOS 40D with an EF 28-135mm lens. The exposure was $^1/_{200}$ at f/9 and ISO 100. © 2011 Kent Hepburn. **LEFT**—Lighting for this photo of Victoria was made using a four-head setup connected to Dynalite SP2000 power pack. At camera right, the main light used a Chimera large lightbank, fill was provided by a Chimera striplight placed at camera left, a hair light on a boom had a small Chimera lightbank mounted, and instead of a background light, the fourth head was aimed at the subject's back to backlight her hair. The exposure was $^1/_{80}$ at f/8 and ISO 100.

For others, it's "available light," meaning they want to use every possible light that's available! For most photographers, anything from two to three lights will produce a lighting setup and results that they—and the subject—will like, but the reality is you can use as many different lights as you can afford.

7. WORKING IN YOUR STUDIO SPACE

"I never made a person look bad. They do that themselves. The portrait is your mirror. It's you."—*August Sander*

There are lots of things you'll need to consider when working in your temporary studio space, beginning with tailoring the possibilities to the space that's available. Next, you have to determine the exposure for your finished studio lighting setup, which was covered in the previous chapter. That available space will determine the kind of lenses and focal lengths you'll be able to use, but what about your subject? You'll need to work with them in the space you've set aside and place them in natural and realistic poses to get the best-possible photographs. Posing is highly subjective, but I'll share a few tips that I've learned over the years.

YOUR CHOICE OF LENSES

I like to use long lenses because they produce a more natural look than wider-angle lenses, which can easily produce distortion when you get too close to

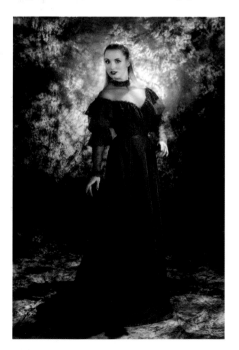 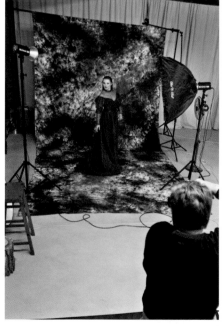

LEFT—I call this my Harry Potter shot. Four lights were used: A White Lightning X1600 monolight (www.white-lightning.com) with Paul C. Buff foldable medium softbox attached was placed at camera right. Another X1600 with a grid was at camera left. Two Nikon SB800 Speedlights were also used: one was placed on a boom as a hair light, and the other served as a background light. The image was made with a Pentax K-x with an SMC DA L 18–55mm f/3.5–5.6 lens. The manual mode exposure was $^1/_{100}$ at f/5.6 and ISO 200. **RIGHT**—Here I am making that photograph. The first thing you will see is the placement of the lights. I hope that you'll also notice where I am standing. For this particular shot, I used a Pentax K-x with an SMC DA L 18–55mm f/3.5–5.6 lens. For a full-length shot, I was using the longest (55mm) end of that particular lens' focal that, because of the camera's 1.5x multiplication factor, produces an effective 82.5mm. Why? I'll explain that in the next section. © 2010 Jack Dean.

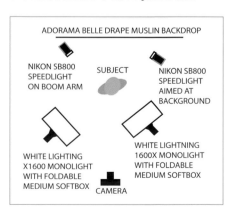

ADORAMA BELLE DRAPE MUSLIN BACKDROP

NIKON SB800 SPEEDLIGHT ON BOOM ARM SUBJECT NIKON SB800 SPEEDLIGHT AIMED AT BACKGROUND

WHITE LIGHTING X1600 MONOLIGHT WITH FOLDABLE MEDIUM SOFTBOX CAMERA WHITE LIGHTING 1600X MONOLIGHT WITH FOLDABLE MEDIUM SOFTBOX

the subject. Arnold Newman and I had the same mentor early in our photographic careers (unfortunately, we never met). One of his best-known color images is an eerie portrait that shows Alfried Krupp shot with a wide angle lens and split lighting. Some people call this Frankenstein lighting (see chapter 6) because he is lit from below. Take the time to Google Newman and Krupp and you'll see why I don't like to use wide-angle lenses for portraits. If you think you have to use a wide-angle lens due to limited space, just take a look at Jerry Bolyard's work that appears throughout the book. He shoots in a tiny space using a wide-angle zoom but at the longest end of the focal length range.

It's time to consider the lenses you need for your studio photography, and the good news is that you'll probably find yourself needing just a couple most of the time—a medium telephoto lens in the 135–180mm range and a shorter lens, either 50 or 85mm. The shorter lenses can be prime focal length lenses, like Canon's EF 135mm f/2.8 SF lens, which I like because its provides a nice perspective and is not expensive, especially if purchased used. My favorite lens is still the EF 85mm f/1.8, but I sometimes use a zoom lens because I don't have enough space to work. I am currently using

Jerry Bolyard photographed Kayla in his dining room using one Alien Bees B400 monolight with a 24x24 softbox mounted and placed at camera right and one Alien Bees (www.alienbees.com) B400 monolight with a 7-inch cone reflector mounted and aimed at the background. The camera was a Canon EOS 40D with an 18-50mm lens at the longest end of the focal length range. © 2010 Jerry Bolyard.

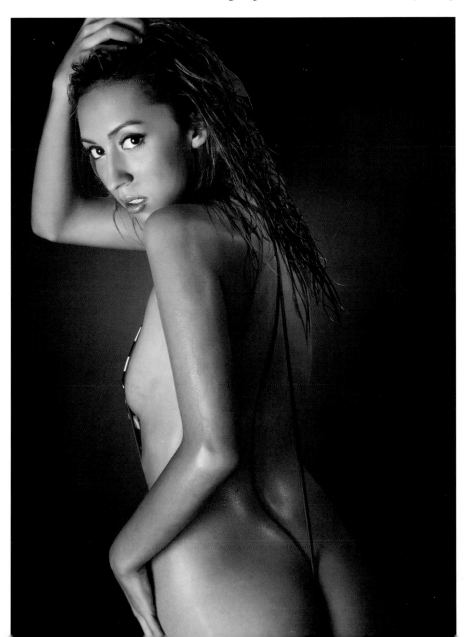

an EF 28–135mm IS lens, but for a long time I used the inexpensive and quite sharp EF 28–105mm f/3.5–4.5. When using zoom lenses, there are a few trade-offs—most notably slower maximum apertures. While fixed focal length telephotos often have a maximum aperture of f/2.8 or even faster, others—like Nikon's AF-S DX Nikkor 18–200mm f/3.5–5.6G, which I recently tested—are somewhat slower.

While my favorite lens for portraiture these days may be the Canon EF 85mm f/1.8, I have fond memories of shooting with the 105mm f/2.5 Nikkor lens when I was using Nikon film cameras. That lens is available for digital today as the AF DC Nikkor 105mm f/2D. The closest Canon has to it is a EF 100mm f/2 USM, but I prefer to use the new EF 100mm f/2.8L Macro IS because it is image stabilized and a macro lens. While designed for close-up photography, I often used my old Canon EF 100mm f/2.8 USM macro lens for portraiture. *Tip:* If you use a macro lens, make sure that your subject

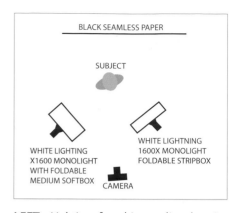

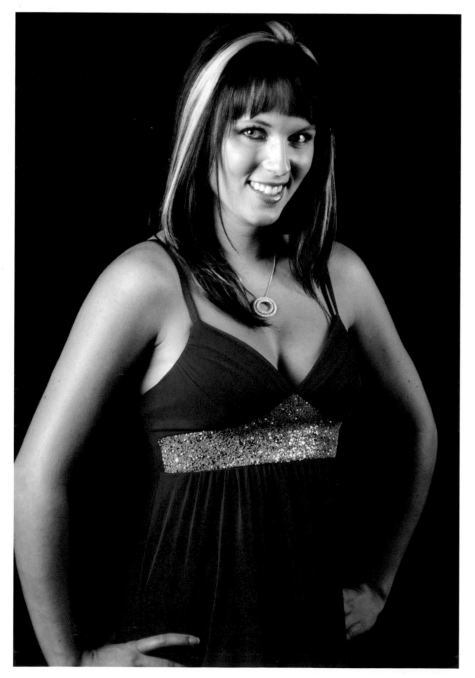

LEFT—Lighting for this studio shot included two White Lightning X1600 monolights. The main light, at camera left, was housed in a Paul C. Buff foldable medium softbox. The light on camera right had a foldable stripbox attached. The exposure was 1/80 at f/5 and ISO 200. A Nikon D300s with a Nikkor 18–200mm f/3.5–5.6G was shot at the 142mm focal length. **TOP RIGHT**—The Alien Bees B1600 monolight produces 640 watt-seconds and 1600 effective watt-seconds of power, with 28,000 lumenseconds of output that is independently adjustable over a stepless 5-stop range from full down to 1/32 power. Photo courtesy of Paul C. Buff, Inc. **BOTTOM RIGHT**—This is the Nikkor 18–200mm f/3.5–5.6G lens that I used. It features three aspherical lens elements that virtually eliminate coma and other aberrations even at wide apertures. Also, Nikon's VR II (Vibration Reduction) image stabilization enables handheld shooting at up to four shutter speeds slower than would otherwise be possible. Photo courtesy of Nikon Inc. USA.

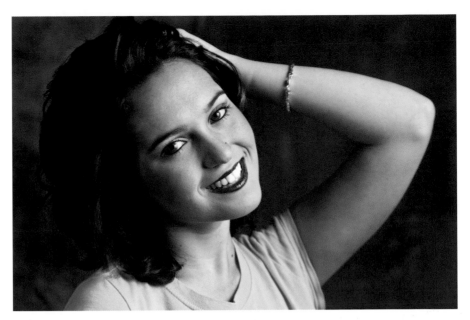

LEFT—As I write this, the EF 100mm f/2.8L IS USM macro lens is Canon's newest "L" series lens and its first mid-telephoto macro lens to include Hybrid Image Stabilization that works in 1:1 macro mode and compensates for both angular and shift camera shake during close-up shooting. Image courtesy of Canon USA. RIGHT—As can be seen in this headshot, Victoria is a young model who has beautiful skin and could easily handle the EF 100mm f/2.8L IS USM macro lens's unflinching optics. This lens renders every tiny freckle on her face in perfect sharpness. The manual mode exposure using studio lights was $^1/_{100}$ at f/5.6 and ISO 400.

can handle the extreme sharpness that will show every possible pore and skin defect or just shoot and plan to spend some time running the soft focus and diffusion tools that are available in the digital darkroom.

If you're a newbie, you'll find that you can use longer focal lengths for headshots or close-ups of your model and they are also useful when you want to separate your model from the background by using a shallower depth of field. For indoor photographs where space is limited and you may have to work closer to the subject, you'll need to use shorter focal lenses, especially to capture full-length poses, but I still tend to shoot at the longer end of the zoom lens range to minimize the possibility of even a hint of distortion.

Don't forget that many of these lenses are available used. KEH (www.keh.com) sells a grade of used equipment they call "bargain" at prices that are quite low. Equipment with this rating might not look great but will function properly and have good optics. Buying such bargains allows you to have access to higher-quality lenses than your budget might otherwise permit.

HOW TO POSE YOUR SUBJECTS

I would like to repeat a story that I told in my previous book for Amherst Media because I think it is relevant. When I was learning the professional photography business, I asked my mentor, "What's the worst mistake I could make when photographing a wedding?" His answer surprised me. "The worst thing you can do," he told me, "is not talk to the people." I'll pass his words of wisdom along to you so you'll know that when it comes to photographing people, it's not just about the equipment, it is mostly about your interaction with your subjects. Often, I see photographers working with models and expecting the models to do all the work. Though it may be okay to assume that experienced models can be self-directed, the occasions when you will be photographing professional models will likely be few and far between.

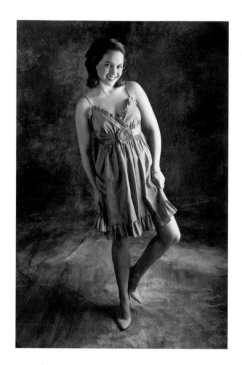

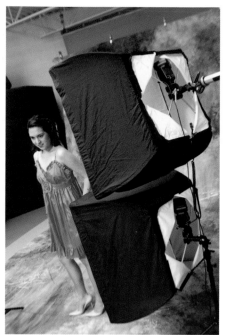

LEFT—Victoria is a high-energy model. All you have to do is tell her where to stand and take photos. Models like her will toss poses and expressions at you faster than you can click the shutter. The camera was a Nikon D700 with a 24–70mm f/2.8 lens. The exposure was $^1/_{125}$ at f/6.3 and ISO 200. © 2011 Paul Peregrine. **RIGHT**—For this shot of Victoria, Paul Peregrine used two stacked Grin&Stir's (www.lightware-direct.com) 30-inch FourSquare light-banks each with a single Nikon Speed-light mounted inside one. A reflector was placed at camera left. Backdrop was a "Joe Farace" carbonite muslin background that's available from Silverlake Photo (www.silverlakephoto.com).

I believe there are two types of photo subjects: those who are inner-directed and those who are outer-directed.

Inner-directed people are the Energizer bunnies of photo subjects. You tell them, "Stand over there," point the camera at them, and they will change poses as fast as you can click the shutter. You will get lots of good poses, some great ones, and a few that are not so good because the model is not getting any feedback, except from themselves. The downside is that you will shoot a lot of photos, which will require a lot of editing time (see chapter 8) and bigger memory cards. These experienced models can make you look like a better photographer than you are, but it's still your job to get the lighting right. Unfortunately, this type of subject comprises only 20 percent of the models or subjects that the average shooter photographs.

Outer-directed subjects represent the other 80 percent of photo subjects or models. These people expect you to tell them what to do. Shooting this type of subject takes longer, but taking the time to communicate what you want the subject to do will help get great results. The best subjects will respond better if you show them what the photograph looks like on the camera's LCD screen—big screens really help with this. The bottom line is that it's up to you to tell them how to pose and in order to do that, you need to know what you want.

There is as much conflicting advice on posing portrait subjects—and typically the person giving the advice claims his is the best way. One useful source of ideas is Amherst Media's series of posing guides, including *Master Posing Guide for Portrait Photographers* (J.D. Wacker, 2002). Remember that these are just guides. You should select poses that you think you'll like, try them, and improve on them if you can. Your model will have her own ideas too.

> Experienced models can make you look like a better photographer than you are.

Keep in mind that there is no one perfect way to pose every subject. They come in all sizes, weights, and abilities to understand your directions. Keep the pose simple, and if the subject is comfortable and the pose looks good, it's a good one.

I can't tell you the best way to pose people, so I'll just tell you how I do it. In a studio—no matter where it is—posing against a backdrop is difficult because often there are no objects that the subject can interact with. The biggest mistake many photographers make is assuming that once a model is placed in a pose, all they need is one shot. Wrong! That's just the beginning! Follow up by refining the pose with a slight head tilt to the left or right, have her move her chin up and down. Have her look at the camera then not look at the camera. Don't just click the shutter. Watch what happens and follow up on a good pose with slight variations that can turn it into a great one. The

TOP LEFT—Kent Hepburn photographed Maria Eriksson using three lights: One Photogenic 150 watt-second monolight was used with a 42x78-inch white scrim to the model's right, another light with 24x24-inch lightbank was placed to her front left, while the third monolight was aimed at the white background to push it to high key. A Calumet radio trigger was used to trip the lights. Camera was Canon EOS 40D with EF 28–135mm lens and an exposure of $^1/_{200}$ at f/8 and ISO 200. © 2011 Kent Hepburn. **BOTTOM LEFT**—Nicole isn't wearing much, but I asked her to "rip off" her clothes, and this is the pose and great smile she gave me. The photograph was made in my basement studio using two Flashpoint II (www.adorama.com) monolights. The camera was a Canon EOS 40D with a 50mm f/1.8 lens that I bought on eBay for $50. Exposure was $^1/_{60}$ at f/10 and ISO 100. The background was a Belle Drape muslin. **BOTTOM RIGHT**—Dave Hall originally captured this unique pose (you'll need a limber model) in color in his living room. A monolight with a lightbank mounted was positioned at camera left. A second monolight with an umbrella for fill was placed at camera right. The image was shot with a Canon EOS 50D and an exposure of $^1/_{80}$ at f/7.1 and ISO 160. © 2011 Dave Hall, Hall Photographic.

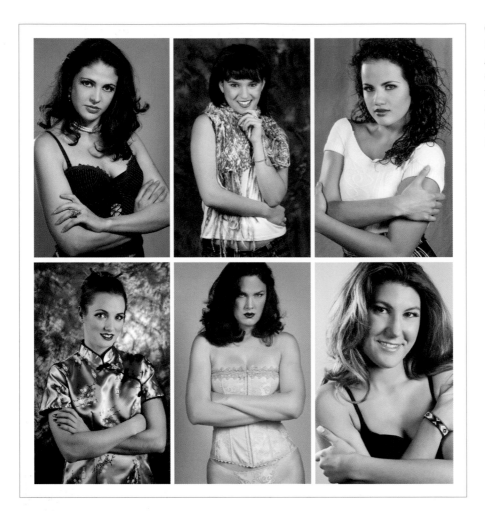

Once a subject or a model is comfortable, I like to ask her to cross or fold her arms. As you can see by these six examples, each woman has interpreted this direction in her own way! With subjects who are outer-directed, establishing this basic position gives you a starting point for improving that pose.

most important advice I can give you—and you can take this to the bank—is to keep talking to the subject so the portrait becomes a collaboration between you and the subject.

The biggest problem when working with new models or portrait subjects is deciding what to do with their hands. That's when props, like the chains Jerry Bolyard used for his "blue" photograph in chapter 1, come in handy. One of my other favorite hand poses is to have them tugging at their clothing in some way. I ask them to look like they are ripping their clothing off, and this often elicits poses that I can refine.

No subject is perfect, and you can fix some flaws by posing. For example, heavier subjects should never be posed with their shoulders square to the camera. I believe that the purpose of any portrait is to idealize or glamorize the subject. If she has a few extra pounds, why not minimize them by having her stand at three-quarters to the camera rather than straight on? It's also a good idea to ask her to shift her weight to the foot that's farthest from the camera to avoid the flat-footed pose that makes her look like she is just standing there—even if she is just standing there! Conversely, you can pose thinner subjects so they are square to the camera to give their body more weight and depth.

The biggest problem when working with new models or portrait subjects is deciding what to do with their hands.

Faces are not symmetrical, and we all really do have a "good" and "bad" side that will photograph better or worse than the other. Experienced models know this and will only give you what they think is their good side, but they are often wrong. So shoot a few test shots and determine which side of the subject's face looks best to you. This pose may be lighting dependent, so what looks good under directional lighting may look completely different under soft or flat lighting. The important thing to remember is that even drop-dead-gorgeous models have a good side and a bad side. Learn early in the session which one works best for you.

Just as it's important to minimize any flaws your model might have, it's important to look for her strong points and accent those features. Are her eyes beautiful? Then you should shoot headshots and close-ups. Does a female subject have long, shapely legs? Shoot several images from a low angle and don't be afraid to use slightly wide-angle lenses to accent them. Watch your camera angles too. Don't get too low. Nobody likes looking up somebody's nostrils—no matter how beautiful they may be.

One of my favorite posing instructions is to ask the model to twist and bend at the waist. They interpret this in many ways, including this pose. In this shot, the main light at camera right had a Westcott Halo mounted on it. The fill light at camera left had a 32-inch Westcott satin optical white umbrella attached. The third light was placed behind and to camera left. The camera was a Canon EOS 5D with an EF 135mm f/2.8 SF lens. The exposure was $^1/_{50}$ at f/9 and ISO 100.

8. DIGITAL WORKFLOW

"I think photographs should be provocative and not tell you what you already know. It takes no great powers or magic to reproduce somebody's face in a photograph. The magic is in seeing people in new ways."—*Duane Michals*

One of the few problems with digital image capture is that you tend to shoot more photographs than you might if you had to pay for film and processing. I hate to be the one to break it to you—there is no free digital lunch. You really do have to pay for all these extra images stored on memory cards and hard disks. In addition, if you're going to make lots of pictures, you're going to need a standard way to manage the process.

GETTING ORGANIZED

Organization starts before you begin the session. If you are shooting an assignment with specific categories of shots, you may want to organize your images right in the camera on your memory card. Every digital camera has its own methodology for creating folders and assigning image file numbers, so take a few minutes to read the user's manual; it could save time later. If you can assign a group of image files from a particular sequence or event to a specific folder while you shoot them, you won't have to do it later in the workflow process.

You may want to consider how you set your file numbering system too. Most digital SLRs give you the option of resetting to zero each time you insert a memory card, while others permit sequential numbering. Even if you're shooting on low-capacity memory cards, using sequential file numbering will keep you from creating identical file names. It will also allow you to keep track of how many images you've captured with the camera. Those shutters won't last forever, pardner, so think of it as an image odometer.

It's a good idea to get rid of the "dogs" right away. During a break in shooting, take some time to chimp your photographs on your camera's LCD screen, erasing those that don't make the grade. Toss away the horribly under- or overexposed shots or ones with expressions so bad the subject says, "Get rid of that one!" when they see the shot. Take their advice and just do it. Don't be too hard on yourself (unless you don't own many memory

During a two-hour session with Nicole, I shot 148 images and she made three clothing changes. This image was made in my basement studio using a Canon EOS 40D and 50mm f/1.8 lens with an exposure of 1/60 at f/10 and ISO 100. There were two Flashpoint monolights used: one at camera right with a Westcott Halo mounted and the other at camera left with a 32-inch Westcott umbrella attached.

"Chimping," if you're not familiar with the term, is the behavior that many digital camera owners exhibit when looking at pictures on LCD screens. The action gets its name because the typical response to seeing your own images on the LCD screen is "ooh, ooh."

Inexpensive internal USB 2.0 cards for Mac OS and Windows computers are available from companies such as Belkin (www.belkin.com) and are easy to install even for the least technically inclined photographer. Image courtesy of Belkin International.

cards). You can keep marginal images for later critical evaluation or to create composites, which is something I often do.

When you get back to the office or home, it's time to copy the image on the memory card to your computer's hard drive. Unless you're using a USB 2.0 or FireWire device, transferring images via a typical card reader can be slow. USB 2.0 readers are inexpensive and fast, but make sure that your computer has a USB 2.0 connection, not just one that's "USB compatible." That means the port is really USB 1.1 and is ten times slower than 2.0. If you can inexpensively add USB 2.0 ports to your computer, just do it. You've got better things to do than wait for files to be moved form one place to another. *Note:* As I write this, USB 3.0 is on the horizon with a projected higher transfer rates up to 4.8 Gbps or ten times that of USB 2.0. If USB 3.0 is widely available by the time you read this, that method will be the way to go for moving files from card to computer.

At this point of the process, I've stored all of my files in a single unorganized folder on a hard drive. However, because I'm paranoid about losing image files, I prefer to keep photographs stored in many places to provide back up. I also use Apple's Time Machine to back up everything onto an external 2TB hard drive. That's why my next step is to burn a CD or DVD of all files from the shoot. In longer sessions when I am shooting RAW+JPEG files, I use an external Blu-ray recorder and discs to store the images. Sure, Blu-ray discs cost more, but they save a lot of space. After a disc is recorded, I test it to make sure it works and then label it. Then I take it another step and think about how I will find that CD/DVD next week or next year. I start by entering the information from the shoot into a database created using Microsoft (www.microsoft.com) Excel, assign it a disc number, and using Roxio's (www.roxio.com) Easy Media Creator software, I produce a descriptive cover for the CD/DVD case that features a large picture from the shoot on it so I can immediately see what images are inside. A small label is made with the file number. It is affixed to the cover before the disc is moved to the basement archive.

SORT 'EM OUT

I prefer to sort images using Adobe Bridge. I then edit anything missed during the chimping process. My first pass through all the photographs is quick, and the idea is to get rid of images that aren't technically up to par. If I have any questions about a particular image, I set the preview window to a large size so I can more critically evaluate the photograph, and if it's not up to my standards, I click the trash can icon and it's gone. But what happens if it turns out that you can use that image later on? Remember that all of the files from the shoot—the good, bad, and ugly—are already backed up on CD/DVD. At this point, I'm only working with those images that are stored on my computer's hard drive.

Since Adobe Bridge allows me to view thumbnails for RAW files, I prefer to sort them into folders before doing any kind of processing. Processing first seems a waste of time and hard drive space.

My next pass through Bridge is slower, and I use its Label menu to assign ratings to the images. I use a one-star rating for marginal images and five stars for "select." When going through your images, be honest with yourself and only give a five star rating to exceptional or salable photographs.

At this point, separate items by content and put them in folders that are assigned names that help to identify the content. In the photographs of the model that's illustrated above, I created several folders (inside the main shoot folder)—one for each different setting or outfit that she was wearing. Next I dragged files one at a time or click-drag groups of image files into the folder as sorted by content. Once inside each individual folder, I sort the images by their rating so the best ones appear first in a Bridge view of that folder. At this point, the truly anal may want to make another CD, but I confess that I wait until I have actually processed some of the files before doing that.

While the files are temporarily stored on the hard disk, I pick ones to crop, color correct, or otherwise enhance. These retouched image files are kept in the same folder as the originals, and I save them in Photoshop's PSD format, with all the manipulation layers intact. I continue to use the camera's numbering protocol but add a "-1" to the file name (if I make two copies, I add "-2"). They are never sharpened or resized until I am ready to do something with a specific image, then I'll flatten the file (Layer>Flatten Image) and save it in the TIFF format, creating what might be a third version of the image file. Think of it as another layer of back-up.

When my hard disk begins to fill up, I look at the oldest folders and before dumping them in the Recycle Bin, copy all of the data, including the manipulated files, onto a new CD or DVD. Some people prefer to use external FireWire hard drives for data storage and, when they fill up, they buy another one, keeping all of their image data "hot." Since my Mac Pro has space for four internal drives, I have occasionally swapped out smaller drives and then

At this point, separate items by content and put them in folders . . .

I open a representative image and apply my edits. When do I do this? Not right away unless I have a client breathing down my neck who needs a photograph right now! I prefer to let my images steep, much like a good cup of Earl Grey tea, until I have achieved some distance in time and space from them so I can clearly see the difference between a great shot and a so-so one.

copied the files onto the new, larger drive. (Here's how I do it: I remove the old drive and replace it with the new one. [That's easy to do on a Mac Pro.] Then I install the "old" drive in an external drive housing and then copy all the files onto the new drive. Then the old drive goes in cold storage in my basement as a backup. The choice of backup method is up to you, but having the image data stored in two, maybe three different places is more than a good idea.)

What happens to the images next depends on the client or my final application. I sometimes shoot for fun and treat the images as if they were produced for an assignment or a real stock shoot. In such cases, I will shoot in the largest JPEG size. With a camera like the Canon EOS 1D Mark II N, the JPEG file is adequate for magazine reproduction even up to full-page bleed.

Sometimes a client just needs a single image and wants to see thumbnails. Using Photoshop's Save for Web command (File>Save for Web), I create a few JPEG files that can be easily e-mailed. It's probably a good idea to use Photoshop's text tool to add a copyright notice to identify the file among the many the client may be evaluating. (However, the copyright notice won't deter a thief.)

Of course, there is more to workflow than making folders and saving multiple copies of files.

COLOR TO BLACK & WHITE IN A FEW STEPS

One of the reasons photographic purists usually refer to black & white prints as "monochrome" is that it's a more precise, descriptive term that also covers images produced in sepia and other tones. There is much more to black & white photography than simply an absence of color. Maybe we wouldn't feel this way if the first photographs had been made in full color, but that

> Sometimes a client just needs
> a single image and wants
> to see thumbnails.

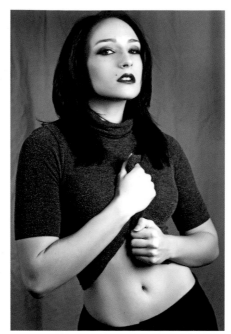
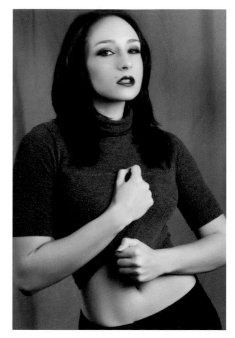

didn't happen and, like many photographers, I grew up admiring the works of W. Eugene Smith and other photojournalists who photographed people at work, play, or just being themselves in glorious black & white. As a creative medium, traditionalists may still call it "monochrome," but digital imagers prefer "grayscale." To paraphrase Billy Joel, "It's still black & white to me."

I wish I'd photographed some of the above images in color, done a better retouching job, then converted the images to monochrome. By shooting in RAW+JPEG capture, you can have your cake and eat it too: and one of the biggest advantages is that you always have the pose you like in either mode. After retouching a color image, you can convert the file to black & white using some of the tools I'm going to show next. (Note: Some of the products are available as a plug-in and an application, but a plug-in doesn't have to be an application. Life was never simple in the chemical-based traditional darkroom, and it isn't in the digital darkroom either.)

MONOCHROME CONVERSION

Nik Silver Efex Pro (www.niksoftware.com) is a Photoshop- and Aperture-compatible plug-in that offers emulations of eighteen different black & white films from Agfa, Fuji, Ilford, and Kodak, along with a grain engine that mimics the traditional silver halide process. In the Film Types area on the right-hand side of the interface you'll find controls for Sensitivity and Tonal Curve, which will allow you to fine-tune the effect. The plug-in uses Nik Software's patented U Point technology borrowed from Nikon's Capture NX software, which allows selective control of an image's brightness, contrast, and structure. By placing points on specific parts of the photo, you can control how much of the effect is applied to only those areas. When making the final monochrome conversions, Nik's Silver Efex Pro uses algorithms to protect

LEFT—One of the simplest ways to create a black & white photograph is to shoot in monochrome capture mode as I did in this photograph. This image was made with a Canon EOS 50D with an EF 100mm f/2.8 macro lens. The exposure was $^1/_{60}$ at f/8 and ISO 100. A Flashpoint II (www.adorama.com) monolight with Westcott Apollo softbox was placed at camera right. Another Flashpoint II was at camera left with the 32-inch Westcott white umbrella mounted. Both were set at $^1/_4$ power. CENTER—This image was captured in black & white in-camera. The upside of direct monochrome capture is that the image is already in black & white; the downside when photographing people is that retouching is slightly more time consuming because the really good retouching tools (like Imagenomic's [www .imagenomic.com] Portraiture) don't work as well in black & white. RIGHT—One of my favorite ways to convert a color file into monochrome is to use Photoshop-compatible plug-ins. You can always use Adobe Photoshop's Black & White command (Image>Adjustments>Black & White); it's a pretty good tool. Here I used that command to create a third, less contrasty version of the original photograph.

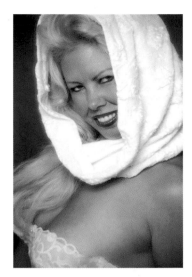

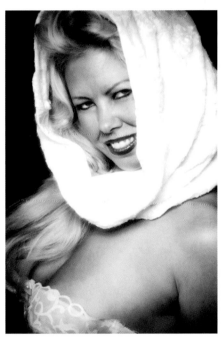

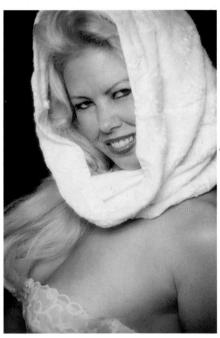

TOP LEFT—Dawn Clifford (www.dawn oftherockies.com) wanted to do a retro Hollywood shoot. This image was captured in my living room using one Flashpoint monolight with a 43-inch Westcott umbrella at camera right (see diagram). It was shot on color negative film with a Contax 167 and 85mm Zeiss lens. **TOP RIGHT**—Silver Efex Pro offers one-click presets in the Style Browser (left-hand side) or you can manually shift gears by using the controls on the right-hand side. Here you'll find access to control points, color filters, specific film responses, and a stylizing menu that lets you tone and vignette. **BOTTOM LEFT**—Silver Efex Pro includes many presets, including Sepia Landscape, which I used here; it seemed to capture the drama of images of Hollywood's past. **BOTTOM RIGHT**—Nik Software offers monochrome conversion plug-ins in the Color Efex Pro package. Their B/W Conversion plug-in provides an entirely different black & white look.

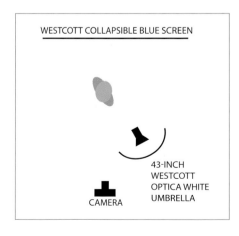

WESTCOTT COLLAPSIBLE BLUE SCREEN

43-INCH
WESTCOTT
OPTICA WHITE
UMBRELLA
CAMERA

against creating unwanted artifacts. The plug-in works with 8- and 16-bit images, RGB, CMYK, and LAB color spaces and is compatible with Photoshop's Smart Filters feature.

Power Retouche's (www.powerretouche.com) Black & White Studio includes a pop-up Control menu, giving you access to three different interfaces—Film, Print, or Zones. Film lets you apply the light sensitivity of specific films (Kodak Tri-X, T-MAX, etc.) and types (panchromatic, orthochromatic), or you can create your own sensitivity curves and save them for later use. There's also a Perceptual Luminance option in the Filmtype Presets popup menu that does a pretty good job if none of the included Agfa, Ilford, or Kodak presets work for you. The Print controls put the darkroom back in digi-

USING PLUG-INS

Although Adobe defined the standard, you don't need Photoshop to use plug-ins. Compatible plug-ins can be used with other image-editing programs including Corel's Painter, PhotoPaint, and Paint-Shop Pro, but not all plug-ins work with Photoshop Elements and some monochrome conversion plug-ins, such as Exposure, are not currently compatible with Apple's Aperture. Some companies offer Aperture-compatible plug-ins. Companies have extended their technology to work with Lightroom, but its plug-in architecture is dissimilar to Photoshop. Adobe differentiates between plug-ins and external editors, and Lightroom 2 has the ability to define as many external editors as you want. According to Adobe, "Image processing plug-ins are best utilized through Photoshop."

When working with the plug-ins used to create the images in this chapter, it's important to remember one of Farace's Laws of digital imaging: monochrome conversion, like all effects, is subject dependent. One effect may look great for portraits, while another may work best with landscapes, so you may need more than one plug-in. Many, if not all, of the plug-ins discussed are available in trial or demo versions, so be sure to visit the companies' web sites, download any that interest you, and use them with your own photos.

tal darkroom, offering sliders for Multigrade, Exposure, Contrast, Saturate Blacks, and Black Soft Threshold. Zones may not be a direct implementation of Ansel Adam's Zone System, but it's close enough, allowing you to assign three separate zones to an image and apply separate contrast, brightness, and balance to each one.

Power Retouche's Toned Photos plug-in makes a wonderful complement to Black & White Studio and lets you add sepia, Van Dyck, Kallitype, silver gelatin, palladium, platinum, cyanotype, light cyanotype, or silver toning using presets or its controls to create your own. Both plug-ins work with 8, 16, 48, and 64-bit RGB, grayscale, duotone, or CMYK image files.

These presets are the starting point and can be tweaked to suit a particular photograph.

CONVERSION AND MORE

Alien Skin Software's (www.alienskin.com) Exposure 2 contains two plug-ins: Black and White Film emulates a dozen different film stocks, and Color Film not only re-creates a film's distinctive look as a more-or-less one-click operation but manages saturation, color temperature, dynamic range, softness, sharpness, and grain at the same time. These presets are the starting point and can be tweaked to suit a particular photograph or applied to a batch using Photoshop Actions. Exposure 2 can add grain to an image's shadows,

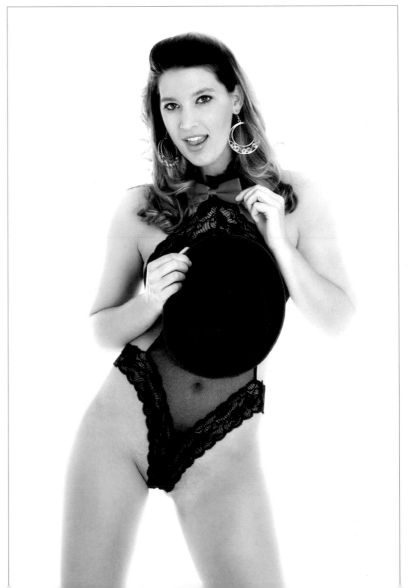

TOP LEFT—Kent Hepburn made this photograph of Deanna using three Photogenic (www.photogenic .com) monolights. The main light with lightbank attached was placed in front of the subject and to her left. A second light with 42x78-inch white scrim was placed to her right. The third light was aimed at the white background to push it to high key. The camera was a Canon EOS 40D with an EF 28–135mm IS lens. The exposure was $^{1}/_{160}$ at f/5 and ISO 100. **TOP RIGHT**—Power Retouche's Black & White Studio includes a Perceptual Luminance option (found in Filmtype Presets pop-up menu) that does a pretty good job if none of the included Agfa, Ilford, or Kodak presets work for you. **BOTTOM**—To knock the edge off of the extremely sharp images, after applying Power Retouche's Black & White Studio, I used Nik Color Efex Pro's (www.niksoftware.com) Classical Soft Focus filter to add just a touch of softness.

mid-tones, or highlights and emulates the size, shape, and color of real-world grain. The plug-in's presets include high-level contrast and highlight and shadow controls that can be applied with just a click. Additional features reproduce studio and darkroom effects such as cross processing, split toning, push processing, and glamour portrait softening. Exposure 2 even includes presets for cross-processed Lomo-style images, shot with your choice of four different manufacturers' film! In addition to a before/after button, the preview window includes an optional split preview and combines unlimited undo/redo pan and zoom using Photoshop-style keyboard shortcuts. Right now, the plug-in costs $249.95.

While it's not specifically designed for monochrome conversion, Imagenomic's (www.imagenomic.com) RealGrain Photoshop-compatible plug-in lets you perform conversions—and then some. This Mac OS and Windows software offers methods for simulating grain pattern, color, and the tonal response of different kinds of black & white films to produce film-like effects. RealGrain also simulates traditional toning effects such as sepia, platinum,

TOP LEFT AND DIAGRAM—Mary Farace captured Dawn Clifford as Molly Brown using a Flashpoint II monolight placed above and at camera left to balance the window light. She used an Olympus E-330 with a 7–14mm (14–28mm equivalent) lens. The exposure was $^1/_{160}$ at f/4.5 and ISO 400. © 2011 Mary Farace. **LEFT**—Alien Skin's Exposure 2 can be operated by selecting film presets from the Settings tab. It provides what may be the most extensive library of film tonalities available on any software. © 2011 Mary Farace. **TOP RIGHT**—The final black & white result. You would be remiss if you did not explore the Color, Grain, or Focus tabs in the interface—I completely removed the grain, for example—and use the controls to refine the final effect (perhaps adding a touch of toning). Infrared fans should also take note of the separate "IR" tab, which can be used to tweak your shots to produce the most realistic infrared emulation available. © 2011 Mary Farace.

TOP LEFT—Here's a photo of my wife that I made while testing Canon's EOS 1Ds Mark III for *Shutterbug*. I used three Flashpoint II monolights: The main light was at camera right and had a Westcott Halo mounted. Fill was from a monolight at camera left with a 32-inch Westcott umbrella attached. The third light was to the left rear with standard reflector mounted. The exposure was $1/60$ at f/11 and ISO 100. **BOTTOM**—Imagenomics' RealGrain plug-in features versatile methods for simulating the grain patterns, color, and the tonal response of different black & white or color (you can ignore that part, if you like) film types and lets you produce a convincing film-like effect. **TOP RIGHT**—For the final portrait, I applied the Kodak BW 400CN preset, which is just one of the twenty film types from Fuji, Kodak, and Ilford that are available. Sorry, Agfa fans.

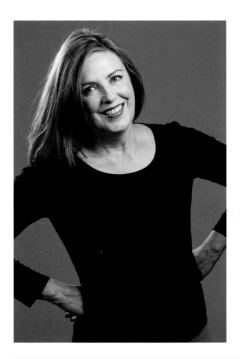

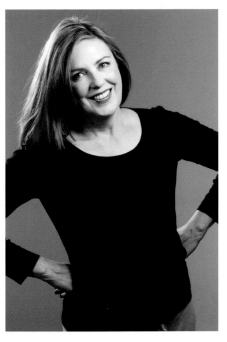

and others, as well as split toning. The plug-in automatically adjusts grain size based on the image file's physical dimensions and dynamically renders accurate color or black & white film grain patterns for varying file sizes. RealGrain has a library for many color and monochrome films and lets you fine-tune hue, saturation, and brightness. You can even use master saturation and hue sliders to manipulate saturation and hue levels for all color ranges. Finally, you can also control color toning for shadows and highlights, as well as for single-tone effects or to adjust the tint in color images.

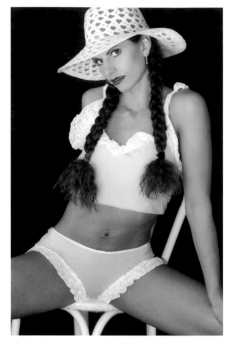

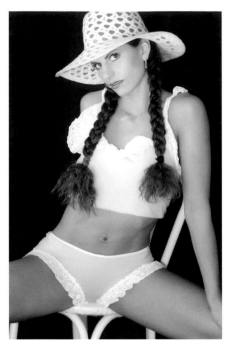

Pixel Genius's (www.pixelgenius.com) PhotoKit shows up in Photoshop's File>Automate menu tree. The inexpensive PhotoKit includes 141 effects, offering digital versions of traditional analog photographic effects ranging from burning and dodging, to digital toning, to adding black edges to your images. The Color to B&W set doesn't just convert to grayscale but mimics the effect of shooting with a color filter on your lens. The same rules that apply to in-camera photography apply here; the applied filter lightens image colors that are the same as the filter, while darkening complementary (opposite) colors. Each effect has a full and ½ option, and you can run it several times if applied using layer masks.

Tip: Turn off the layer (click the eyeball icon in Photoshop's Layers palette) before running PhotoKit again. The B&W Toning Set includes nine toning effects that are applied to a new layer. The tones themselves vary from merely great to amazing, as is the case with the platinum effect. A simple dialog calls up the PhotoKit tool sets, but there is no real plug-in interface, no sliders, and no preview window. The process may be off-putting at first, but you'll get used to it as you begin to love what PhotoKit does for your images.

OnOne Software's (www.ononesoftware.com) PhotoTools and Photo Tools Professional are a collection of effects accessible through a single interface that provides a wide range of effects, corrections, and automation. Both programs allow you to apply digital neutral density, color correction, and polarization filters, as well as darkroom and alternative processes like solarization, cyanotype, and palladium printing. PhotoTools Professional includes ten presets for monochrome conversions but lets you stack effects on top of one other and control the order in which each is applied, as well as how the effects blend together. The entire package includes 150 different effects that

LEFT—I photographed Jamie-Lynn against a black seamless paper in a friend's living room. The main light was a Flashpoint II monolight with a 45-inch Westcott optical white satin umbrella. Window light from camera left provided fill. The camera was a Canon EOS 1D Mark II with a EF 85mm f/1.8 lens. The exposure was $^1/_{60}$ at f/5.6 and ISO 400. **CENTER**—The minimalist interface of PhotoKit belies the power that hides between the two popup menus. The first lets you select the set you want to apply (B&W Toning, Burn Tone, Color Balance, Convert to B&W, Dodge Tone, Photo Effects, and Tone Correction), while the second lets you pick a specific effect within that set. PhotoKit is optimized for images between 8 and 18MB and is useful on larger sizes, but some of the effects don't translate to smaller Web-sized files. **RIGHT**—Using PhotoKit, the finished effects take less time to apply than it will take you to read this caption. This is the platinum effect, which applies a warm monochrome tone to the image.

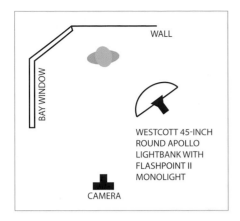

WESTCOTT 45-INCH
ROUND APOLLO
LIGHTBANK WITH
FLASHPOINT II
MONOLIGHT

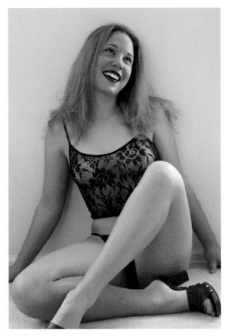
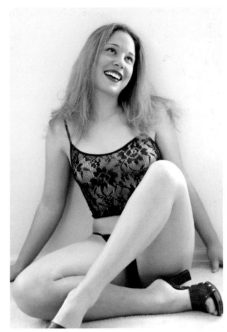

TOP LEFT—I made this image in my living room studio. A Flashpoint II monolight served as the main light. Window light provided fill. The camera was a Canon EOS 5D with an EF 85mm f/1.8 lens. The exposure was $^1/_{50}$ at f/13 and ISO 200. **BOTTOM**—Once you've created an effect, you can use PhotoTools' batch processing engine to apply that particular look to a folder of images. You can then process the files using multiple output formats with different sizes, color spaces, and names. Both the PhotoTools Professional version and the standard program accomplish much more than monochrome conversion. **TOP RIGHT**—This image was converted to monochrome using PhotoTools' GM Warm +1 and Snappy A1+ preset. When printed on matte inkjet paper, the effect is even more striking.

can be applied to color or monochrome images, which means the combinations and possible permutations are almost infinite.

PROOFING AND OUTPUT

All of my photography is done for publication in books or magazines, whether in print or online, so I don't deliver any kind of traditional prints or proofs to the people I photograph. Instead of proofs I give them a CD containing all of the images that I make. Online proofing? Fuggedaboutit. Several wedding photographers have told me that they've seen print sales go down after they instituted online proofing. These days, young clients are digitally driven. As long as they can see—and show their friends—photos on their iPhone, it's "real" and they don't want or need prints or proofs.

In my Amherst Media book *Joe Farace's Glamour Photography,* I wrote about the TFP (Time for Photos) concept. While some photographers and models like to make the process complicated, I think it all boils down to a simple trade of services: the model gets photographs, the photographer gets to work with the model. In general, a TFP shoot provides both subject and photographers with photos they can use in their portfolios, but like any contract, you and she can negotiate about what you each want.

The TFP concept may have started with prints but nowadays includes digital delivery in the form of a CD/DVD. The content of these discs can vary based on whatever agreement you make with the subject. Some photographers provide only low-resolution images, but I think that's cheating. She supplied you with high-resolution posing during the session, and I think you should supply her with high-resolution photographs for her efforts. One model told me she only got one photo from a TFP shoot. It was a great shot, she said, but she nevertheless felt cheated. Some photographers supply every image that was made during the shoot, while others only include a few retouched photos of the photos they like. Me? I give her the kitchen sink; she gets every photo I make. If a person I've photographed asks, I'll retouch selected images for the client using techniques that are covered in an entire chapter in my first Amherst Media book.

As far as output is concerned, I haven't made a print for a client in several years. The models and people I photograph take the CDs to Target and make their own prints. I don't even make prints for portfolio use ever since a big-time New York-based magazine, now out of business, stole my 11x17-inch portfolio. You can read that cautionary tale in my first book as well. These days, I show potential clients images on my Apple iPad or even an iPod Touch. These devices display the images with incredible clarity, are easy to update, and infinitely more portable than a print portfolio, especially an 11x17-inch one.

If models or clients want prints that are better or larger than Target's, that are surprisingly good for the price, I send them to White House Custom Color (www.whcc.com). The staff make outstanding quality prints at affordable prices. My wife, Mary, has had several images printed by White House and she really likes the quality, especially on black & white prints that were noticeably free of any color cast and perfectly neutral.

I used to make prints. Here I am back in 2004 holding a print when I was doing an outdoor shoot for an automobile magazine. The 13x19-inch print was made on an Epson desktop printer using the default settings for the Epson paper used. No mumbo-jumbo, no RIPs, just stick the paper in and print. But the key is that you should make sure that your monitor has been color calibrated. I use Datacolor's (http://spyder.datacolor.com/product mc-s3pro.php) Spyder 3 Pro, but you can use any product you like and can afford.

CONCLUSION

"And in the end, the love you take is equal to the love you make."—*John Lennon*

Whew, it's hard to believe that we've come to the end of the book already. Over the past eight chapters, I have tried to give you a crash course in my personal approach to studio lighting, even if that studio is only in your mind. Since this book was written many months ago and you may be reading it months after its release, you can keep up with what I am doing by following me on Twitter (www.twitter.com/joefarace), where you can see some of the images I'm making right now. I strongly believe that photographers must grow and change both in the technologies that we use to make our images and in the ways that we use them. Even subject matter can change and morph over time as our interests and tastes are affected by societal changes. Some things that won't change are an interest in capturing people using natural or artificial light—and the need to understand how the color and quality of that light affects the look of those photographs.

The main light was a square lightbank mounted on a Zebra 320 monolight and placed at camera left. Fill was provided by another Zebra 320 with a 36-inch umbrella, while the hair light was a Zebra 160 with barn doors placed at right rear. Manual exposure with an Olympus E-30 and 40-150mm f/4-5.6 lens was 1/60 second and ISO 125. © 2011 Mary Farace.

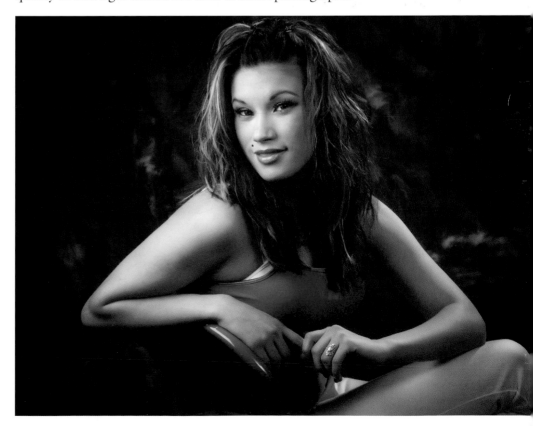

GLOSSARY

The world of studio lighting equipment and techniques gave rise to its own language—buzzwords—that is used to describe the tools and methods used to achieve even the simplest of lighting effects. Words like "snoot" and "cucoloris" (sometimes spelled cuculoris, kookaloris, or cucalorus) abound, so knowing the lingo will help you put into practice some of the techniques that appear in this guide. Here's a brief introduction to some of the most commonly used lighting terms.

AWB (Auto White Balance). Many times this white balance setting will produce spot-on color the first time without any color temperature gymnastics. If all else fails, you can use the camera's built-in controls to create a custom white balance for a specific lighting setup. The key for doing this is having a dependable "white" color source that can be used to calibrate your camera. The flipside of the Kodak Gray Card is white and makes a good reference tool.

Bounce. This kind of lighting bounces off a particular modifier (such as an umbrella, wall, or any reflective surface) to surround the central object with light. A bounce-lit photograph will have fewer shadows and softer lighting that doesn't appear to originate from a specific source.

Bracketing. A time-honored technique where multiple images of the same subject are made at different exposure levels. The idea is that one of the exposures will be the best. Some SLRs feature an Auto Bracket mode. When this setting is used, the first frame is exposed with no compensation, the second is underexposed, and the third is overexposed. The sequence varies by camera and can sometimes be modified. Check your camera's user's guide for more information.

Broad lighting. A portrait lighting technique where the main light source illuminates the side of the face closest to the camera.

Continuous light. Studio lighting can be broken down into two basic categories: continuous light and electronic flash. Continuous light is so named because it's on continuously, like a lightbulb, enabling you to use your in-camera light meter to measure exposure. These kinds of lights can be inexpensive and make a good starting point for anyone on a budget. They also allow you to see what the light is doing (e.g., you can see the shadows and highlights). Continuous light sources such as quartz or photofloods can produce a great deal of heat, leading to the use of the term "hot lights." An increasing number of continuous lighting tools are being made using fluorescent lights, enabling photographers to opt for cool "hot lights."

Continuously variable output. Most studio lights have individual power settings of $\frac{1}{4}$, $\frac{1}{2}$, $\frac{3}{4}$, and full. This allows you to adjust the output of the light to suit a single-subject portrait. Having continuously variable output available also allows you to fine tune the exposure to get precisely the aperture and depth of field you want.

Cucoloris. A device for casting shadows or silhouettes to produce patterned illumination on a background or subject. The word is sometimes shortened to "cookie" or "coo-koo." The cookie is used to create a more natural look by breaking up the light from a man-made source.

Fill. A fill light (often simply called "fill") is used to reduce the contrast of a photograph and provide some illumination for areas of the image that are in shadow. A common lighting setup places the fill light along the lens axis, perpendicular to the main light.

Flash duration. This is exactly what it sounds like: it is the amount of time elapsing after triggering the electronic flash tube in the flash head. It is usually really short in duration, $\frac{1}{1000}$ or even less.

Guide number. A number that describes a flash's power output. The higher the guide number, the more

the light output. Guide numbers (GN) are quoted in feet or meters (depending on where you live in the world) and are valid for a given ISO setting. Guide numbers serve as a way to calculate aperture when shooting flash in manual exposure mode. To determine the correct aperture, you divide the guide number by the flash-to-subject distance—not the camera-to-subject distance.

HMI. Hydrargyrum medium arc iodide lights have several advantages over standard incandescent or quartz lights. When compared to incandescent lights, they deliver five times the light output per watt and generate less heat. Unlike quartz, the color temperature of HMI lights is the same as sunlight and doesn't require an on-camera filter or a tungsten color balance setting in the camera. Originally designed for the film and video industry, HMI is a flicker-free light source that's also recommended for digital still photographs that require long exposures. The downside is these lights are pricey.

Hot lights. *See* Continuous light.

Incident light meters. There are two basic types of light meters: incident or reflected. Incident light meters measure the amount of light falling on the subject. Most handheld light meters can be used for measuring incident or reflected light. *See also* Reflected light meters.

Kelvin. In the 19th century, Lord Kelvin urged the elimination of negative values when measuring temperatures and suggested that an absolute zero temperature be the basis for the scale. Higher Kelvin color temperatures are at the cool (blue) end of the spectrum. On the lower side, light sources are on the warmer (red) end of the spectrum. On a clear day at noon, the sun measures 5500 degrees Kelvin. On an overcast day, the temperature rises to 6700 degrees Kelvin. The light measures 9000 degrees Kelvin in open shade on a clear day. Traditional hot lights have a temperature of approximately 3200 degrees Kelvin, while household lightbulbs usually measure about 2600 degrees.

Key light. This is an alternate name for the main light. Photographers seem to like to have more than one name to refer to a given tool.

Lighting ratio. The difference in the brightness of light falling on your subject from the main light and the fill light (of course, many setups use additional lights, like hair lights and background lights to accent specific areas of the subject or scene). A ratio of 3:1 is considered "standard" or normal for color photography, but I believe that photographers can be flexible in applying this rule.

Lumen. A lumen is a unit of measurement of light intensity falling on a surface.

Lumensecond. A lumensecond refers to a light of one lumen for a one second or the equivalent, such as two lumens for half a second. The number of lumenseconds produced by a particular flash system depends on the efficacy, how effectively the flash turns electrical energy into light energy, or watt-seconds into lumenseconds. Most electronic flash units produce 15 to 50 lumenseconds per watt-second. What this means is that sometimes an efficient 300 watt-second system may produce as much actual light energy as an inefficient system rated at 1000 watt-seconds.

Main light. The light used to establish the shadows and modeling in a scene. The direction of the main (or "key") light is the most important in establishing the general look of the photograph.

Modeling light. A continuous light source that's built into a flash head or monolight and lets you preview the effect of the flash lighting in real time. Less expensive lights provide an on/off modeling light control to give you some idea of what the final lighting effect will be. Those with proportional settings allow the modeling light to vary with flash output. Keep in mind that although the modeling light may be bright, it is not as bright as the flash. Also, when you choose a low power setting when the ambient light is high, the effect of the modeling light may be difficult to see.

Monolight. (Known as a monobloc by our European friends.) This is a self-contained studio flash, typically AC powered, that allows the fitting of light modification attachments, such as umbrellas. It consists of a power source and a light head, all contained within a single, compact housing.

Noise. In digital photographs, noise is the visual equivalent of the static you hear in AM radio signals. The unvarnished truth is that most digital cameras add some level of noise to image files. The nearest equivalent in traditional photography is grain. In digital images as in film, noise is more noticeable at high ISO settings. It is also more visible in areas of uniform color, such as skies

and shadows. Noise increases during long exposures made under low-light conditions and is most obvious in underexposed areas.

PC (Prontor-Compur) cord. This is a synchronization cord that allows a studio light to be triggered when it's connected to your camera's corresponding PC outlet and the shutter release is pressed. These days, not all digital SLRs, especially inexpensive ones, have a PC connection, so an adapter may be required to connect to studio lights.

Proportional modeling light. Less expensive studio lights just provide an on/off modeling light to give you some idea of what the final lighting effect will be. Those with proportional settings allow the modeling light to vary with flash output.

RAW files. RAW files are unprocessed data directly from the sensor to your memory card. No white balance or any other in-camera processing is applied to the image file. RAW files take more space than JPEG images but less than TIFF. As the price of high-capacity memory cards decreases, it may not be an issue whether to use RAW or JPEG. Note that different manufacturer's use different file format tags for their RAW files: CRW (Canon), NEF (Nikon), ORF (Olympus), and more.

Recycle time. The time it takes after the electronic flash has fired before the unit is fully charged and able to be fired again. This can be an important factor when comparing monolights.

Reflected light meters. Reflected-light meters measure the light that's reflected by the scene to be photographed. All in-camera meters are reflected-light meters, but some handheld light meters can be used for measuring incident or reflected light.

Reflector. There are two different uses of the word "reflector" in lighting techniques: (1) Most studio lighting devices have a reflector that's built-in or optional that attaches to the front and focuses the light on the subject. The size and shape of that reflector and where you place the light will determine the quality of the lighting. These reflectors also allow an umbrella to be attached to the light. (2) A reflector is a flat surface that "bounces" light from any light source. Most reflectors are made of some kind of reflective fabric and are available in different colors to change the color of the reflected light. More often than

not, these reflectors collapse into a more portable form for travel. These kinds of reflectors follow the same rules as all lighting devices: bigger sources used close to the subject produce softer light; smaller sources positioned farther away produce harder light. Collapsible reflectors come in many shapes, sizes, and variations on a theme.

Slave. A cordless method of firing a studio light that often uses an optical device that can be set to fire the flash when it "sees" another flash go off. These days, radio-controlled slaves are a popular option that allow a monolight to be wirelessly triggered without a flash or sync cable, which is especially useful for SLRs that lack a PC connection.

Snoot. A simple lighting accessory that replaces the light's standard reflector to more tightly control the path of the light and prevent stray light striking the front element of your camera's lens, causing flare. *Warning:* When using a snoot, turn off the head/monolight's modeling light to avoid heat buildup.

Specular highlight. A bright spot of light that appears on shiny objects when illuminated. The size and characteristics of this specular highlight change with the size of the light source and the distance from the source to the subject.

Sync speed. The sync (synchronization) speed is the fastest shutter speed on your camera that will provide a fully exposed image. You may shoot at any speed less than the specified sync speed, but if you shoot at a speed higher than the sync speed, you will get a partially exposed image. See chapter 7 for a good (or, rather, bad!) example.

Watt-seconds. A measurement of the power and discharge capacity of an electronic flash's power supply. This measurement does not always indicate the total amount of light that can be produced by the electronic flash unit, as the reflector's impact on the output is not taken into consideration.

INDEX

OTHER BOOKS FROM

Amherst Media®

JOE FARACE'S
Glamour Photography

Farace shows you budget-friendly options for connecting with models, building portfolios, selecting locations and backdrops, and more. *$34.95 list, 8.5x11, 128p, 180 color images, 20 diagrams, index, order no. 1922.*

JEFF SMITH'S
Studio Flash Photography

This common-sense approach to strobe lighting shows working photographers how to master solid techniques and tailor their lighting setups to individual subjects. *$34.95 list, 8.5x11, 128p, 150 color images, index, order no. 1928.*

Just One Flash

A PRACTICAL APPROACH TO LIGHTING FOR DIGITAL PHOTOGRAPHY

Rod and Robin Deutschmann

Get down to the basics and create striking images with just one flash. *$34.95 list, 8.5x11, 128p, 180 color images, 30 diagrams, index, order no. 1929.*

Multiple Flash Photography

OFF-CAMERA FLASH S FOR DIGITAL PHOTOGRAPHERS

Rod and Robin Deutschmann

Use two, three, and four off-camera flash units and modifiers to create photos that break creative boundaries. *$34.95 list, 8.5x11, 128p, 180 color images, 30 diagrams, index, order no. 1923.*

CHRISTOPHER GREY'S
Lighting Techniques
for Beauty and Glamour Photography

Create evocative, detailed shots that emphasize your subject's beauty. Grey presents twenty-six varied approaches to classic, elegant, and edgy lighting. *$34.95 list, 8.5x11, 128p, 170 color images, 30 diagrams, index, order no. 1924.*

UNLEASHING THE RAW POWER OF
Adobe® Camera Raw®

Mark Chen

Digital guru Mark Chen teaches you how to perfect your files for unpreceented results. *$34.95 list, 8.5x11, 128p, 100 color images, 100 screen shots, index, order no. 1925.*

BRETT FLORENS'
Guide to Photographing Weddings

Brett Florens travels the world to shoot weddings for his discerning clients. In this book, you'll learn the artistic and business strategies he uses to remain at the top of his field. *$34.95 list, 8.5x11, 128p, 250 color images, index, order no. 1926.*

Understanding and Controlling
Strobe Lighting

John Siskin

Learn how to use a single strobe, synch lights, modify the source, balance lights, perfect exposure, and much more. *$34.95 list, 8.5x11, 128p, 150 color images, 20 diagrams, index,*

WES KRONINGER'S
Lighting Design Techniques

FOR DIGITAL PHOTOGRAPHERS

Design portrait lighting setups that blur the lines between fashion, editorial, and traditional portrait styles. *$34.95 list, 8.5x11, 128p, 80 color images, 60 diagrams, index, order no. 1930.*

DOUG BOX'S
Off-Camera Flash

TECHNIQUES FOR DIGITAL PHOTOGRAPHERS

Master off-camera flash, alone or with light modifiers. Box teaches you how to create perfect portrait, wedding, and event shots, indoors and out. *$34.95 list, 8.5x11, 128p, 345 color images, index, order no. 1931.*

ROLANDO GOMEZ'S
Lighting for Glamour Photography

In this book, renowned glamour guru Rolando Gomez teaches the simple and complex lighting strategies you need to create the figure-enhancing shots that will make every woman look her very best. *$34.95 list, 8.5x11, 128p, 150 color images, index, order no. 1918.*

Corrective Lighting, Posing & Retouching

FOR DIGITAL PORTRAIT PHOTOGRAPHERS, 3RD ED.

Jeff Smith

Address your subject's perceived physical flaws in the camera room and in postproduction to boost client confidence and sales. *$34.95 list, 8.5x11, 128p, 180 color images, index, order no. 1916.*

Wedding Photography
ADVANCED TECHNIQUES FOR WEDDING PHOTOGRAPHERS
Bill Hurter

The advanced techniques and award-winning images in this book will show you how to achieve photographic genius that will help you win clients for life. *$34.95 list, 8.5x11, 128p, 150 color images, index, order no. 1912.*

Off-Camera Flash
CREATIVE TECHNIQUES FOR DIGITAL PHOTOGRAPHY
Rod and Robin Deutschmann

Push the limits of design with these off-camera flash techniques. Covers portraits, nature photography, and more. *$34.95 list, 8.5x11, 128p, 269 color images, 41 diagrams, index, order no. 1913.*

The Art of Posing
TECHNIQUES FOR DIGITAL PORTRAIT PHOTOGRAPHERS
Lou Jacobs Jr.

Jacobs culls strategies and insights from ten photographers whose styles range from traditional to modern. *$34.95 list, 8.5x11, 128p, 180 color images, index, order no. 2007.*

The Beginner's Guide to Photographing Nudes
Peter Bilous

Covers every aspect of finding models, planning and executing session, and getting your images out into the world. *$34.95 list, 8.5x11, 128p, 200 color/b&w images, index, order no. 1893.*

Portrait Lighting for Digital Photographers
Stephen Dantzig

Dantzig shows you the hows and whys of portrait lighting. Advanced techniques allow you to enhance your work. *$34.95 list, 8.5x11, 128p, 230 color images, index, order no. 1894.*

JERRY D'S Extreme Makeover Techniques
FOR DIGITAL GLAMOUR PHOTOGRAPHY
Bill Hurter

Learn the secrets of creating glamour images that bring out the very best in every woman. *$34.95 list, 8.5x11, 128p, 270 color images, index, order no. 1897.*

Professional Commercial Photography
Lou Jacobs Jr.

Insights from ten top commercial photographers make reading this book like taking ten master classes—without having to leave the comfort of your living room! *$34.95 list, 8.5x11, 128p, 160 color images, index, order no. 2006.*

500 Poses for Photographing Brides
Michelle Perkins

Filled with images by some of the world's best wedding photographers, this book can provide the inspiration you need to spice up your posing or refine your techniques. *$34.95 list, 8.5x11, 128p, 500 color images, index, order no. 1909.*

500 Poses for Photographing Women
Michelle Perkins

A vast assortment of inspiring images, from head-and-shoulders to full-length portraits, and classic to contemporary styles—perfect for when you need a little shot of inspiration to create a new pose. *$34.95 list, 8.5x11, 128p, 500 color images, order no. 1879.*

500 Poses for Photographing Men
Michelle Perkins

Overcome the challenges of posing male subjects with this visual sourcebook, showcasing an array of head-and-shoulders, three-quarter, full-length, and seated and standing poses. *$34.95 list, 8.5x11, 128p, 500 color images, index, order no. 1934.*